READING
FASHION
IN ART

READING
FASHION
IN ART

INGRID E. MIDA

BLOOMSBURY VISUAL ARTS
LONDON · NEW YORK · OXFORD · NEW DELHI · SYDNEY

BLOOMSBURY VISUAL ARTS
Bloomsbury Publishing Plc
50 Bedford Square, London, WC1B 3DP, UK
1385 Broadway, New York, NY 10018, USA

BLOOMSBURY, BLOOMSBURY VISUAL ARTS and the Diana
logo are trademarks of Bloomsbury Publishing Plc

First published in Great Britain 2020

Cover design: Adriana Brioso
Cover image: *Empress Eugenie, surrounded by her Ladies-in-Waiting* (oil on canvas),
by Franz Xaver Winterhalter, 1855. © Bridgeman Images.

A catalogue record for this book is available from the British Library.

Library of Congress Cataloging-in-Publication Data
Names: Mida, Ingrid, author.
Title: Reading fashion in art / Ingrid E. Mida.
Description: London ; New York, NY : Bloomsbury Visual Arts, 2020. |
Includes bibliographical references and index.
Identifiers: LCCN 2019046109 | ISBN 9781350032705 (paperback) | ISBN
9781350032699 (hardback) | ISBN 9781350032712 (epub) | ISBN
9781350032736 (pdf)
Subjects: LCSH: Clothing and dress in art. | Fashion in art.
Classification: LCC N8217.F33 M53 2020 | DDC 704.9/49391--dc23
LC record available at https://lccn.loc.gov/2019046109

ISBN: HB: 978-1-3500-3269-9
 PB: 978-1-3500-3270-5
 ePDF: 978-1-3500-3273-6
 eBook: 978-1-3500-3271-2

Typeset by Lachina Creative, Inc.
Printed and bound in India

To find out more about our authors and books visit
www.bloomsbury.com and sign up for our newsletters.

This book is dedicated to my mother, the late Magdalene Masak, who taught me that learning is a lifetime adventure.

Contents

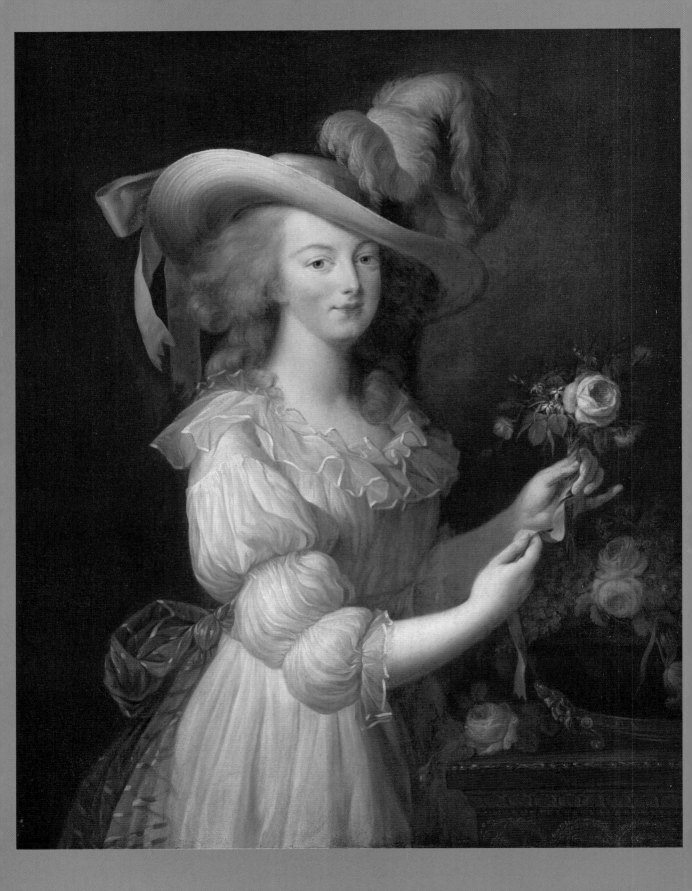

Introduction

When artists represent the human form in works of art, the narratives of culture become embedded in the manner in which the body has been fashioned therein. And while artists may enhance, exaggerate, or take artistic license with that representation to satisfy their client, to make an artistic statement, or to challenge hegemonic norms, the manner in which the body is fashioned in an artwork provides clues to the expression of aesthetic ideals and norms for that period in history. These clues might include the posture, gaze, and stylization of the body of the sitter, the extent to which the figures are dressed or undressed, the types and colors of textiles and embellishments depicted, how the hair is fixed, and what accessories or props are included. As Anne Hollander so powerfully expressed in her seminal book *Seeing Through Clothes*, "clothes make, not the [wo]man, but the image of the [wo]man," such that art and clothing are "connected links in a creative tradition of image-making."[1]

Although clothing cannot be read as easily as text, a close study of how the body has been fashioned in an artwork can reveal cultural beliefs of a particular moment in time, including notions of beauty, gender, modesty, dignity, propriety, morality, and representations of power. This is readily illustrated by the infamous portrait of Marie Antoinette by artist Elisabeth Vigée Le Brun exhibited in the 1783 Paris Salon for the Académie Royale that resulted in considerable controversy over the way the Queen of France was dressed. For Vigée Le Brun's first submission to the Salon as a newly admitted member of the Academy, the artist depicted Marie Antoinette in a three-quarter length portrait in which she is standing against a dark background holding a flower in one hand with her body turned slightly as she gazes towards the viewer (Figure 0.1).[2] Marie Antoinette's un-coiffed hair was topped with a wide-brimmed straw hat ornamented with ostrich feathers and a satin ribbon. She was dressed in a loose-fitting lightweight gown with a deep round flounced neckline, softly gathered elbow-length sleeves, and a sash of gauze tied at the waist and fastened into a bow at the back (Figure 0.1). This style of dress,

OPPOSITE
Figure 0.1

Elisabeth Vigée Le Brun (unsigned copy),
Marie Antoinette in a Chemise Dress.
after 1783. Oil on canvas (92.7 × 73.1 cm).

initially known as *robe en gaulle* and later as *chemise à la reine*, was a favored style in the Queen's wardrobe, especially during her visits to the more intimate setting of the Trianon or the pastoral setting of the Hameau de la Reine. The Queen had been introduced to this style in the summer of 1780 by her *marchande de mode*,[3] Rose Bertin, who had copied the style from the lightweight gowns worn in the warm tropical climate of the French colony of Saint-Domingue.[4] These loose-fitting chemise-style gowns suited the Queen's affinity for comfort and simplicity and were also readily adaptable as maternity wear during her pregnancies.[5] Although the Queen appears modestly dressed by today's standards, this 1783 portrait was considered indecent at the time, underlining the prevailing role that dress played in notions of propriety and morality.

Vigée Le Brun's first royal portrait commission of the Queen in 1778 illustrated the traditional iconography of royal portraiture (Figure 0.2). In this earlier full-length portrait, the Queen was placed in a theatrical interior setting that reflected her royal status. She was formally attired in a court dress of white satin with wide panniers and a long train with a fleur-de-lis pattern; her hair was powdered and ornamented with a headdress topped with white ostrich feathers; and her golden crown sat on a pillow on a draped table nearby. Marie Antoinette did not look directly at the viewer; instead she looked away, off into the distance. All the artistic choices in this composition, including the setting, the props, and Marie Antoinette's gaze, posture, and dress conveyed the dignity of her royal position. By contrast, Vigée Le Brun's portrait of 1783 presented Marie Antoinette, not in the manner expected of a Queen, but as a fashionable lady in informal dress that was at the time considered suitable only in the privacy of the home. Although this portrait was not the first instance in which the Queen had appeared informally dressed in a commissioned work,[6] these other portraits of Marie Antoinette were either made for her own pleasure or sent to her mother in Vienna and were not put on public display.

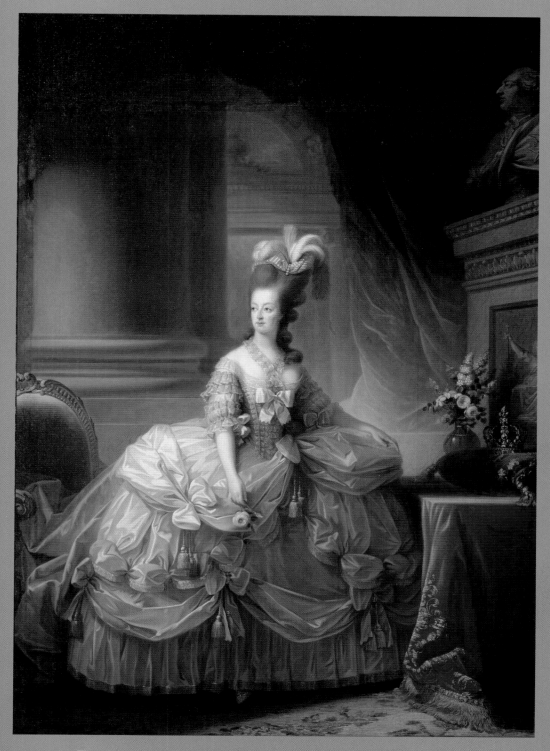

Figure 0.2

Elisabeth Vigée Le Brun, *Marie Antoinette in Court
Dress*, 1778. Oil on canvas (273 × 193.5 cm).

Before Vigée Le Brun created the portrait of the Queen wearing the *robe en gaulle*, the artist had previously convinced several women of the French aristocracy to wear this informal style of gown for their portraits, including the Comtesse du Barry in 1781[7] as well as the Duchesse de Polignac in 1782 (Figure 0.3).[8] The artist also preferred this style of dress herself and in her 1782 self-portrait she wears a similar style of gown tied at the neck and waist with cerise ribbons (see Figure 1.3). In England, Sir Joshua Reynolds, Angelica Kauffman,[9] and other members of the Royal Academy were creating portraits of their female clients attired in revealing styles of dress, modeled after classical ideals, as a means of elevating and dignifying their subject.[10] This style of informal dress, although admired by artists and increasingly popular amongst the aristocracy, blurred the lines between the classes and caused some degree of "confusion between high and low, princess and peasant."[11]

Made of very fine linen or muslin, these gowns were "lined in flesh color" giving the illusion of naked flesh but only the semblance thereof.[12] The public thought the *robe en gaulle* worn by the Queen in her 1783 Salon portrait resembled a woman's chemise—a garment similar to a slip that was only worn under other clothes or in the privacy of the boudoir. The news quickly spread that the Queen had "been painted in her underwear" in clothing that was more properly "reserved for the interior of their palace."[13] Furthermore, the portrait was judged to be lacking the grandeur typically associated with royal portraiture. As Mademoiselle de Mirecourt commented, the Queen had violated "the fundamental law of this kingdom, [which is] that the public cannot suffer to see its princes lower themselves to the level of mere mortals."[14] As art historian Mary D. Sheriff observed, the rituals of the French court dictated that the Queen was "to be dressed and undressed in elaborate ceremony" such that "the queen did not own her own body"[15]; but Marie Antoinette "wanted to be what she—willful woman that she was—wanted to be, not what French etiquette would make her."[16] The artist was asked to withdraw the Queen's portrait, and a month later Vigée Le Brun substituted another painting of the Queen standing in the same pose but this time wearing a dress more appropriate to her station made of blue-gray silk trimmed with scalloped lace (Figure 0.4).

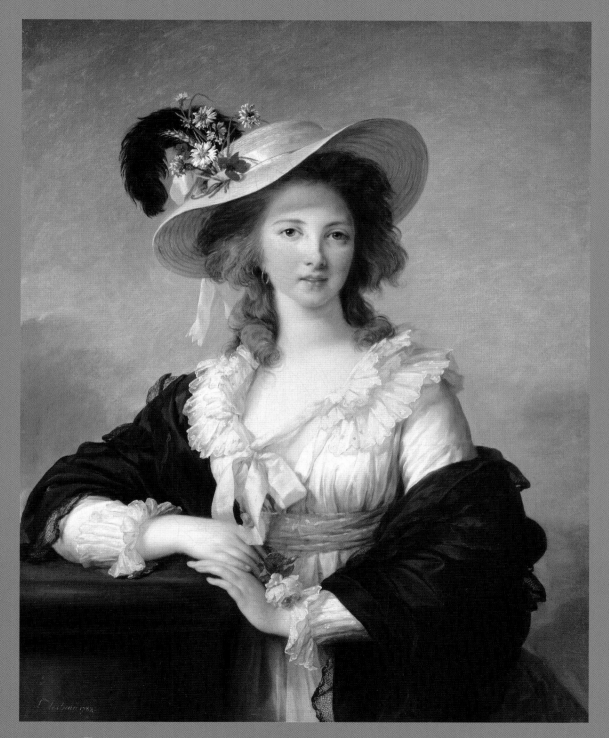

Figure 0.3

Elisabeth Vigée Le Brun, *The Duchesse de Polignac in a Straw Hat,* 1782. Oil on Canvas (92.2 × 73.3 cm).

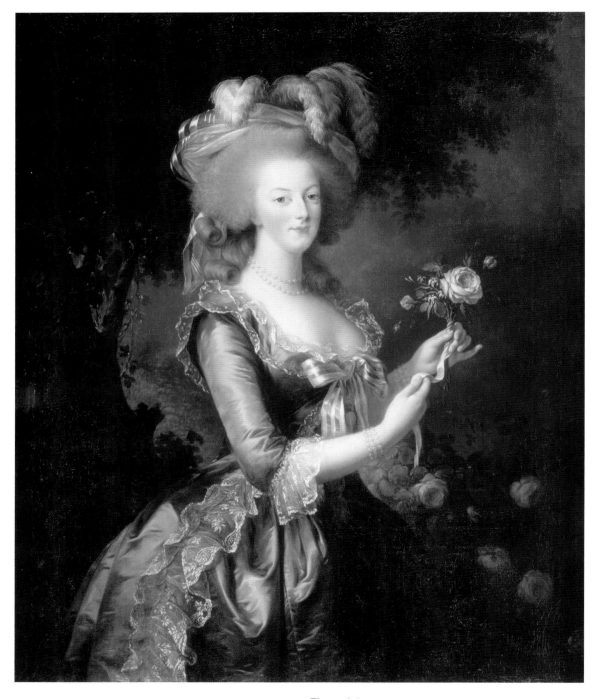

Figure 0.4

Elisabeth Vigée Le Brun, *Marie Antoinette with a Rose*, 1783. Oil on Canvas (116.8 × 88.9 cm).

This example illustrates the significance of dress in a work of art. The lightweight gown worn by the Queen in the 1783 Salon portrait was neither revealing nor immodest but was nonetheless judged indecent and inappropriate for a portrait of the Queen of France. It did not matter that other aristocratic women had dressed in such gowns for their portraits or that the summer of 1783 had been the hottest summer in three centuries.[17] Ironically, the scandal associated with the painting ultimately fueled the popularity of white chemise gowns, such that within months women were wearing them not only in the hot summer months, but "year-round, regardless of etiquette and inclement weather."[18] The dress also presaged the simplicity of the body-skimming, transparent neoclassical styles worn by women in the late 1790s and early 1800s.[19]

As this example shows, fashion and figurative art are inextricably connected. A thoughtful study of how the body has been dressed in an artwork can inform and enrich the scholarly study of art history, dress history, and other disciplines. Even though the artist may have imagined or idealized the fashions in a work, dress can be read as an artistic tool of expression that can be unraveled to reveal something about the ideas that were percolating in society at that time. For the periods in history for which few garments have survived, artworks might serve as the primary source of evidence as to what was worn by the upper class.[20] For more recent artworks, an analysis of the dressed body may reveal prevailing or shifting cultural beliefs and structures of power. Although art history has long privileged a male Eurocentric white settler viewpoint,[21] contemporary artists like Mari Katayama, Kent Monkman, Yinka Shonibare, Mickalene Thomas, Kehinde Wiley, and others have created figurative works that challenge the definitions of beauty, gender, and identity in their renditions of the fashioned body and in this way reflect a more diverse and inclusive vision of humanity.

The goal of this book is to help the reader learn to look at any work of art that includes the dressed or undressed body and confidently develop a critical analysis of what they see. My hope is that after reading this book, the reader will become familiar with the steps of visual analysis and also come to understand how dress and undress can be harnessed as artistic tools that express or challenge cultural beliefs. Like my previous book *The Dress Detective: A Practical Guide of Object-based Research in Fashion*, this book offers a checklist-based approach to the analysis of fashion in art and similarly encourages the adoption of a method of looking that I call the *slow approach to seeing* that will be reviewed in chapter 2.[22] A new checklist has been developed specifically for the analysis of dress in artworks and has been divided into three phases of Observation, Reflection, and Interpretation. The checklists included in this book are intended to guide readers through their analysis of artworks and have also been designed to avoid some common pitfalls.

This book offers a practical guide to this research methodology for use in the university classroom or by anyone wanting to learn how to untangle the layers of meaning embedded in an artwork or a photograph that includes the dressed or undressed body. The book might also serve as a supplement to an art history or research methods course, since many students find that they are uncertain how to progress from writing a description of the art to interpreting the work. It is important to formally acknowledge the foundational work of scholars like Anne Hollander and Aileen Ribeiro, who have immeasurably enriched the fields of art and dress history through their eloquent scholarship on the intersections of fashion and art. It is my sincere hope to extend their legacy by helping others to learn to love art and discover the rich narratives embedded therein, especially since visual analysis is a skillset that is often learned through trial and error.

At this point, it is necessary to articulate what I mean by fashion, since the term *fashion* can describe different things and be employed in a variety of contexts. Used as a verb, *to fashion* means to make or alter, and can be used to describe the fashioning of clothing or the body. Used as a noun, the term *fashion* can be used to describe clothing, accessories, ideas, and imagery, as well as the underlying systems and institutions that produce and disseminate such products. In this book, the word *fashion* is used to describe the prevailing or preferred manner in which the body is dressed, accessorized, and presented at any given time. In her book *The Fashioned Body*, Joanne Entwistle presents dress as a situated body practice in which each of us negotiates the needs of our body in relation to the social constructions of culture. That means that the "right way to dress" at any given moment is defined by the place and time in which we live.[23] A dress or clothing ensemble may or may not be *in fashion* at a particular moment, and it is this difference that distinguishes fashion from dress. The term dress is used to describe clothing, skins, or other materials used to cover and adorn the body that may or may not have once been fashionable for a specific time and place. Used in this way, fashion expresses the idea of rapid change that serves to freeze the moment in an aesthetic "gesture of the only-right-way-to-be."[24]

In the context of analyzing an artwork or photograph, it is helpful to understand whether or not an article of clothing was in fashion at a specific moment in time in order to properly assess the intent of the artist or creator in dressing the sitter in that manner. For example, knowing that Marie Antoinette's wearing of the chemise dress for her 1783 Salon portrait and that the scandal associated with the portrait predated the widespread adoption of this style of dress later that year enhances our understanding of this work's significance. Nonetheless, I suggest that the singular focus of the analysis *should not* be on whether or not the dress in an artwork or family photograph is fashionable or not. A dress is not a text, but it communicates something about its wearer or societal beliefs. I encourage readers to look deeper and consider what it is that the artist or creator has expressed in that work through the fashioning of the body and ask whether this message is an echo of or challenge to the ideas or cultural beliefs at a specific moment in time. This is particularly relevant in the analysis of contemporary works where artists,

like Yinka Shonibare or Mickalene Thomas, may have designed or commissioned garments to communicate messages about the politics of representation and challenge hegemonic norms.

There is a complex interplay of message and meaning in an artwork that can be challenging to unpack. For a historical portrait, it can be very difficult to know who influenced whom and who ultimately decided on the pose, the props, and the clothing. For example, in the case of Elisabeth Vigée Le Brun's informal portrait of the Queen in 1783, the critics assumed that the artist "would not have taken such liberties on her own,"[25] even though this was not the only portrait in which Vigée Le Brun's sitter was dressed in this way. In her memoirs, Vigée Le Brun remained silent on her interactions with the Queen about her dress for this portrait even though she indirectly took credit for "popularizing the chemise gown."[26] Memoirs, diaries, notes, artist statements, or interviews may be helpful in illuminating artistic intent, but some artists have let the work speak for itself. For example, French-American artist Marcel Duchamp left very few clues that reveal his intentions when he cross-dressed as a woman for photographs made in 1920–1921 in collaboration with the Jewish-American photographer Man Ray and that are discussed in chapter 9. In contrast, Cree artist Kent Monkman carefully articulated his artistic process and ideas in his artist statement for the painting entitled *The Academy* (2008) discussed in chapter 10. In reading such works, there are inherent challenges to identifying, unraveling, and interpreting the evidence from both within and outside of the artwork.

While there is no single *right* answer when reading an artwork, in articulating an opinion, it is necessary to present a clear thesis or claim that is supported by evidence. In my experience, the process of gathering and interpreting evidence is messy and fraught with challenges and it can be tempting to include everything uncovered during the research process; but more is not necessarily better and in reality, too much extraneous information may obscure the most salient parts of the analysis. Using theory as a lens of interpretation gives the essay focus and direction and also helps to structure the argument, and this use of theory has been carefully modeled in the case studies.

The selection of works in this book inherently reflects my background and training as a historian, as well as the constraints of my picture budget. It is important to acknowledge that my selections have also been impacted by the collecting practices of the past in terms of what is preserved within museum and study collections, namely the artworks, clothing, and narratives of the European elite. Until recently, museum collections have not adequately reflected the contributions of women artists as well as other marginalized groups.[27] In making my selections and in writing my analysis, I have tried to adopt the suggestion of art historian Linda Nochlin in becoming "more self-conscious" and "more aware" of the "very languages and structures of the various fields of scholarship," including the acceptance of what seems "natural."[28] Accordingly, I have aimed for diversity of representation by including images made by or that represent women, indigenous, Jewish, black, disabled, and the LGBTQ+ community, but I recognize for some

readers this might not be sufficiently inclusive. And so, I must emphasize that the aim of this book is to articulate an easy-to-follow step-by-step approach to studying works of art and visual culture. In my work and life, I celebrate diversity, and in this book, I discuss the politics of representation, but this is not the primary goal of this text. And, I feel that it is also necessary to discuss iconic and familiar works from the past that lend themselves to the articulation of certain themes.

This book is divided into two parts, with Part I providing an overview to the methodology and Part II providing five case studies as examples of interpretation. Although it is also possible to dip in and out of chapters as interest and time allows, readers are encouraged to read the book from beginning to end in order to get the most out of the sample essays.

In **Part I**, the book offers both an overview and a practical guide to the interpretation of fashion in art. I have divided the analysis of an artwork into three distinct phases of research:

1. **Observation** – gathering information from the work
2. **Reflection** – contemplating what that evidence means and looking for additional contextual information
3. **Interpretation** – developing a written analysis of how the dressed figure in the work articulates aspects of culture using the lens of theory

Breaking down the research into phases helps ensure that sufficient attention and time is given to the necessary steps. Each of these steps is presented in a separate chapter.

Chapter 1, "**Artists & Wardrobes**," highlights the role of fashion in shaping the central ideas presented by the work and provides a brief overview of the myriad of ways that artists have negotiated the dress of their sitters. The chapter is divided into two parts to correspond with the periods before and after the invention of photography.

Chapter 2, "**The Slow Approach to Seeing**," introduces the concepts of visual analysis and literacy and articulates the idea of slow looking as a method of seeing. This chapter expands on the material that was introduced in *The Dress Detective* and shows how drawing as a method of slowing down can help identify specific elements of dress as well as the nuances of an artist's process. Tips on putting this method into practice are offered.

Chapter 3, "**Observation**," articulates the steps to an initial read of the visual elements within an artwork. The checklist for the observation phase is divided into four thematic sections:

A. Preliminary Background
B. Composition
C. The Fashioned Body
D. Formal Qualities

This chapter includes annotations for each of the forty questions on the checklist and also demonstrates their application in observation of the photographs of

(Ina) Sarah Forbes Bonetta with her husband James Davies taken by French photographer Camille Silvy in 1862.

Chapter 4, "**Reflection**," covers the second phase of analysis. In this part, the viewer weighs the evidence presented by the artwork relative to other artworks by the same or other artists as well as other sources of information. The Reflection Checklist is divided into five sections that address:

A. Formal Qualities of the Artwork
B. Elements of Dress
C. Personal Reactions
D. Artist
E. Contextual Information

This chapter provides annotations for each of the twenty-five questions in the checklist and also demonstrates the application or the reflection stage of analysis for the 2010 painting *Les déjeuner sur l'herbes: Les trois femmes noires* by the American artist Mickalene Thomas.

The goal of chapter 5, "**Interpretation**," is to help the researcher bridge the gap between what they observe and what to do next. This chapter includes a brief discussion of the role of theory and outlines the third phase of interpretation in guiding the translation of evidence observed in the artwork into a hypothesis. The five questions in the Interpretation Checklist are directed towards helping the reader link the artwork to the most commonly used lenses of interpretation within fashion studies.

In **Part II**, selected artworks are presented in case study format with each chapter serving to illustrate the way in which the results of careful observation and reflection can intersect with theory. The sample case studies model certain key themes of interpretation, including the intersections of fashion with status and identity, modernity, ideals of beauty, gender, race, globalization, and politics. If space allowed, this thematic list might be extended to include the interpretation of fashion in art as expressions of sexuality, states of psychology, reflections of popular culture, feminism, or queer theory. In choosing the artworks for the case studies, I aimed to include a representative selection of artworks from the eighteenth century to the present day as well as different mediums of art production including painting, engraving, photography, and installation. It is simply beyond the scope of this book to represent all cultures and time periods and I have stayed within the parameters of western art (that which originates from Europe, United Kingdom, and North America), but that does not mean that the methodology cannot be used in the analysis of artwork from elsewhere.

Chapter 6 considers the iconic portrait of Mr. and Mrs. Andrews by the British painter Thomas Gainsborough dated to ca. 1750 in the collection of the National Gallery of London as a vehicle by which to communicate **status and identity**. In this chapter, I show that the painting is not only a portrait of husband and wife, but also a portrait of their estate in reflecting the romanticized notions of the English landscape. As well, I analyze the sitters' fashionable but "simple" dress, which was

used by the artist to convey the privileged status of these landowners as well as ideals of grace and beauty of the period. In addition, the reader is invited to later reflect on the restaging of this work as an installation work by contemporary artist Yinka Shonibare in the Coda.

Chapter 7 uses the lens of **modernity** to consider French painter Eugène Boudin's beach scene paintings of the fashionable bourgeoisie at the French seaside in the mid-nineteenth century. In these paintings by Boudin, modernity—the idea of progress, novelty, and rapid change brought about by the processes of industrialization—is reflected in the setting, the style of painting, and in the elegant fashions in the crowds.

Chapter 8 focuses on a large-scale work by French artist James Jacques Tissot, called *La Mondaine* or *The Woman of Fashion* in order to explore the theme of **beauty**. This painting was one of fifteen in a series called *La Femme à Paris* created in the years 1883–1885 in which Tissot depicted his vision of the modern Parisienne. In this case study, I analyze how Tissot used the fashionable dress of *la mondaine* to communicate the ideals of Parisienne beauty in the latter part of the nineteenth century.

Chapter 9, looking at the theme of **gender**, presents a little-known photograph of French-American artist Marcel Duchamp dressed as a woman that was created in collaboration with Jewish-American photographer Man Ray (Emmanuel Radnitsky) in 1920–1921. In this case study, I explore the intersection of fashion and gender focusing on the dress of the new modern woman of the 1920s, known as the flapper or *la garçonne*, as possible inspiration for this work.

Chapter 10 considers the intersection of fashion and **politics** in the work of Kent Monkman, a Canadian contemporary artist of Cree heritage. In the 2008 painting called *The Academy* in the collection of the Art Gallery of Ontario, Monkman uses dress and undress as an artistic tool to engage with the complex, sensitive, and intertwined issues of colonization, gender, and race.

In the Coda, I briefly discuss the work of Yinka Shonibare and invite readers and other scholars to continue my exploration of fashion in art.

Fashion has come to be associated with novelty that sometimes belies its deeper importance as the aesthetic manifestation of the underlying desires, ideas, and beliefs that govern contemporary life. In writing this book, I take up Anne Hollander's suggestion that "clothes must be seen and studied as paintings are seen and studied."[29] Ultimately, my aim is to show with this book that fashion is itself a lens that can be used to unlock the meaning and significance of a figurative work of art.

ENDNOTES

1. Anne Hollander, *Seeing Through Clothes* (Berkeley: University of California Press, 1993), xv–xvi.

2. This work is a copy of the original portrait, painted after 1783. It does not materially differ from the original portrait that is presently housed in the collection of the Hessische Hausstiftung, Kronberg. In Vigée Le Brun's memoirs, she lists three copies of *Queen with a Hat* also painted in 1783. See Elisabeth Vigée Le Brun, *Memoirs of Madame Vigée-Lebrun*, trans. Lionel Strachey (London: Dodo Press, 1903), 211.

3. This term describes a French Guild of fashion merchants active in Paris during the period 1776–1791. Rose Bertin was elected the first mistress of the Guild and in that role toured the European capitals to advertise French fashion. She is perhaps best known for her relationship with Marie Antoinette. In this role, she fashioned the Queen's look, coordinating the many dressmakers and other suppliers who made the garments, trimmings, and other accessories. See Kimberly Chrisman-Campbell, "Bertin, Rose," in *The Berg Companion to Fashion*, edited by Valerie Steele. Oxford: Bloomsbury Academic, 2010. Web. Accessed: December 12, 2018.

4. Caroline Weber, *Queen of Fashion: What Marie Antoinette Wore to the Revolution* (New York: Henry Holt and Company, 2006), 192.

5. Kimberly Chrisman-Campbell, *Fashion Victims: Dress at the Court of Louis XVI and Marie Antoinette* (New Haven: Yale University Press, 2015), 180–186.

6. See for example the equestrienne portrait of Marie Antoinette by Louis Auguste Le Brun from 1783 in the collection of Versailles, Chateaux de Versailles et de Trianon.

7. *The Comtesse du Barry in a Straw Hat*, ca. 1781 is in a private collection.

8. *The Duchesse de Polignac in a Straw Hat*, c.1782 by Elisabeth Vigée Le Brun is in the collection of the Musée National des Châteaux de Versailles et de Trianon (MV 8971). The artist also created another portrait the following year entitled *The Duchesse de Polignac at the Pianoforte*, c. 1783, which is in the collection of The National Trust, Waddesdon Manor, Aylesbury, Buckinghamshire (2154).

9. Sir Joshua Reynolds suggested that students of the Academy adopt classical dress in their works as a means of elevating taste and dignifying their subjects. His friend Angelica Kauffman, also a painter (1741–1807), was one of the founding members of the Royal Academy. Some of her works can be found in the National Portrait Gallery in London and at the Uffizi Gallery in Florence.

10. Amelia Rauser, "From the Studio to the Street: Modelling Neoclassical Dress in Art and Life," in *Fashion in European Art: Dress and Identity, Politics and the Body, 1775–1925*, ed. Justine De Young (New York: I.B. Tauris, 2017), 11–15.

11. Weber, *Queen of Fashion*, 160.

12. Chrisman-Campbell, *Fashion Victims*, 193.

13. Chrisman-Campbell, *Fashion Victims*, 187–189.

14. Mademoiselle de Mirecourt quoted in Weber, *Queen of Fashion*, 161.

15. Mary D. Sheriff, *The Exceptional Woman: Elisabeth Vigée-Lebrun and the Cultural Politics of Art* (Chicago: The University of Chicago Press, 1996), 157.

16. Sheriff, *The Exceptional Woman*, 168.

17. The exceptional heat of the summer in 1783 in Europe was thought to be the consequence of the eruption of the Icelandic volcano Laki.

18. Chrisman-Campbell, *Fashion Victims*, 195.

19. See Rauser, "From the Studio to the Street," 11–30.

20. Prior to the invention of photography, portraiture was mainly the privilege of the upper class. For this reason, it can be difficult to find imagery of everyday dress in paintings that date prior to the mid-nineteenth century.

21. See Linda Nochlin, "Why Have There Been No Great Women Artists?," in *ARTnews*, January 1971: 22–39, 67–71.

22. The idea of slow looking will be explained at length in Chapter 2. For my explanation of how I came to develop this idea, see also Ingrid Mida, "The Curator's Sketchbook: Reflections on Learning to See," *Drawing: Research, Theory, Practice* 2 no.2 (2017b): 275–285.

23. See Joanne Entwistle, *The Fashioned Body: Fashion, Dress and Modern Social Theory* (Cambridge: Polity Press, 2000), 6–39.

24. Elizabeth Wilson, *Adorned in Dreams: Fashion and Modernity* (London: I.B. Tauris, 2011), vii.

25. Baillio et al, *Vigée Le Brun*, 87.

26. Chrisman-Campbell, *Fashion Victims*, 186.

27. For a discussion of the marginalization of people of color from art history, see Denise Murrell, *Posing Modernity: The Black Model from Manet and Matisse to Today* (New Haven: Yale University Press, 2018). Also see Jan Marsh (ed.) *Black Victorians: Black People in British Art 1800-1900* (Hampshire: Lund Humphries, 2005).

28. Linda Nochlin, "Why Have There Been No Great Women Artists?," in *ARTnews*, January 1971: 25.

29. Hollander, *Seeing Through Clothes*, xvi.

1

Artists &
Wardrobes

INTRODUCTION

Prior to the widespread adoption of photography, it would take an artist many days of work to create a portrait and render the complex folds, textures, and patterns of the sitter's clothing,[1] especially if the model was wearing a dress of striped French brocade like that illustrated in Figure 1.1. To streamline this process and spare the sitter the long, grueling hours of having to stand or sit without moving, portrait artists crafted solutions of various kinds, including hiring models or using servants as stand-ins for their sitters, and/or using wooden mannequins dressed in the sitter's clothing.[2] Some portrait painters, like Joshua Reynolds (1723–1792) hired drapery specialists.[3] Artists also appropriated ideas and looks from fashion plates, and many artists borrowed, rented, or purchased garments for use as props in their studios.[4] Some artists even amassed large collections of dress, including the English-born genre painter Talbot Hughes (1869–1942), who once owned the eighteenth-century gown shown in Figure 1.1 and whose significant collection of historic dress was transferred to the Victoria & Albert Museum in 1913.[5]

 With the invention of photography in the mid-nineteenth century, the ease and pleasure of having a likeness of one's self became accessible to all and not only reduced the demand for painted portraits but changed how many artists worked. This chapter provides a brief overview of the myriad of ways that artists have harnessed fashion in creating their figurative works and is divided into two parts to correspond with the periods before and after the invention of photography. The first part, "Before Photography," begins with a discussion of how leading eighteenth-century portraitists Adélaïde Labille-Guiard (1749–1803), Elisabeth Vigée Le Brun (1755–1842), Joshua Reynolds (1723–1792), and Thomas Gainsborough (1727–1788), used clothing and drapery in their figurative works. The second part, "After the Invention of Photography," considers the impact of this technological development on portraiture and figurative works. The key idea of this chapter is that cloth and clothing are artistic tools in the creation of the work and must be read with care.

BEFORE PHOTOGRAPHY

For an artist, a self-portrait dispenses with the need to hire a model and can also serve as a calling card. In Adélaïde Labille-Guiard's self-portrait with two students dated 1785 (Figure 1.2), she wears a seemingly impractical choice of dress for the messy work of a painter: a beautiful, pale blue, silk satin *robe à l'anglaise* gown with low décolletage trimmed with delicate lace and lined in white silk. Her two pupils, Marie Gabrielle Capet and Marie Marguerite Carreaux de Rosemond, stand behind her chair and are dressed more simply and modestly. From the artist's selection of elegant attire for herself, it is clear that she wants us to admire her skill in rendering the lustrous sheen and complex folds of her fashionable gown as well as the downy texture of the delicate ostrich feathers that top her large brimmed

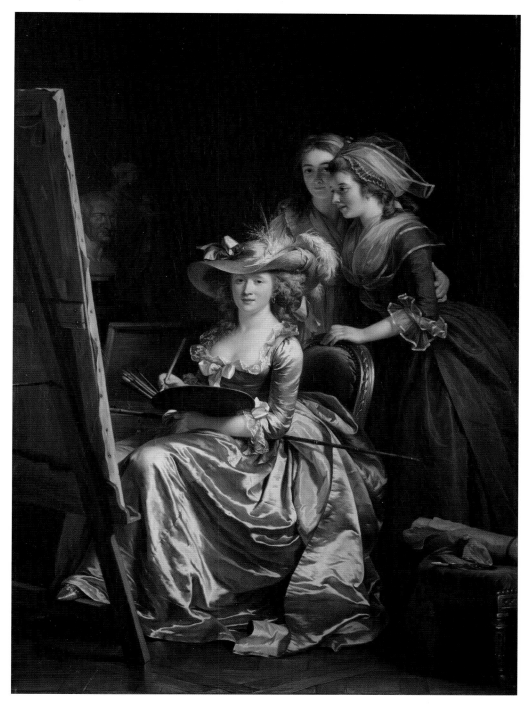

Figure 1.2

Adélaïde Labille-Guiard, *Self-Portrait with Two Pupils,
Marie Gabrielle Capet and Marie Marguerite Carreaux
de Rosemond*, 1785. Oil on canvas (210.8 × 151.1 cm).

straw hat. This dress and her ostrich-trimmed hat are very similar to ensembles found in fashion plates from *Galerie des Modes et Costume Français* ca. 1784.[6] At this time in France, women artists who publicly exhibited their work were "criticized for their immodesty."[7] Although the low décolletage of the gown worn by Labille-Guiard reveals the gentle curves of her breasts, this "immodesty" is countered somewhat by the inclusion of two classical sculptures in the background (including a sculpture of her father and one of the Vestal Virgin).

As well, the crisp handling of paint on this monumental canvas, a size and format more typically associated with male artists, suggests that Labille-Guiard was challenging the notion that women could not undertake such work.[8] At this time, the number of women allowed in the French Academy was limited to four by the King's decree.[9] Labille-Guiard was admitted to the Academie Royale in 1783 but faced obstacles in finding society patrons since she had left her husband and lived in modest lodgings.[10] In light of Labille-Guiard's decision to teach rather than pursue a society clientele, this canvas can be read as a propaganda piece that argues for the admission of more women to the French Academy. In this case, the dress worn by the artist in her self-portrait embodies both an artistic and a political statement.

In contrast, the celebrated portraitist Elisabeth Vigée Le Brun (whose 1783 Salon portrait of Marie Antoinette was discussed at length in the introduction to this book) chose to dress informally for her self-portrait called *Self-Portrait with Cerise Ribbons* dated 1782 (Figure 1.3). In this work, Vigée Le Brun wears the *robe en gaulle* and showcases her ability to deftly render the delicate fabric, as well as capture the intricate texture of the lacy shawl draped over her shoulders and the iridescence of her opal earrings. In her memoirs, Vigée Le Brun recounted that she preferred to wear these "white dresses of muslin or lawn" but also had other formal gowns that were suitable for her trips to Versailles.[11] She also indicated that she had strong ideas about how she wanted her sitters to dress and expressed her dislike for the prevailing fashions of the time. When she could, she fashioned the drapery arrangements herself, as she revealed in this quote: "after getting the confidence of my models, I was able to drape them according to my fancy. Shawls were not yet worn, but I made an arrangement with broad scarfs lightly intertwined round the body and on the arms, which was an attempt to imitate the beautiful drapings by Raphael and Domenichino."[12] Vigée Le Brun's 1789 self-portrait with her daughter (Figure 1.4) illustrates this type of artistic draping of cloth, creating an image that is difficult to date with its allusions to classical antiquity. Vigée Le Brun was not the only artist to employ this type of classical drapery in portraiture.

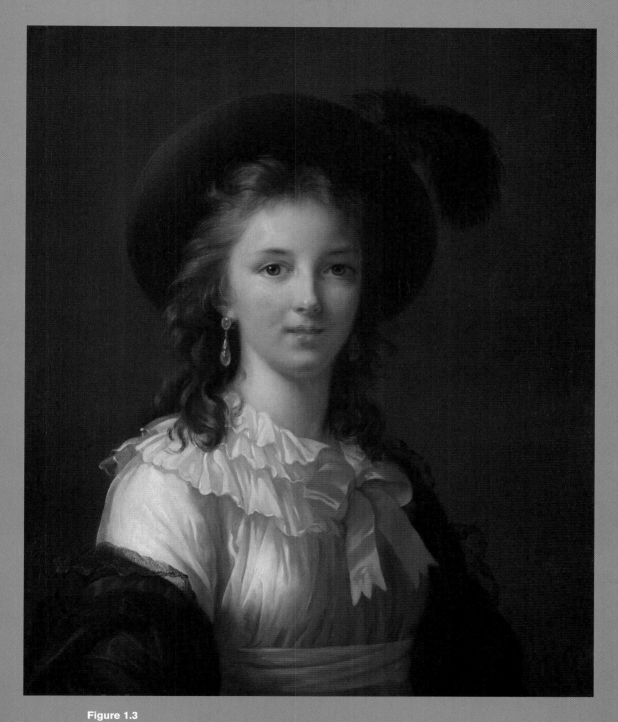

Figure 1.3

Elisabeth Vigée Le Brun, *Self-Portrait with Cerise Ribbons*, 1782. Oil on canvas (64.8 × 54 cm).

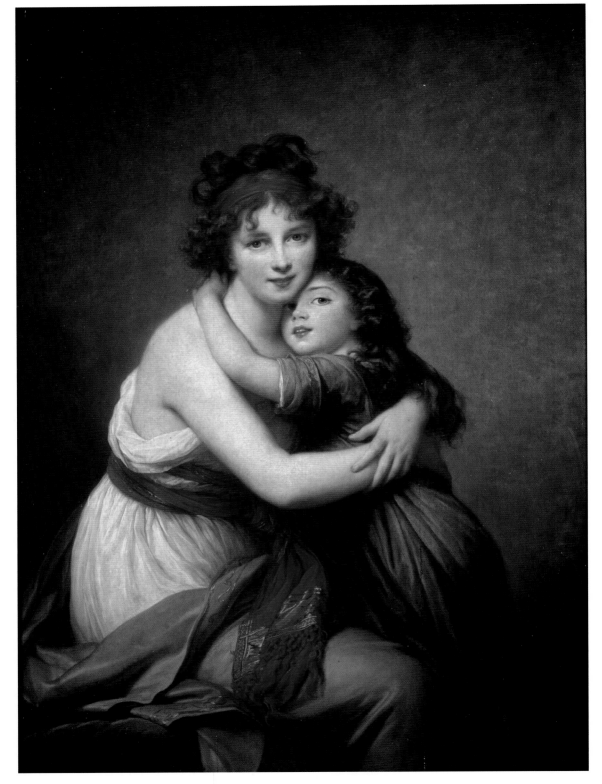

Figure 1.4

Elisabeth Vigée Le Brun, *Self-Portrait with Daughter Julie (à l'Antique)*, 1789. Oil on wood (130 × 94 cm).

Sir Joshua Reynolds, the founder of the Royal Academy of Arts in London, also preferred that his sitters wear antiquarian or fancy dress. In his self-portrait from 1780,[13] Reynolds wore his academic robes and cap of the University of Oxford from which he had received an honorary doctorate degree in 1776.[14] In many ways, this painting recalls the dress and style of Rembrandt's self-portraits—and no doubt this fashioning of the body was intended to connect his work to that of the Old Masters. In a statement to the members of the Academy in 1776, Reynolds said that it was the role of the portraitist to "dignify his subject, which we will suppose is a lady" and accordingly the artist "will not paint her in the modern dress, the familiarity of which alone is sufficient to destroy all dignity."[15] His contemporary Thomas Gainsborough (who is the subject of the case study in chapter 6) expressed reservations about this practice, believing that "this kind of generalized portraiture served rather to destroy the possibility of capturing of a likeness" and instead encouraged his sitters to wear "modern, fashionable dress."[16] The two men were rivals and although their ability to render a likeness was considered a strength for Gainsborough and a weakness for Reynolds, it was Reynolds who was the more celebrated artist.[17] Reynolds operated a large studio with many assistants that was said to resemble "a manufactory, in which the young men who were sent to him for tuition were chiefly occupied in copying portraits or assisting in draperies and preparing backgrounds."[18] Reynolds also had a large collection of dresses for sitters to choose from as well as an array of textiles in his studio. According to Mary Isabella Manners née Somerset, Duchess of Rutland, for her portrait of 1781 by Reynolds (see a copy of this portrait in an engraving by Valentine Green in Figure 1.5), she "had to try on eleven different dresses" before the artist began the sitting and painted her in "that bedgown."[19] Although he took great care in the selection of garments for his sitters' portraits, Reynolds generally did not paint clothing himself. His records reveal that "the clothing of his clientele was routinely shipped out, along with their portraits, to drapery painters"[20] as he may have done for the infamous portrait of Lady Worsley (Figure 1.6) in which she is dressed in a riding habit fashioned in the style of the uniform of her husband's regiment, the Hampshire Militia.[21] Unlike other works by the artist that depict the sitter in classical dress, here Reynolds has made compositional choices that serve to emphasize the sitter's femininity: the lines of her jacket emphasize her narrow waist and the soft forms of the clouds echo the forms of her ostrich-plumed hat. In this striking work, Reynolds showcases his consummate skill in creating a dynamic figurative composition.

As these examples highlight, the leading eighteenth-century portraitists differed in their approach to dressing their sitters. Adélaïde Labille-Guiard and Thomas Gainsborough preferred that their sitters wear modern fashionable dress, while Elisabeth Vigée Le Brun and Sir Joshua Reynolds wanted their sitters to wear dress that referenced classical antiquity.

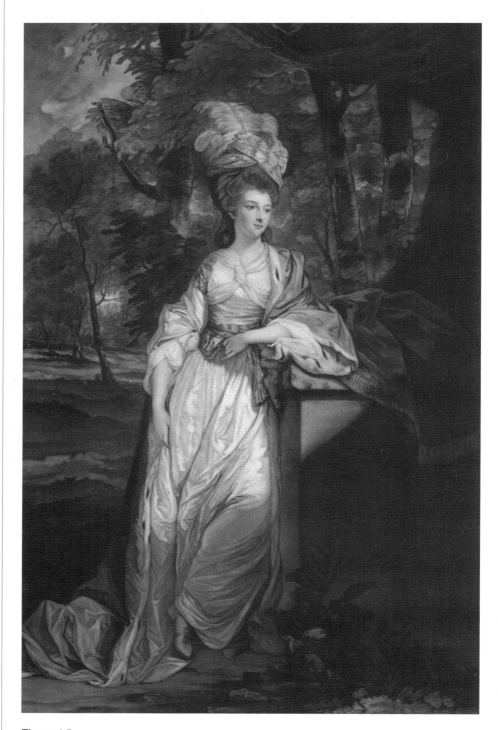

Figure 1.5

Valentine Green, *Mary Isabella, Duchess of Rutland (after Joshua Reynolds)*, 1780.
Mezzotint on cream, laid paper (60 × 38.7 cm).

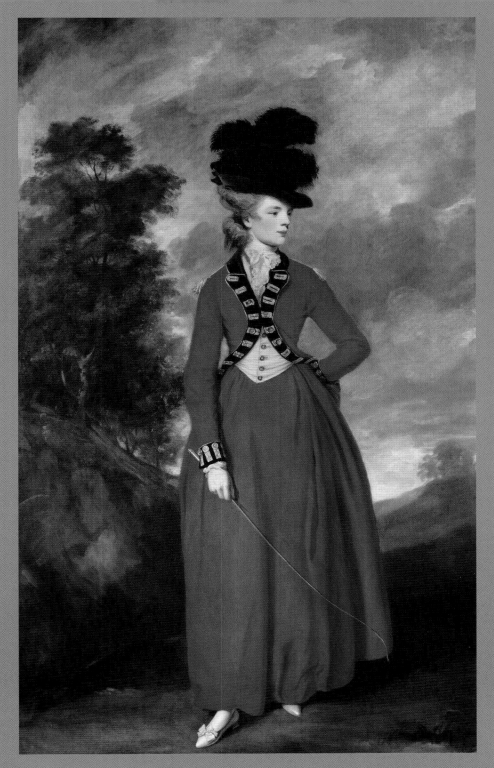

Figure 1.6

Sir Joshua Reynolds, *Portrait of Lady Worsley*, 1776.
Oil on canvas (236 × 144 cm).

AFTER THE INVENTION OF PHOTOGRAPHY

The invention of photography in the nineteenth century radically changed the demand for portrait artists. With the further innovation of the *carte de visite* in the latter half of the 1850s,[22] portraiture was no longer a privilege of the aristocracy and "the narcissistic pleasures of possessing an image of oneself could be enjoyed by an ever wider public, just at a time when kings and princes were busy making sure everyone had pictures of them in an attempt to convey a sense of both authority and social stability."[23] By 1860, the wildly popular *carte de visite* had penetrated "every layer of society as effectively as the wearing of mourning or the fashion for crinolines."[24] Some photographers owned wardrobes of clothing and accessories that were available for rent by the sitters; others printed pamphlets with suggestions as to what clothing to wear. For example, William Notman, a notable Canadian photographer and the manager of the largest photographic business in North America, published a booklet called "Photography: Things You Ought to Know" that included the following advice:

> The most suitable colors are black and the different shades of green, brown, drab, grey, slate, provided they are not too light. Those to be most avoided are white, blue, mauve, and pale pink. Dark checks and plaids take very distinctly, sometimes too much so, as they form too prominent an object in the picture.
>
> Lace scarfs, open mantles, shawls, etc. greatly assist in securing graceful flowing lines. Avoid opaque white shawls, such as china crepe, avoid also dressing the hair in any style unusual to the individual or wearing and unfamiliar kind of head dress.
>
> The above precautions apply only to plain Photography, where colored pictures are required, the painter can restore or add to the Photograph any color necessary.[25]

Although such recommendations undoubtedly ensured a good likeness, it also resulted in a level of drab uniformity that was noticed by and irritated some writers and critics.[26] Charles Baudelaire mocked the daguerreotype portraits that were shown at the 1859 Salon as products of "our loathsome society" that had "rushed, like Narcissus, to contemplate its trivial image on the metallic plate."[27] In 1867, literary critic Barbey d'Aurevilly wrote an article for *Le Nain Jaune* in which he considered the popularity of portrait photography as evidence of "a decadent race gone soft."[28] In spite of such vitriolic critiques, photography became hugely popular around the world and across all social classes (see Figure 1.7 and Figure 1.8), and these images document the dress of both elite and everyday people.

Although photography largely replaced portraiture as a medium with which to capture a likeness, this innovation did not eradicate the medium of painted portraiture entirely nor did it negate the popularity of figurative works. Some nineteenth-century artists, including Edgar Degas, harnessed photography as an

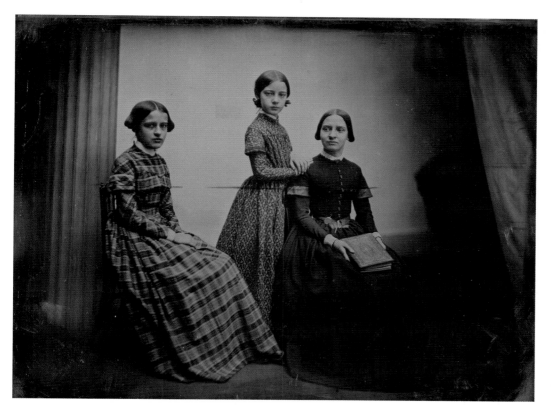

Figure 1.7

Southworth & Hawes,
*Portrait of three unidentified
young women*, ca. 1856.

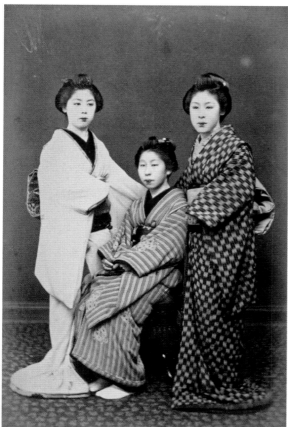

Figure 1.8

Fratelli Alinari, *Portrait of
three young Japanese women
in kimono*, ca. 1865.

auxiliary tool that allowed them to make photographic studies in advance of their paintings.[29] Although artists had access to photography, many of them chose not to depict contemporary fashions as art critic and poet Charles Baudelaire noticed in 1863 when he commented on the fact that many artists had continued the practice of dressing their figures in the looks of classical antiquity:

> Casting an eye over our exhibitions of modern pictures, we are struck by a general tendency among artists to dress all their subjects in the garments of the past. . . . This is clearly symptomatic of a great degree of laziness; for it is much easier to decide outright that everything about the garb of an age is absolutely ugly than to devote oneself to the task of distilling from it the mysterious element of beauty that it may contain, however slight or minimal that element may be.[30]

Baudelaire suggested that artists should instead study the specific garments and textiles of contemporary times, writing: "The draperies of Rubens or Veronese will in no way teach you how to depict *moire antique*, *satin à la reine*, or any other fabric of modern manufacture, which we see supported and hung over crinoline or starched muslin petticoat."[31] For Baudelaire, it was fashion that expressed the "transitory, fugitive element" of modernity and he encouraged artists to capture modernity in their works.[32] In his treatise *The Painter of Modern Life*, published in 1863 in installments in *Le Figaro*, Baudelaire recommended that the figurative artist should observe and render the particular elements that constitute the look of the moment, including the cut and silhouette of dress, the accessories, the hairstyles, and the distinctive posture and gestures of the time.[33]

Baudelaire's writings had a powerful influence on many artists of the period, including Eugène Boudin (the subject of the case study on modernity in chapter 7), and James Jacques Tissot (the subject of the case study on beauty in chapter 8). As we shall see in the case studies, Boudin preferred to paint in the open air and captured his impressions of the fashionable bourgeoisie on the beach, whereas Tissot's works were more carefully crafted in the studio to create highly polished, realistic portraits and genre scenes depicting fashionable society.[34] Tissot paid exquisite attention to the details of dress in his works and they were so like photographs that John Ruskin once described them as "mere coloured photographs of vulgar society."[35] Tissot grew up surrounded by textiles as the son of a linen-draper and milliner and was known to have an extensive wardrobe of dresses in his studio,[36] often reusing garments in multiple paintings. For example, the white lawn two-piece summer dress with ruffles and yellow bows appears in several works,[37] including the 1878 paintings *Spring* (Figure 1.9) and *July* (Figure 1.10). Tissot was also known to mix up references, intentionally using old clothes "in combination with modern elements to create an historical ambiance."[38] This type of ambiguity is a signal that the artist wants to communicate something other than the representation of fashionable dress associated with a specific time and place.

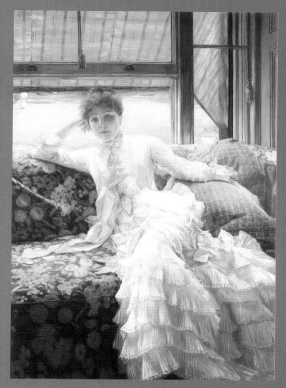

Figure 1.9

James Jacques Tissot, *Spring*, ca. 1878.
Oil on canvas (141.6 × 53.3 cm).

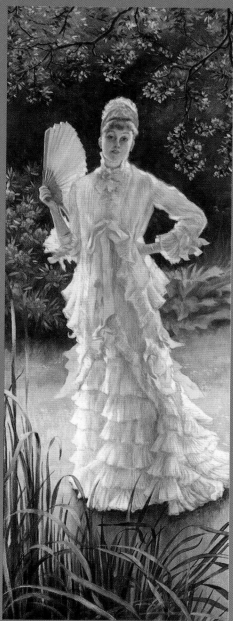

Figure 1.10

James Jacques Tissot, *July*, ca. 1878.
Oil on canvas (87.6 × 59.0 cm).

Many contemporary artists have recognized and harnessed the visual language of clothing and fashion to explore and articulate aspects of their identity in their self-representation in painted, photographic, sculptural, installation, and performance works. For example, in 1920–1921, Marcel Duchamp played with gender in his self-fashioning as a woman in the photographs taken in collaboration with Man Ray of his alter ego Rrose Sélavy, as will be discussed in chapter 9. Another artist who explored aspects of identity in her life and in her self-portraiture was Mexican artist Frida Kahlo (1907–1954) who adopted Tehuana dress to reflect her political beliefs and to disguise her disability.[39] Celebrated American photographer Cindy Sherman (b. 1954), described in 2012 by the Museum of Modern Art as "one of the most important and influential artists in contemporary art," also makes conscious use of clothing and props to transform herself into various guises that articulate various aspects of female identity.[40] In my artistic practice, I once donned a Baroque-inspired theatre costume to communicate the timeless and universal narrative of grief in my photographic series called *All Is Vanity* (Figure 1.11).[41]

Contemporary artists have made careful choices of dress for their sitters in figurative works that emulate iconic works from art history to communicate aspects related to the politics of representation. In restyling their sitters in contemporary dress or in using textiles associated with black culture, artists like Mickalene Thomas (Figure 4.1) and Yinka Shonibare (see Figure 11.1), whose works will be discussed in the chapters to come, address the absence of black identity in western art.[42] Canadian Cree artist Kent Monkman (b. 1965), whose work is the subject of the case study in chapter 10, has created a body of artistic work in which his gender-fluid alter ego Miss Chief (pronounced "mischief") Eagle Testickle not only pays homage to Duchamp but more importantly highlights issues related to race, gender, and sexuality.[43] This important shift to embracing diversity of representation in contemporary art is both notable and significant and worthy of much deeper analysis than the scope of this book allows.

The main idea of this chapter is that artists make choices in deciding how to depict the fashioned body and what messages they hope to convey with their work. In order to fully appreciate the narratives of culture embedded in the figurative works of any artist, it is necessary to search for the clues that reveal those choices. In the chapters that follow, I will discuss how that might be done.

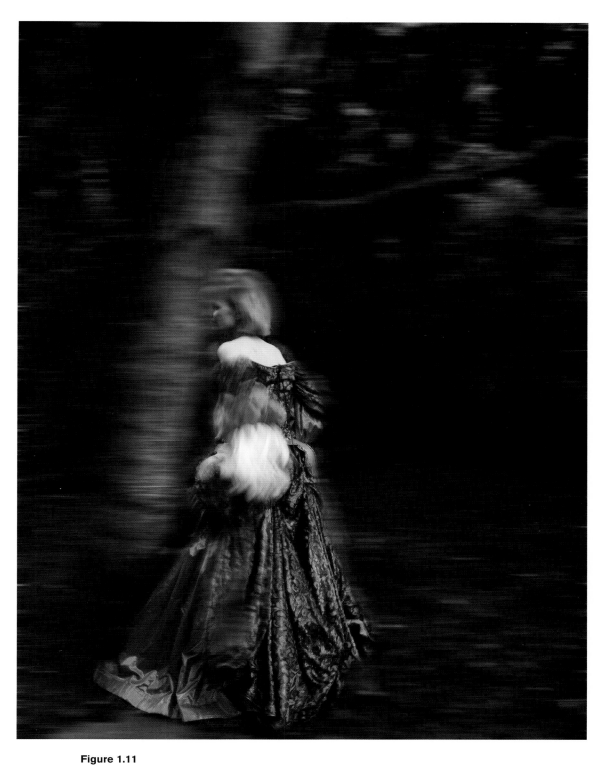

Figure 1.11

Ingrid Mida, *All Is Vanity*, 2010, Digital image
(printed 61 × 91.4 cm), Private Collection.

ENDNOTES

1. In the 1672 account about Antony van Dyck's working process, Peter Lely wrote: "Mr. Laniere himself told me, he satt seaven entire days . . . seaven dayes both morning and afternoon," [sic] ellipsis added. Peter Lely quoted in Stijn Alsteens and Adam Eaker, *Van Dyck: The Anatomy of Portraiture* (New Haven: Yale University Press, 2010), 104.

2. For example, the Countess of Sussex sent her dress and sable fur to Antony van Dyck in November 1639 for her portrait. The artist added jewels that did not belong to her, and she later wrote that "it is no great matter for another age to thinke me richer then I was" [sic]. See Alsteens and Eaker, *Van Dyck*, 31.

3. Martin Postle, "Joshua Reynolds and His Workshop," in *Joshua Reynolds: Experiments in Paint*, ed. Lucy Davis and Mark Hallett (London: Paul Holberton, 2015), 55.

4. For example, Édouard Manet was known to visit "the establishments of reputed *modistes* for hats and dresses" to dress the models in his figurative works. See Scott Allan, Emily A. Beeny, and Gloria Groom, "Introduction: Beauty, Fashion, and Happiness," in *Manet and Modern Beauty: The Artist's Last Years*, edited by Scott Allan, Emily A. Benny, and Gloria Groom (Los Angeles: Getty Publications, 2019), 1.

5. Although Hughes was described as a "rising star" in artistic circles in 1902, he never lived up to that early acclaim. Instead his legacy largely lives on in the Victoria & Albert Museum dress collection as well as two publications: the 1913 catalogue related to the exhibition of his collection at Harrods (Figure 1.1 comes from this catalogue) and the 1913 book *Dress Design: An Account of Costume for Artists & Dressmakers*.

6. Laura Auricchio, *Adélaïde Labille-Guiard: Artist in the Age of Revolution* (Los Angeles: The J. Paul Getty Museum, 2009), 45–46.

7. Auricchio, *Adélaïde Labille-Guiard*, 16.

8. Auricchio, *Adélaïde Labille-Guiard*, 46–47.

9. Katharine Baetjer, "The Women of the French Royal Academy," in *Vigée Le Brun*, edited by Joseph Baillio, Katharine Baetjer, and Paul Lang (New Haven: Yale University Press, 2016), 43.

10. Auricchio, *Adélaïde Labille-Guiard*, 26.

11. Elisabeth Vigée Le Brun, *Memoirs of Madame Vigée Le Brun*, trans. Lionel Strachey (USA: Dodo Press, 1903), 42.

12. Vigée Le Brun, *Memoirs of Madame Vigée Le Brun*, 19.

13. This portrait is in the collection of the Royal Academy in London.

14. Lucy Davis and Mark Hallett, "Introduction: The Experimentalist," in *Joshua Reynolds: Experiments in Paint*, ed. Lucy Davis and Mark Hallett (London: Paul Holberton, 2015), 14.

15. Mark Hallett, *Reynolds: Portraiture in Action* (New Haven: Yale University Press, 2014), 386.

16. Lucy Davis, "Interacting with the Masters: Reynolds at the Wallace Collection," in *Joshua Reynolds*, 36.

17. Davis, "Interacting with the Masters," 38.

18. Naomi E. Tarrant, "The Portrait, the Artist and the Costume Historian," *Dress* 22 no. 1. (1995): 70.

19. Tarrant, "The Portrait, the Artist and the Costume Historian," 70.

20. Martin Postle, "Joshua Reynolds and His Workshop," in *Joshua Reynolds: Experiments in Paint*, ed. Lucy Davis and Mark Hallett (London: Paul Holberton, 2015), 56.

21. The scandal of Lady Worsley was documented in detail in the book *Lady Worsley's Whim: The Divorce That Scandalized Georgian England* by Hallie Rubenhold (London: Chatto & Windus, 2008). In this fascinating account, it is revealed that Lady Worsley, wanting to divorce her husband, ran away with Captain George Bissett, who served alongside Lady Worsley's husband in the Hampshire Militia. Rather than granting her a divorce, Sir Richard instigated criminal proceedings against Bissett which resulted in a lurid trial.

22. The *carte de visite* was first patented in Paris by André Adolphe Eugéne Disdéri in 1854 but did not arrive in England until 1857 and the format spread around the world quickly thereafter.

23. Jean Sagne, "All Kinds of Portraits, the Photographer's Studio," in *A New History of Photography*, ed. Michel Frizot, trans. Colin Harding (Milan: Konemann, 1998), 103.

24. Jean Sagne, "All Kinds of Portraits, the Photographer's Studio," 110.

25. Stanley G. Triggs, "The Man and the Studio" (Montreal: McCord Museum of Canadian History, 2005), 53.

26. Sagne, "All Kinds of Portraits, the Photographer's Studio," 111.

27. Charles Baudelaire, "The Modern Public and Photography," in *Classic Essays on Photography*, ed. Alan Trachtenberg (Sedgwick: Leete's Island Books, 1980), 86–87.

28. Sagne, "All Kinds of Portraits, the Photographer's Studio," 111.

29. Alice Mackrell, *Art and Fashion* (London: Batsford, 2005), 105–106.

30. Charles Baudelaire, "The Painter of Modern Life," in *The Painter of Modern Life and Other Essays*, trans. and ed. Jonathan Mayne (New York: Phaidon Press Inc., 2010), 12. Ellipses added.

31. Baudelaire, "The Painter of Modern Life," 13.

32. Baudelaire, "The Painter of Modern Life," 12.

33. Baudelaire, "The Painter of Modern Life," 10–13.

34. After 1886, Tissot would later abandon this type of imagery and painted only works with biblical narratives.

35. John Ruskin qtd. in Katharine Lochnan, "Introduction," in *Seductive Surfaces: The Art of Tissot*, ed. Katharine Lochnan. (New Haven: Yale University Press, 1999), xv.

36. Edward Maeder, "Decent Exposure: Status, Excess, the World of Haute Couture, and Tissot," in *Seductive Surfaces: The Art of Tissot*, ed. Katharine Lochnan (New Haven: Yale University Press, 1999), 77.

37. Tissot painted similar white dresses with yellow ribbons in several other works including *A Portrait of Miss Lloyd* (1876), *A Passing Storm* (1878), and *Convalescent* (1878).

38. Edward Maeder also notes that in several works by Tissot, he combines "old clothes . . . used in combination with modern elements to create an historical ambiance." See Maeder, "Decent Exposure," 83–85.

39. See Claire Wilcox and Circe Henestrosa, *Frida Kahlo: Making Herself Up* (London: V&A Publishing, 2018).

40. See "Cindy Sherman," Museum of Modern Art, February 26–June 11, 2012. Accessed June 18, 2019 at https://www.moma.org/calendar/exhibitions/1154

41. Works in the series *All Is Vanity* were exhibited in Toronto in 2010.

42. Another artist worthy of mention is prominent American artist Kehinde Wiley who painted the 2018 presidential portrait of Barack Obama for the collection of the National Gallery in Washington. Wiley often recasts iconic works from art history using black sitters wearing streetwear or contemporary fashions to challenge traditional representations of black identity. See Eugenie Tsai, *Kehinde Wiley: A New Republic* (New York: Brooklyn Museum in association with DelMonico Books, 2015). See also the artist's website, accessed June 18, 2019 at https://kehindewiley.com/

43. See artist Kent Monkman's website. Accessed June 18, 2019 at www.kentmonkman.com

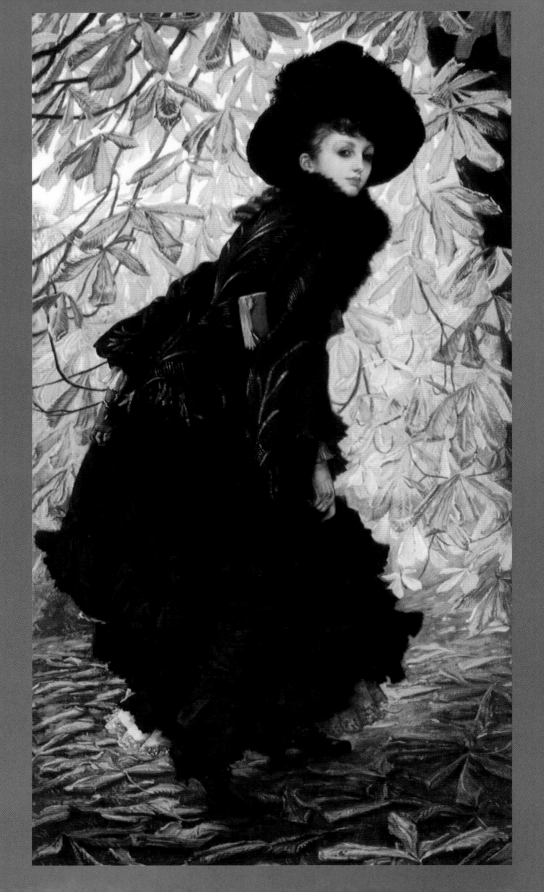

2

The Slow Approach
to Seeing

OPPOSITE
Figure 2.1

James Jacques Tissot, *October*, 1877.
Oil on canvas (216 × 108.7 cm).

When we first encounter an artwork, it can be challenging to know where to begin. For example, in *October* (Figure 2.1), a painting from 1877 by James Jacques Tissot (1836–1902), the central figure appears to be wearing black from head to toe and the rich details of the dress ensemble are revealed only after careful observation. This chapter articulates the idea of slow looking as a method of seeing, expanding on the material that was introduced in *The Dress Detective* to show how drawing as a method of slowing down can help identify specific elements of dress as well as the nuances of an artist's process. Tips on putting this method into practice will be offered later in the chapter.

Vision is how most of us come to understand the world, as art critic John Berger observed when he wrote, "Seeing comes before words. The child looks and recognizes before it can speak."[1] For much of history, art has privileged sight, and while contemporary art forms also embrace sound, touch, and other forms of sensory engagement, most paintings, drawings, photographs, and sculptures are experienced as visual encounters. Today with the ease of accessing visual imagery in digital format, this encounter is often mediated by the screen such that our reading of the image does not typically account for the format, medium, size, or texture of the original work. Nonetheless, whether we are encountering a work in person, in a book, or on a screen, we begin with looking.

To fully appreciate the nuances of the work, especially the fashions depicted therein, and to facilitate critical analysis of the work, I suggest that a period of extended looking at the work is necessary. It is this type of looking that I have previously described elsewhere as the *slow approach to seeing.*[2] I maintain that there is a marked difference between *looking* and *seeing*, since one can *look*, but still not really *see*. For me, drawing facilitates seeing and a deeper level of engagement with that thing. I record the path of my eyes on the paper as I study the object or artwork, and even if my drawing bares little or no resemblance to the thing I am looking at, when I finish a drawing, I feel like I have touched that thing.[3] This is a feeling that is otherwise denied in a museum or gallery experience since the touching of artworks and artifacts is generally prohibited.

Drawing is a process in which the eye, the hand, and the thinking brain work in concert to create a form of embodied knowledge.[4] Philosopher Martin Heidegger argued that, "Every motion of the hand in every one of its works carries itself through the element of thinking, every bearing of the hand bears itself in that element. All the work of the hand is rooted in thinking."[5] Although Heidegger does not mention drawing, it is in drawing that the hand is in motion, making marks on a surface that originate in the thinking brain, such that the mind and body become one. In replicating artworks through drawing, I believe we undertake a journey of discovery that helps us to feel the speed and skill of an artist's gestures and also to see the subtle details of the dress in a figurative work as well as other details in the artwork. And likewise, in drawing a dress artifact, we come to see the subtle patterns of wear and usage or details of construction that might not otherwise be apparent at first glance.

Other art critics and educators before me have argued in favor of drawing in learning how to see. In 1857, John Ruskin, the first Slade Professor of Fine Art at Oxford University, described the process of learning to draw as "a refinement

of perception" in his preface to *The Elements of Drawing*.[6] He articulated his hope that in teaching drawing, he would teach his students to love nature and ascribed more importance to having his pupils engaged with nature through drawing, than in learning to draw. He wrote, "I believe that the sight is a more important thing than the drawing; and I would rather teach drawing that my pupils learn to love Nature, than teach the looking at nature that they may learn to draw."[7] Almost a hundred years later, John Berger made a similar argument in his 1953 essay "Drawing Is Discovery." Berger observed that an artist embarks on a journey of discovery in drawing and is forced to look at the object to mediate the discrepancies between the representation on paper and the object itself. He wrote, "It is a platitude in the teaching of drawing that the heart of the matter lies in the specific process of looking. A line, an area of tone, is not really important because it records what you have seen, but because of what it will lead you on to see."[8] Art educator Betty Edwards, author of the 1979 book *Drawing on the Right Side of the Brain*, argued that anyone could learn to draw and in the process of doing so also learn to see. She wrote, "in learning how to draw, I believe you will learn how to 'see differently.' And that, in turn, will enhance . . . powers of creative thought."[9] For Edwards, drawing facilitates creative problem solving in that the extended process of looking allows the brain to process and analyze the visual inputs, and in this way, drawing encourages moments of creative insight.

Like Berger, Ruskin, and Edwards before me, I too encourage drawing as a way of seeing and recommend drawing as a tool to yield insights into dress artifacts as well as artworks.[10] I have used drawing as a research method and have also used drawing exercises in teaching research methods at the undergraduate and graduate levels. In these classroom and workshop exercises, I have observed that drawing facilitates seeing because it produces deep levels of engagement with the artwork and/or dress artifact being studied, especially for those who do not routinely draw.[11] And while it might be daunting to pick up a pencil and draw for the first time, the process is more important than what the end result looks like. Even if the drawing ends up being little more than scribbled lines, drawing helps the brain slow down and looking becomes seeing. As the hand traces the path of the eye in marks on a page or tablet, the brain is processing those inputs and insight is gained.[12] As well, recent scholarly research by Myra A. Fernandes, Jeffrey D. Wammes, and Melissa E. Meade has revealed that drawing an object enhances recall of that object that is "superior not only to writing but also to visual imagery and viewing pictures."[13] This research supports my anecdotal observations from the classroom that taking time to draw enriches recall and understanding of the artwork, object, or artifact.

Let's turn back to Tissot's painting *October* and see what insights can be gained by using drawing and the *slow approach to seeing* to study this work. When I first encountered this oil painting at the Montreal Museum of Fine Art years ago, and in my subsequent viewings thereof, I observed a larger-than-life work of art depicting Tissot's beautiful mistress Kathleen Newton seemingly dressed in black from head to toe holding a book under her arm, and walking quickly through leaves in a colorful late fall setting (Figure 2.1). There is a sense of movement created by her leaning forward and also picking up her long skirt, daringly revealing her

Figure 2.2

James Jacques Tissot, *October*, 1878. Etching and drypoint on paper (55 × 28 cm).

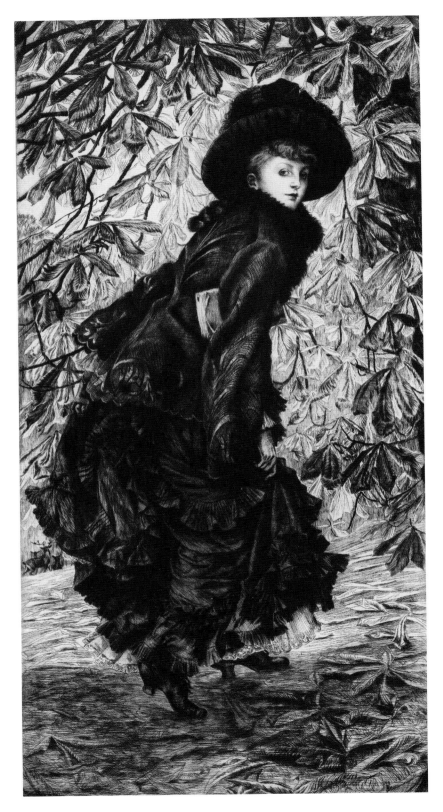

feet, so that she might move more quickly. For this book, I spent about an hour drawing the details of the dress in Tissot's replication of this work in his 1878 etching *October* from the Art Gallery of Ontario's collection (Figure 2.2). In drawing from Tissot's etching, I was acutely aware of the artist's consummate skill—each of his marks had both purpose and energy. In light of the complexity of the work, I focused on the details of Newton's dress and left out her facial features, hair, and background. My line drawing revealed subtle details of Newton's dress that were not first apparent to me, including the lush fur collar, the corded trim and wide over-sleeve with fan-shaped velvet applique on her mantle or dolman coat; the pleated organza cuffs on her blouse; the complex folds on her tiered skirt worn over the white eyelet petticoat; the kidskin gloves; her high-heeled black shoes with ribbon tie closure and her enormous hat with ostrich plumes and bow (Figure 2.3). These fine details—the applique on her coat, the pleats of her skirt, the fur collar, and the ostrich plumes on her hat—distinguish her dress ensemble and accessories as expensive and highly fashionable.

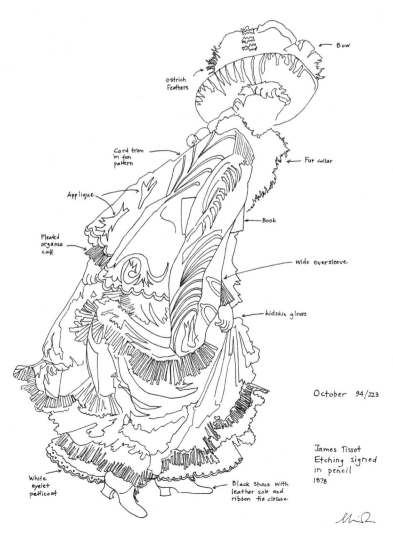

Figure 2.3

Ingrid Mida, study drawing of *October* by Tissot, 2017. Pen and ink (36 × 46 cm).

Of course, it is also possible to discern such elements without taking the time to draw the work, especially if the researcher uses the checklists provided in this book. However, I maintain that either way, a slow and extended period of looking is both helpful and also necessary in order to see these subtle details, especially for a dress ensemble that is mostly black, but with the skirt more purple than black. As art historian Justine De Young has argued, painting in black presented a particular challenge for artists since the absence of color made the subject less legible for the viewer, but nineteenth-century artists (like Tissot) often liked to use black to signal their modernity in relation to photography, since that medium of reproduction had "rendered the world in shades of gray."[14] Although the color black is typically associated with mourning, Anne Hollander observes that the wearing and depiction of women dressed in black in the nineteenth century represented "the original anti-fashion, rebellious tradition, which seeks to isolate and distinguish the wearer."[15] In this context, it is possible to see Tissot's choice of black for his mistress as a provocative choice that distinguished her as a chic rebel.

This is one of several paintings by Tissot dating to 1877–1878 that depicts the seasons,[16] and in this particular work, intended to convey an autumnal setting, the choice of warm colors for the leaves scattered on the grass and that fill the background accentuate the effect of Newton's stylish black day dress ensemble. The formal qualities of this oil painting—the use of warm colors that contrast with the purplish-black dress, the strong diagonals of Newton's body in movement, the large size and scale of the work—all serve to create a vibrant work that depicts a beautiful fashionable young woman on the move (Figure 2.1). She is recognizable as Tissot's mistress, but she is also an archetype of the modern fashionable woman since her beautiful features and elegant dress are the height of fashion. As well, her ensemble is similar to that found in fashion plates of the time showing women from the back or side, since fashions in 1875–1879 gave emphasis to the back of the dress. A similar, but not identical, ensemble in black was identified in a fashion plate from the German fashion publication *Illustrirte Frauen-Zeitung* dated May 17, 1875 (Figure 2.4). Another example of a similar dolman coat, here identified as a redingote, but this time worn over a green silk dress, is seen in a fashion plate from the French fashion journal *La Mode Artistique* (Figure 2.5). The Costume Institute at the Met has several examples of similar silk velvet dolman coats or mantles with fur trim and applique, including one in black (Figure 2.6).[17] Tissot was highly attuned to fashion, paying close attention to dress and thus aware of tropes of illustration in fashion journals from the time. In fact, one writer of the time argued that the artist set fashion trends when he wrote, "at the present time in England Mr. James Tissot and Mr. George Du Maurier exercise considerable control over fashions."[18]

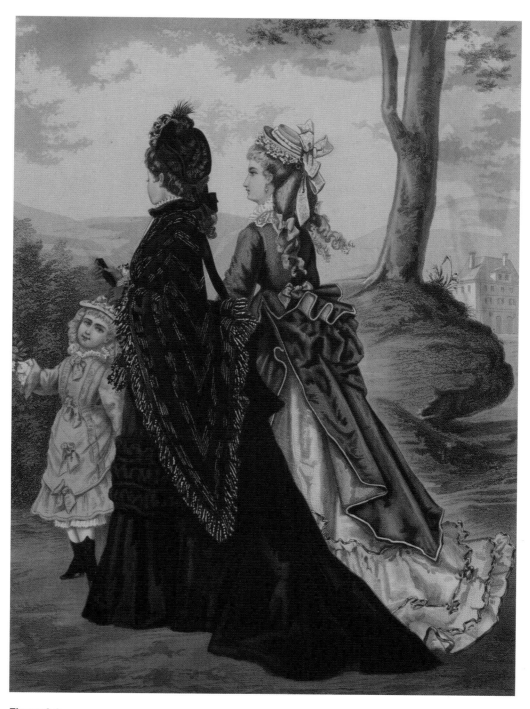

Figure 2.4

Artist unknown, *Illustrirte Frauen-Zeitung*,
May 17, 1875.

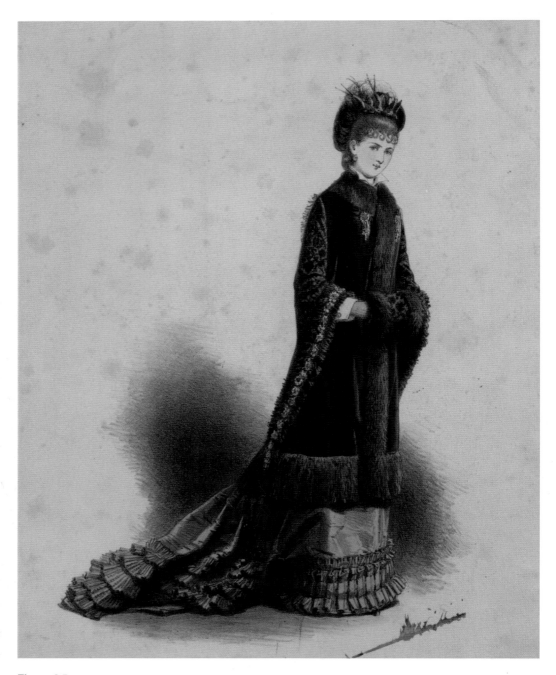

Figure 2.5

Gustave Janet, *La Mode Artistique*, 1878.

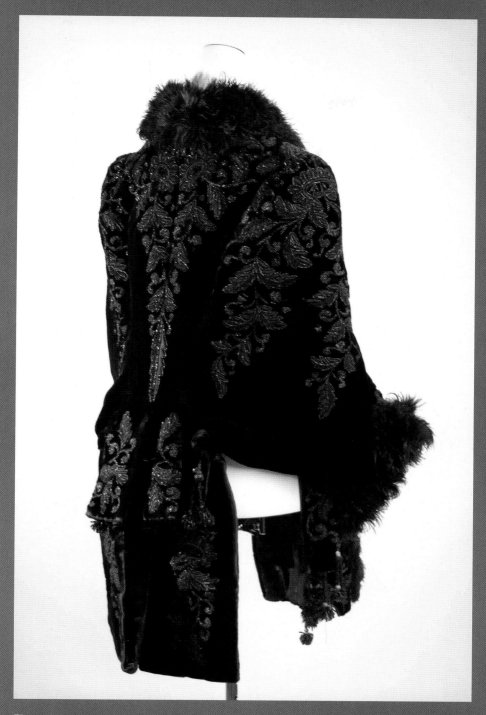

Figure 2.6

Unknown maker, dolman coat, ca. 1880s.

This type of comparative visual analysis, in conjunction with other efforts to contextualize the work within the artist's oeuvre and period, is well established in art history.[19] In this book, I suggest that the analysis of artworks can be greatly enriched by studying extant garments similar to those seen in paintings, photographs, and other artworks. Not only is this helpful in identifying whether or not the item was in fashion, but additional insights might be revealed that illuminate the artist's choices in rendering the clothing and that also can be helpful in contextualizing the dress depicted in the work in relation to broader issues within society such as views on gender, beauty, or morality. Art historian Aileen Ribeiro has long advocated for the close study of garments in developing a more nuanced understanding of artworks and has documented the connections between works of art and extant garments from museum collections in several of her books.[20] Other fashion scholars, including Alexandra Palmer, have also advocated for this methodology.[21]

Ideally, the researcher examines garments similar to that in the artwork in person since clothing engages the senses, particularly through its tactile qualities, and doing so facilitates an enhanced understanding of the material qualities of that object and the relationship of the garment to the body. And while I embrace and encourage that methodology, I recognize that this type of research is not always feasible for a variety of reasons. Therefore I also suggest that the researcher identify similar garments from museum or university study collections. This process has become much easier as institutions have digitized substantial portions of their collections, and it also aids in the understanding of the artwork.[22] In each of the case studies considered in the chapters that follow, I have identified examples of similar garments from institutional collections and compared them to that depicted in the artwork (including another work by Tissot discussed in chapter 8 in which the model wears a lavish fur coat), and in some cases, I was also able to examine such garments in person. To analyze contemporary fashions, it might be helpful to consult an online fashion archive, like Bloomsbury Fashion or Vogue.

As this chapter has argued, it is in drawing that the *slow approach to seeing* can be practiced. I encourage the use of drawing as a research method that reveals insights into the artwork. It can also help yield a deeper understanding of evidence related to the artwork, including both extant garments from museum or study collections as well as fashion plates, illustrations, or other forms of visual culture. Nonetheless, I recognize this approach has limitations, including a pervasive fear of drawing especially amongst those who have not received formal art training. Even though we all instinctively were able to draw as children, it can be intimidating to draw as an adult. However, I suggest that it is worth drawing anyway, because it is in the course of making marks on the page or a tablet that creative insight is nurtured. The drawings do not have to be included with the research outputs, and it is really the process and not the result that matters in the end. I also recognize that drawing a dress artifact in a museum can be a challenge, especially since there are often time constraints and the close supervision or

proximity of a curator or monitor. However, even a quick sketch of the artifact can help facilitate that critical shift in thinking from being out in the world to being fully present and engaged with the artwork or artifact. Here again, it is not a polished rendering that is wanted; drawing is seen as a way to practice the *slow approach to seeing*.

The key takeaway of this chapter is to look slowly and carefully at the artwork and any related evidence thereto, and where possible, use drawing as a way of slowing down to look and as a research method. But, as the next chapters will show, research is a multi-step process that is often not linear, and aspects of the work sometimes reveal themselves in ways not envisioned when the research began. The next three chapters will outline a checklist-based approach to analysis of the artwork that will help guide the researcher from start to finish.

Tips for Drawing in Museums

- Advise the curator or monitor in advance that you would like to draw, so that you are given sufficient time to do so during your appointment.
- Museums and research facilities typically restrict researchers to using pencils. It can be helpful to bring a mechanical pencil so as to avoid having to sharpen the tip, especially during an extended period of drawing.
- Erasers are not advisable because they create deleterious material that is unwanted in the research facility.
- A drawing tablet is another alternative, provided that the tablet and pencil have been fully charged.
- Turn off the notifications on your mobile device and be fully present.
- Harness the *slow approach to seeing*, recording the path of your eye on the paper and touching the object with your eyes.

List of Supplies
1. Sharpened pencil(s), preferably H or HB, or mechanical pencil with extra leads.
2. Pad of smooth paper and/or drawing tablet (with charging cord).
3. Measuring tape.
4. Camera to facilitate research photographs.

ENDNOTES

1. John Berger, *Ways of Seeing* (London: Penguin, 1972), 7.

2. See "The Slow Approach to Seeing," in Ingrid Mida and Alexandra Kim, *The Dress Detective: A Practical Guide to Object-based Research in Fashion* (London: Bloomsbury Academic, 2015), 33–36. For an articulation of how I came to develop this idea, see also Ingrid Mida, "The Curator's Sketchbook: Reflections on Learning to See," *Drawing: Research, Theory, Practice* 2 no.2 (2017): 275–285.

3. I want to acknowledge the assistance of Sarah Casey on alerting me to the relationship between drawing and touching when she first visited the Ryerson Fashion Research Collection in 2016. For her philosophical analysis of the process of touching-not touching when drawing, see Sarah Casey, "A Delicate Presence: The Queer Intimacy of Drawing," *Tracey | Journal Drawing In-Situ* (July 2016): 1–8.

4. For more on this topic, see the chapter on drawing in Ingrid E. Mida, "Refashioning Duchamp: Analysis of the Waistcoat Readymade Series and Other Intersections of Art and Fashion." PhD Dissertation, York University, 2019.

5. Martin Heidegger, *Basic Writings from Being and Time (1927) and The Task of Thinking (1964)*, ed. David Farrell Krell (Toronto: Harper Perennial, 2008), 381.

6. John Ruskin, *The Elements of Drawing with a New Introduction by Lawrence Campbell* (New York: Dover Publications, 1971), 12. Ruskin was deeply interested in drawing and founded the Drawing School at Oxford University in 1871.

7. Ruskin, *The Elements of Drawing*, 13.

8. John Berger, "Drawing Is Discovery," *Statesman and Nation 46* (August 29, 1953): 232.

9. Betty Edwards, *Drawing on the Right Side of the Brain: A Course in Enhancing Creativity and Artistic Confidence* (Los Angeles: Tarcher, 1986), xiii. Although the book was first printed in 1979, the methods continue to be widely used today.

10. Coinciding with my own use of drawing in the classroom, anthropologist Andrew Causey wrote the book *Drawn to See: Drawing as an Ethnographic Method* (Toronto: University of Toronto Press, 2017) in which he discusses his use of drawing as an ethnographic research tool and encourages others to embrace drawing in their research.

11. For some of the exercises used in the classroom, see Ingrid Mida, "The Slow Approach to Seeing," in *Teaching Fashion*, ed. Holly Kent (London: Bloomsbury Academic, 2018), 95–102.

12. One of my former students, Teresa Adamo, described the process of drawing a dress artifact in these terms: "Drawing gives you a comprehensive and in-depth understanding of the physical properties of the artefact. It also makes research more memorable and engaging." Teresa Adamo quoted in Ingrid Mida, "The Curator's Sketchbook," 283.

13. Myra A. Fernandes, Jeffrey D. Wammes, and Melissa E. Meade, "The Surprisingly Powerful Influence of Drawing on Memory," *Current Directions in Psychological Science* 27 no.5 (2018): 303.

14. See Justine De Young, *Women in Black*, PhD Dissertation, Northwestern University, 2009, 107–108.

15. Anne Hollander, *Seeing Through Clothes*, 377.

16. The 1878 series also includes the work *Spring* as well as *July: Specimen of a Portrait*.

17. This coat is described as a dolman and is dated in the 1880s, a little later than Tissot's work, which demonstrates the fashionability of such a garment. There are a number of terms used to describe such a coat including *mantle* and *redingote*. When searching for similar garments in online museum collections, it is advisable to try more than one search term.

18. John Williamson Palmer (1881), quoted by Nancy Rose Marshall and Malcolm Warner, in *James Tissot: Victorian Life/Modern Love* (New Haven: Yale University Press, 1999), 121.

19. See for example, Henry M. Sayre, *Writing about Art* (New Jersey: Pearson, 2009).

20. See for example, Aileen Riberio with Cally Blackman, *A Portrait of Fashion: Six Centuries of Dress at the National Portrait Gallery* (London: St. Martin's Press, 2015). See also Aileen Riberio, *Clothing Art: The Visual Culture of Fashion, 1600–1914* (New Haven: Yale University Press, 2017).

21. In her essay "Looking at Fashion: The Material Object as Subject," Alexandra Palmer compares a Gucci dress in a fashion photograph to the actual dress itself, and in doing so argues that this comparison enhances understanding of the material object. See Alexandra Palmer, "Looking at Fashion: The Material Object as Subject," in *The Handbook of Fashion Studies*, edited by Sandy Black et al. (New York: Bloomsbury Academic, 2013), 44–60.

22. The reader is cautioned that a Google search is unlikely to reveal objects in museum or university study collections, and objects must generally be accessed via the weblink for the institution.

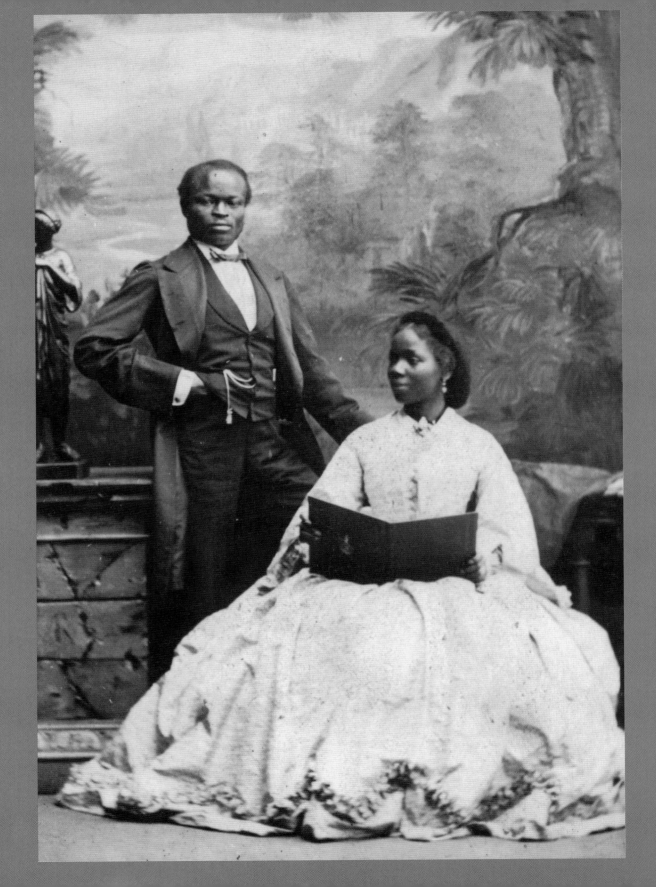

3 | Observation

INTRODUCTION

In this chapter, the focus will be on the first phase of research, called Observation, which involves a careful study of the work and the documentation of evidence gathered during that process. An extended period of looking—*the slow approach to seeing*—allows the eye to absorb the multitude of visual inputs from a figurative drawing, painting, photograph, sculpture, or installation.

Using checklists to organize the gathering of evidence, the researcher identifies and records information about the formal qualities of the work as well as taking note of the setting, use of props, and the fashioning of the figures, especially the creator's choices in the dress and stylization of the body. Upon completion of the checklist, the researcher has gathered sufficient information to write a rich description of the work and the fashioned body or bodies depicted therein (as has been modeled in the sample description at the end of this chapter). As historian Ludmilla Jordanova observes, "description is a form of sharing, of building up a common understanding," that serves as a bridge "between sources and interpretations of them."[1]

The reader is encouraged to answer each of the forty questions included in the Observation Checklist (see Appendix I). The checklist has been divided into four distinct parts that organize the questions by theme:

A. Preliminary Background: information about the artist/creator and the work
B. Composition: identification of the focal point, people, and setting
C. The Fashioned Body: documentation of the dressed or undressed figure
D. Formal Qualities: identification of the stylistic qualities of the work

The goal of this phase of research is to gather information. It can be tempting to skip ahead to analysis, but careful documentation of each stage is critical to the development of a comprehensive and meaningful interpretation. In this chapter, I expand on each question in the Observation Checklist and offer a brief commentary as to each question's meaning and significance.

To help the reader, sample answers (written in italics) are provided for the observation phase related to the portrait photograph of Sarah Forbes Bonetta with her husband James Davies taken by French photographer Camille Silvy in his London studio on September 15, 1862 (Figure 3.1). This photograph is remarkable in that it depicts an African woman who had an extraordinary life and was closely connected to Queen Victoria but remains relatively unknown.[2]

In 1862 when this photograph was taken, Sarah Forbes Bonetta[3] lived in England, but she had been born in West Africa into a Yoruba dynasty with the given name Aina.[4] When she was about five years old in 1848, her parents and siblings were killed in the Okeadon war, and she was held captive by the slave-

trading monarch King Guézo of Dahomey.[5] In 1850, Lieutenant Commander Frederick Forbes, who had been sent to Dahomey by Queen Victoria with the hope that he would persuade King Guézo to end slavery, took custody of the child as a "gift" to Queen Victoria. Forbes anticipated that she would likely soon be sacrificed "on the tombs of the deceased nobility"—a fate reserved for the "high behests of royalty"—and recognized that a refusal of this gift "would have signed her death-warrant; which probably would been carried into execution forthwith."[6] Forbes took the girl back to England with him on the warship *Bonetta* and renamed her Sarah Forbes Bonetta. In his memoirs, Forbes described Sarah as a child of high intelligence with musical talent, writing:

> For her age, supposed to be eight years, she is a perfect genius; she now speaks English well and has a great talent for music. She has won the affections, with but a few exceptions, of all that know her, by her docile and amiable conduct, which nothing can exceed. She is far in advance of any white child of her age, in aptness of learning, and strength of mind and affection.[7]

Sarah was presented to Queen Victoria, who became her godmother, and also funded Sarah's education.[8] In her journal, the Queen records a meeting with the child on January 11, 1851, writing: "After luncheon, Sally Bonita [sic], the little African girl came with Mrs. Phipps and showed me some of her work. This is the fourth time I have seen the poor child, who is really an intelligent thing."[9] Sarah Forbes Bonetta appeared at social events of the royal household, and it was at such an event that she met the widower James Davies (1828–1906). Of African descent and educated in Sierra Leone, Davies served in the British Navy's West African Squadron, achieving the rank of lieutenant before retiring from the navy in 1852 and later becoming a successful merchant.[10] The couple were married in a lavish church ceremony in Brighton on August 14, 1862 that was described in the *Illustrated London News* as "a grand field-day in the fashionable world of Brighton on Thursday week."[11] The couple later settled in colonial Lagos where they established a cocoa farm. Sarah, who had renamed herself Ina,[12] became a mother to a son and two daughters but died of tuberculosis at the young age of 37 on August 15, 1880.

At the end of the chapter, a sample descriptive passage related to the portrait photograph of Ina Sarah Forbes Bonetta Davies (Figure 3.1) using the information gathered in the checklist is presented that brings together the observations documented here. This example also serves to illustrate how this book might also be used to read a photograph that was not originally intended as an artwork, since many such family photographs survive in albums and archives.

OBSERVATION CHECKLIST (30 QUESTIONS)

A. Preliminary Background

In this section, researchers document the basic information about the work, including the title, date, dimensions, and condition.

1. **What is the title of the artwork? Does the title directly reference the work of another artist?**

 This photograph (Figure 3.1) is untitled, but it is known to be one of a series of portraits taken of Ina Sarah Forbes Bonetta with her husband James Davies on September 15, 1862.

The title of the work is the first clue to the creator's intention, since a portrait often identifies a specific person in the title. Family photographs are generally untitled. Sometimes a work is titled to signal reference to an iconic artwork from the past, as contemporary artists Mickalene Thomas (see chapter 4) and Yinka Shonibare (see Coda) and others have done in their efforts to challenge the paradigms of art history.

2. **What type of work is it (painting, sculpture, photograph, installation, digital, mixed media)?**

 Photograph

An artist makes a choice of medium for the work and that choice defines the material qualities of the work. In the case of a commissioned work such as a portrait, the sitter often chooses the medium.

3. **Who is the artist/creator?**

 Camille Silvy (1834–1910)

Identifying the creator of the work allows the researcher to consider other works by the same artist as well as research their background and studio practices. For example, the French photographer Camille Silvy was one of the leading photographers in London at the time, having photographed many members of the royal household including Prince Albert in 1861 (Figure 3.2).

4. **What year was the work created?**

 1862. According to photographer Camille Silvy's datebooks, this portrait of Sarah Forbes Bonetta was taken on September 15, 1862. Only six years later, the popularity of the carte de visite format had waned; Silvy sold his London studio in 1868, returning to France.[13]

Identifying the year of the work helps to contextualize the work within the artist's oeuvre in terms of whether it is an early, mid-career, or late-stage work. It also allows the researcher to consider other material from the time period, including diaries and historical accounts, related literature, and fashion plates or other illustrations.

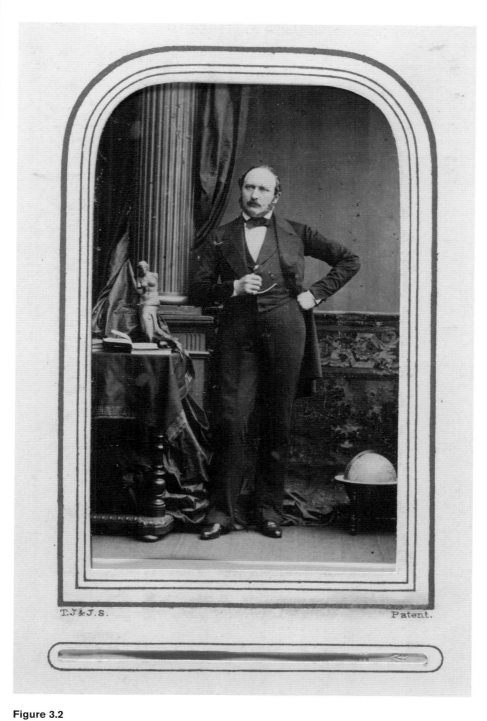

Figure 3.2

Camille Silvy, *Portrait of Prince Albert*, January 1, 1861.

5. Is it part of a series (a multiple, a reproduction)?

There are several other images taken on this date to mark the wedding of Ina Sarah and James Davies.[14] In another image of the couple, they are both standing. There are also other images of Ina Sarah and James taken separately (see Figures 3.3 and 3.4).

Knowing whether or not a work is a multiple or reproduction is central to understanding whether it is unique and singular. Prints and photographs are easily reproduced.

6. Who owns it now (museum, private collector, institution, gallery)?

This image was numbered 11697 and is one of a series taken on this date in the London studio of Camille Silvy. The photographer's datebooks are in the property of the National Portrait Gallery in London, England, documenting over 17,000 portrait sittings, many of which contain sample images from his sittings.

Knowing the provenance of the work gives the researcher information as to the significance of the work to the artist and/or the sitter, since works that have great personal meaning are usually retained as personal property.

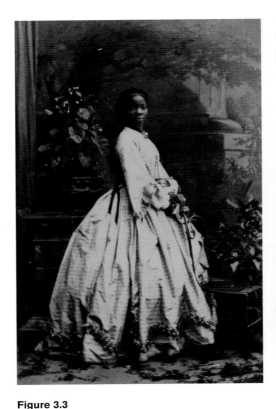

Figure 3.3

Camille Silvy, *Portrait of Sarah Forbes Bonetta,* **1862.**

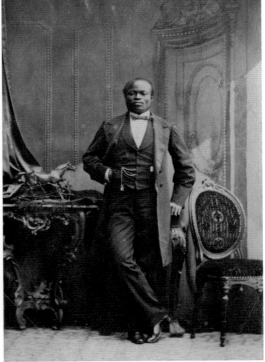

Figure 3.4

Camille Silvy, *Portrait of James Davies,* **1862.**

7. **What are the dimensions of the work (framed and/or unframed)? Is the work large-scale or small-scale relative to the human body?**

 This type of photo, called a carte de visite, was immensely popular until about 1868, when it was supplanted by the larger cabinet card. The carte de visite was a print of 54.0 × 89 mm (2.125 × 3.5 inches) and was typically mounted on a card of 64 × 100 mm (2.5 × 4 inches). In this example, the print has been pasted into the photographer's datebook as a record of the sitting (Figure 3.3).

If the work is close to life-size or larger, the artist is conveying a sense of importance or monumentality to the work. Since images are often viewed on a screen, making all sizes of works appear the same, measurements are relevant in considering the scale of the work.

8. **Is the work horizontal or vertical in orientation? Consider how this orientation impacts the work.**

 The portrait is vertical in orientation, which allowed Silvy to photograph Ina Sarah Davies and her husband from head to toe. In the series of portraits, the couple adopt various poses. In Figure 3.1, Ina Sarah is seated on a low armchair, her head is turned slightly, and she holds a book. Her husband stands to her left with one hand in his pocket and the other resting on the back of the chair; he gazes directly at the photographer. In another image from this series (Figure 3.3), Ina Sarah stands alone; she gazes out at the camera, but her body is turned to the side, capturing the details of the expansive skirt of her dress.

Some works do not show the whole body, instead focusing on the head and shoulders, or are half-portraits. The size of the work bears a relationship to the cost, especially in the case of painted portraits.

9. **Has this work been altered in some way from its original state?**

 Since the image is pasted into the photographer's datebooks, it is considered a record of a portrait sitting rather than an artwork.

If the work has been altered, either by being cut down from a larger work, or perhaps overpainted by the artist or in later restoration efforts, this may materially affect the reading of the work. If the work has been altered in some way, it may be necessary to seek additional information as to what the original work looked like.

B. Composition

The artist makes choices in creating an artwork to create emphasis to certain aspects of the work, directing the viewer's eye through the arrangement of the figures in either a specific place or an indeterminate setting.

Focal Point

10. **Where is the emphasis in the image?**

 In Figure 3.1, the emphasis in this photographic portrait is on the couple; Ina Sarah is seated while her husband stands.

The artist makes compositional choices that direct the viewer's eye through the work. These formal qualities, especially the use of directional line, the definition of space through shape and form, and the intensity and value of the colors, serve to create a focal point in the work.

11. What captures your attention first?

The eye first lands on the face of James Davies since his standing posture elevates him above his wife and dominates the photo. The eye moves from his face down his body. The diagonal created by his bent leg leads the eye to the open book on Ina Sarah's lap. The eye then moves up the buttons on her bodice to her face. The play of contrasts between areas of light and dark punctuates the image with dynamic energy.

Paying attention to where your eye lands first facilitates entry into the work.

People

12. How many persons are included in the artwork?

There are two persons in this portrait: Ina Sarah Forbes Bonetta and her husband James Davies.

In an artwork with more than one person, usually one person dominates or plays a central role in the narrative.

13. Are the figures in the artwork known persons? Is the work intended as a portrait? Can they be identified by name? If so, can this knowledge of their identity inform your analysis?

Yes. The names of the sitters are recorded in the photographer's datebook; in this case, Ina Sarah is identified as Mrs. J.P.L. Davies. And as was discussed in the introduction to this chapter, Ina Sarah Forbes Bonetta Davies had an extraordinary life.

Sometimes in genre paintings, the artist may also use persons that are known to them. For example, in the last chapter, the central figure of James Tissot's painting *October* was his mistress Kathleen Newton, even though this work is not considered a portrait. In portrait sittings, the names of the sitters may be recorded in the datebook, as is the case with this series; in family photographs, sometimes the names of the sitters are recorded on the back of the image.

14. If there is more than one person, what is their physical position relative to each other? Does their position, posture, or body language echo their relationship?

In this image (Figure 3.1), James Davies stands with an erect posture and he takes the dominant role. His direct gaze and proud stance assert confidence. He adopts a similar stance in the image taken of him alone (Figure 3.4).

The placement and posture of figures included in a work is often symbolic of their relationship.

15. **Where is their gaze directed?**
 James Davies looks directly out at the photographer, while Ina Sarah's gaze is directed to the side. In another image from this series (Figure 3.3), Ina Sarah looks directly at the photographer even though her body is turned to the side.

The gaze of the sitter indicates their point of focus and attention. The directness of the gaze marks their relative status. For much of history, women were expected to be demure, directing their gaze downward or to the side rather than directly at the viewer.

Setting

16. **Is the setting indoors or outdoors?**
 Although the painted backdrop suggests an outdoor setting, the portrait series was photographed indoors in Silvy's London studio. The other images in the series illustrate different backdrops.

The setting establishes place and context for the work. The artist's choice of setting is especially significant for a portrait because an indoor setting may contain clues as to the sitter's social status.

17. **Does the artwork depict a specific place or setting?**
 The setting is deliberately ambiguous in combining indoor furniture with a painted landscape as the background.

If the background depicts a specific place, the landscape becomes significant to the reading of the work, as we shall see in the case study of Mr. and Mrs. Andrews in chapter 6.

18. **What elements of the setting or background are notable?**
 On the left side of the image, there is an ornate cabinet painted with what appears to be cherry blossoms. Set on top of the cabinet is a figurative statue that appears to be wearing a turban.

The setting of the work not only situates the work, but it also creates a mood, which is helpful in understanding the artist's intent.

19. **Does the setting convey status, privilege, or other meaning?**
 The studio setting is contrived but is intended to convey privilege.

The setting plays a significant part in reading the intent of the artist/creator.

C. The Fashioned Body

A figurative work includes the fashioned body, even if the bodies are undressed. The fashioning of the body includes the manner in which the body is posed as well as the dressing of the figure, including the accessories, the styling of the hair, and the use of makeup.

Body

20. Are the people in the artwork clothed? If not, are the naked bodies ornamented or fashioned in some way?

Yes, both figures are dressed in the fashions of the period. Their clothing appears to be finely tailored.

Fashion is not confined to clothing and it is important to consider the stylization of the body as well as the ways in which the nude body has been fashioned.[15]

21. How are the people oriented (front facing, three-quarter view, profile, or back facing)? Consider what this orientation signifies.

James and Ina Sarah Davies are both facing front in dynamic poses. In another image (Figure 3.3), Ina Sarah looks directly at the photographer, but her body is turned to the side. This pose captures the elegance of her dress.

The orientation of the figures can be a key element in the artist's storytelling and taking note of this small detail can reveal aspects of the figure's social position, relative status, or other aspects of their identity.

22. What is the gender of each person in the image? Has the artist emphasized gender or obscured it?

This photograph depicts a man and a woman as husband and wife. Each is dressed in a manner that confirms their gender. James Davies wears a three-piece dark wool suit, and Ina Sarah Davies wears a day dress over a crinoline. The photographer has given emphasis to her femininity by having her expansive dress skirt fill the frontal plane of the image.

Gender can be articulated or obscured through the manner of dress. If the artist gives emphasis to certain aspects of dress associated with feminine or masculine identities, this may be a clue to the significance of gender in the work.

23. Consider the posture of the sitter(s). Are they seated, standing, or reclining? Are parts of the body not visible in the image? Is their posture rigid or relaxed? Is posture indicative of a state of mind and/or training of the body?

James Davies is standing with the weight on one leg, the other bent at the knee with his foot elevated, likely resting atop a low stool. His straight back and pulled back shoulders convey his military training and his self-confidence. One hand is tucked into a pocket of his trousers such that his pocket watch is given prominence. His other hand rests lightly on the back of his wife's chair.

Ina Sarah Davies is seated on a low chair beside her husband. Her posture is erect, but she is not stiff. She appears more relaxed than her husband and holds an open book or album in her hands. Much of her body is obscured by the expansive dress skirt. Her shoes are not visible.

Body position and posture can reveal the sitter's social position and training of the body as well as their state of mind, including energy and elegance, or fatigue and despair.

24. **Are other objects or animals included in the image to depict activities, interests or status, such as globes, books, horses, or pets? How does the sitter engage with these objects? What is the scale of these objects relative to the sitter's body?**

 Ina Sarah Davies holds a bound book or album in her hands. The book has gold embossed trim around the edges and there appears to be text or an image on one side. Such a prop suggests learning or reflection. In another image in this series, she holds a fan.

Artists often use objects to reveal something about the sitter. For example, a book is often used to represent learning, while a globe is indicative of travel. For royal personages, like Queen Marie Antoinette, the inclusion of objects that mark status as a royal can be especially significant, as the introductory chapter has shown (see Figure 0.2). In nineteenth-century portrait photography, props were often provided by the photographer.

Dress

25. **Describe the main elements of clothing for each person in the image in detail, noting the garment category (such as day or evening dress), and how it is worn. Also note whether any outdoor clothing such as capes, wraps, or coats are evident.**

 For this portrait sitting, Ina Sarah Davies is wearing a day dress of light-colored fabric, possibly her wedding dress. This dress is cut with a high neckline, sloped shoulders, tight armholes, pagoda sleeves, and an expansive skirt. The dress bodice is close fitting and worn over a corset, buttoning at the front. Ina Sarah wears a white cotton or linen under-blouse that is visible at the neckline and sleeve cuffs. The pagoda sleeves are trimmed near the cuff with a wide satin ribbon. This same type of ribbon is also used at the waist as a dress sash. The full skirt is supported by a crinoline. The bottom of the skirt is trimmed with puffs or loops of fabric that are attached in a scalloped formation. When seen from the side (Figure 3.3), the skirt appears to have a slight train which pools on the floor behind.

 James Davies wears a three-piece dark wool suit. His finely tailored coat is knee-length with wide lapels and deep cuffs. His single-breasted waistcoat has a wide shawl collar, six buttons, and two or four front pockets; the chain to the pocket is clearly visible. His matching trousers have small pockets near the waist, allowing him to tuck his hand inside, giving emphasis to his watchchain and shirt cuffs. His white shirt is accessorized with a narrow tie at the neck and cufflinks at the wrist. In Figure 3.4, his highly polished shoes are visible. His attire is very similar to that worn by Prince Albert in a portrait by Camille Silvy dated January 1, 1861 (Figure 3.2).

As was discussed in the introductory chapter, it is the dress of the figures that is part of the narrative of the work. Taking careful note of each detail, even if it is as subtle as the slight pooling of the skirt of Ina Sarah Davies when she is turned in a sideways pose is helpful in reading the work.

26. **Can the type of textile(s) be determined? Does the artist attempt to convey the nature of that textile, such as the luster of silk or satin, the coarseness of linen, the sumptuous pile of velvet? Note the colors and dominant patterns in the textiles used for the clothing.**

In Figure 3.1, the lighting of the image has washed out the light-colored fabric of the dress, such that the pattern in the textile of the dress is unreadable. However, in another image of Ina Sarah Davies from this series (Figure 3.3), there is a subtle luster seen in the dress textile that suggests it is made of silk. This image also illuminates the pattern, indicating that it is a delicate horizontal stripe overlaid with small crosses or diamond shapes.

James Davies' suit is made of finely tailored wool. His shirt front is crisp and likely made of cotton.

The relative status and rank of a person is typically conveyed through the quality of their clothing. More expensive textiles such as silks, wools, or lace demarcate status.

27. **Is the clothing embellished in any way with fur, lace, jewels, embroidery, braid, or beading?**

Ina Sarah Davies' clothing is trimmed with ornamental details made of the same fabric as the dress, including covered buttons and the scalloped trim at the hem. These two methods of ornamentation would be time consuming, requiring the skillful dressmaker to craft the trim and buttons rather than purchasing them readymade. The dress is also ornamented with shiny satin ribbon on the sleeve cuffs and at the waist. These details would have added to the cost of the dress.

The dress of James Davies is unornamented, which is consistent with the relatively dark and sober dress of men during the nineteenth century.

Ornamentation of dress is expensive and offers clues to the relative status of the sitter. For men, the status of the sitter is often conveyed through subtle details that distinguish the quality of the textile and the tailoring of the garment to fit the wearer.

28. **Is any element of dress exaggerated? Consider the cut of sleeves, size of collar or ruff, length of train, wearing of hoops, or other forms of altering the silhouette of the body.**

The sloping shoulders and wide pagoda sleeves of the bodice as well as the wide bell-shaped skirt of the dress worn by Ina Sarah Davies create the distinctive style and silhouette of fashionable dress for elite women in the early part of the 1860s.

Fashion's point of emphasis changes over time. Taking note of what elements of dress have been exaggerated allows the viewer to consider whether this was as an artistic choice or whether this is consistent with the fashions of a particular period.

29. **Describe the accessories of each person such as hats, gloves, fans, parasols, muffs, purses, bags, belts, shoes, or shawls. Note how they are worn, carried, or placed in the image.**

 In this portrait series, Ina Sarah Davies is not wearing gloves, nor a hat, and her shoes are not visible. However, in another image included in Silvy's datebooks, she holds a closed fan, most likely a studio prop.

What is in fashion at any given time also includes accessories, such as hats, fans, gloves, purses, or bags, etc. Accessories are key elements that complete a fashionable look.

30. **Are there visible signifiers of rank or status such as jewelry, medals, swords, or armor?**

 In this series of images, slow looking reveals that Ina Sarah Davies is wearing several pieces of jewelry, including drop earrings, a black ribbon pendant at her neck, a floral brooch pinned to the neckline of her under-blouse, a gold chain bracelet on one wrist, and a bracelet with a circular stone or locket on the other wrist, a ring on the little finger of her right hand, and two rings on the fourth finger of her left hand.

 In both images, James Davies proudly displays his pocket watch. Such a watch was a signifier of status, particularly if it was made of gold.

Jewelry and medals are significant markers of rank and social status. Taking careful note of such accessories is helpful in reading the identity of the sitter.

31. **Does the clothing serve as an occupational uniform (military, medical, clerical, labor, or other profession) or marker of identity (royalty)?**

 In this series of images, neither is wearing an occupational uniform per se. Both are dressed in the manner of fashionable British elite rather in the traditional dress of their African homeland.

Uniforms are markers of identity. In Jennifer Craik's survey and analysis of the history and cultural politics of the uniform, she traces the origin of the uniform to the battlefields of the seventeenth century and notes this symbol of collective military presence evolved to define norms of masculinity. Craik asserts that men's uniforms serve not only to convey "authority, status, and power" through a unified visual aesthetic, but also present a "heady alignment of heroism, muscularity, sexual prowess, and titillation."[16] However, the military uniform is not the only way that identity can be crafted through dress. As Anne Hollander argued in her book *Sex and Suits*, the sober dark suit adopted by men in the early part of the nineteenth century is a symbolic manifestation of power and masculinity.[17]

32. **Describe the hairstyle and makeup of each person.**

 Ina Sarah Davies wears her long hair with a center part and looped up with a hair net or snood. In Figure 3.3, it appears as if hair ribbons trail down her back. She does not appear to be wearing makeup.

James Davies wears his hair closely cropped. His hairline is receding, and he is clean shaven. He does not sport the long sideburns and close-cropped beard worn by Prince Albert (Figure 3.2).

Hair and makeup are constituent elements of the fashioned body and signify whether or not the sitter was following the trends of the time period.

D. Formal Qualities

Stylistic Qualities

33. Is this a realistic or abstracted image?
 This is a realistic image.

Abstraction of figurative works generally follows stylistic trends in art. For example, with the development of paint tubes in the 1840s, artists were more easily able to transport paints. Not long thereafter, painting in the open air became popular and figures depicted therein were not necessarily rendered in portrait-like detail (see Eugène Boudin's works in chapter 7).

34. Are any parts of the image unfinished or indistinguishable?
 No. However, the small scale of these photographic images makes it difficult to see the fine details of the sitters' dress and accessories.

Sometimes an artist will create emphasis in the painting by using texture or leaving some parts less finished. This can be a deliberate stylistic choice (as in the case of Eugène Boudin's impressionistic paintings of the fashionable set on the beaches of Normandy in chapter 7).

35. Does the artwork fit within a certain stylistic period in art history? If so, is it consistent with the dominant characteristics of that style?
 Yes. Camille Silvy's photographic portraits of the couple fit within the photographic conventions of the period.

Identifying the dominant stylistic characteristics of a particular period allows the researcher to compare and contrast the work with other artist's works from the same period.

Space

36. What is the sense of space in the work? Is there a foreground/middle ground/background? How are they linked? Is the sense of space literal or indeterminate?
 There is an indeterminate sense of space in this image. The couple is situated in the foreground plane, but the painted background conveys the idea of an immense landscape.

In creating a work, especially one that is in two dimensions, the artist/creator makes choices how to frame the space and these choices have different effects on the figure. For example, a small figure in a large background can create a sense of isolation or alienation, whereas a large figure that dominates the landscape can show mastery over the land.

37. Has perspective been distorted or altered for specific effect?
In this work, the illusion of space is deliberately contrived.

Within a two-dimensional work, space is a deliberate construction and the artist's choices become clues to the meaning of the work.

38. What is the scale of the artwork relative to the human body and does this create the illusion of space or evoke a feeling or affect?
This image is very small. This small scale adds a sense of intimacy to the work in that the portrait is small enough to be tucked into a pocket.

The scale of the work is a significant clue to the cost and importance of the sitter. Painted portraits were costly and accessible only to the elite of society. A larger-than-life portrait would be considerably more expensive than a half-length work or a cropped image of head and shoulders. Although the introduction of photography made portraiture accessible to all, the scale of a painted portrait still connotes status.

39. How is space used to contain the representation of the body? Think of the lines within the artwork and how they echo or contain space around the bodies.
The series of images in Silvy's datebooks show that he posed the couple with different backgrounds and props. In Figure 3.1, the photographer has created several diagonal lines through the image. Beginning at the middle left of the image, a diagonal line is formed by the arm of the statue that extends down James Davies' bent arm and leg and then across to the book on Ina Sarah's lap. There is another strong diagonal that begins at the bottom left corner of the image and follows the line of Ina Sarah's dress up her body to the angle of her head, and continues through the branch of the tree in the painted background. These diagonals add interest and movement to the image. In Figure 3.3, Silvy has achieved a similar effect through careful arrangement of props and pose. There are plants with thick foliage on either side of Ina Sarah; and her pose created strong diagonals in the profile of her sleeve and the folds of her skirt. However, in other images from this series, notably a close-up of the couple, Silvy has given less attention to articulation of space and the figures are less dynamic.

Looking closely at the work to see how the artist has constructed space and directed the eye around the work reveals aspects of their thought and artistic processes.

Color

40. Does the use of color bring attention to certain forms, create movement, or generate a mood?

The image is rendered in tones of black and white; the sepia tones of these images are characteristic of the albumen prints popular during this time period.

Color adds interest and vibrancy to the work. Selective use of color is a compositional choice made by the artist. Prior to the invention of the autochrome, the first practical and commercial color photography process by the Lumière brothers in 1907, photographers would hand-color images to achieve a more life-like quality. This step added additional cost to the production of images.

Sample Description (about 500 Words)

A series of *carte de visite* photographs dated September 15, 1862 in the datebooks of London-based photographer Camille Silvy document a portrait sitting of Ina Sarah and James Davies (Figures 3.1, 3.3, and 3.4). The couple had been married in Brighton in the month prior and were dressed formally for the studio sitting in what is likely their wedding attire. For this portrait series, Ina Sarah Davies, goddaughter of Queen Victoria, is wearing a day dress made of light-colored fabric cut in the fashionable silhouette of the time; the dress has a high neckline, sloped shoulders, tight armholes, pagoda sleeves, and a full skirt. The pagoda sleeves of the dress are trimmed near the cuff with a wide satin ribbon and expose the cuffs of her crisp white under-blouse. The expansive dress skirt is supported by a crinoline. The bottom of the skirt is trimmed with puffs or loops of fabric that are attached in a scalloped formation. When seen from the side (Figure 3.3), the skirt appears to have a slight train which pools on the floor behind.

James Davies wears a three-piece dark wool suit. His finely tailored coat is knee-length with wide lapels and deep cuffs. His single-breasted waistcoat has a wide shawl collar, six buttons, and two or four front pockets. His matching trousers have small pockets near the waist, allowing him to tuck his hand inside, giving emphasis to his watchchain and shirt cuffs. His white shirt is accessorized with a narrow tie at the neck and cufflinks at the wrist.

The couple adopts a variety of poses in the series. In Figure 3.1, the couple are shown together, with James standing with one hand resting lightly on the back of his wife's chair. Ina Sarah is seated beside him in a pose that asserts the dominance of husband over wife that is consistent with gendered conventions for portraiture at that time, in which "the man was typically presented in the dominant role, and the woman, in a subservient, deferential one."[18] This photograph also adopts the stylistic conventions of studio photography in the use of a painted backdrop, furniture, and props. Silvy had the couple adopt a variety of postures that illustrate different degrees of artistry in image making, but the result is mostly indistinguishable from the thousands of other photographic images from the period. However, the significance of this particular portrait is marked by the fact that it is a rare image of a little-known member of Queen Victoria's extended royal household.

ENDNOTES

1. Ludmilla Jordanova, *The Look of the Past: Visual and Material Evidence in Historical Practice* (Cambridge: Cambridge University Press, 2016), 19.

2. The Victoria & Albert Museum also has an image of Ina Sarah Forbes Bonetta identified as "Woman in a Dress" in their prints and drawings collection. Accessed July 9, 2019 at http://collections.vam.ac.uk/item/O1436194/woman-in-a-dress-photograph-silvy-camille-leon/

3. There are inconsistencies in the naming and spelling conventions in the various accounts of the life of Ina Sarah Forbes Bonetta. She has been called Ina, Sarah, Sara, and also Sally. Her surname has also been spelled Bonotta and Bonita.

4. There are inconsistencies in the various accounts as to the year of her birth, being either 1842 or 1843.

5. "Sarah Forbes Bonetta and Family," Royal Collection Trust. Accessed July 9, 2019 at https://www.rct.uk/collection/themes/trails/black-and-asian-history-and-victorian-britain/sarah-forbes-bonetta-and-family

6. Frederick E. Forbes, *Dahomey and The Dahomans: Being the Journals of Two Missions to the King of Dahomey, and Residence at his Capital, in the Years 1849 and 1850*, Vol. II. (London: Longman, Brown, Green and Longmans, 1851), 207.

7. Forbes, *Dahomey and The Dahomans*, 208.

8. "Sarah Forbes Bonetta," *Black Victorians: Black People in British Art, 1800–1900*, edited by Jan Marsh (Hampshire: Lund Humphries, 2005), 189.

9. Queen Victoria's Journal, RA VIC/MAIN/QV (W), January 11, 1851. Accessed July 9, 2019 at https://www.rct.uk/collection/themes/trails/black-and-asian-history-and-victorian-britain/queen-victorias-journal-ra

10. "James Pinson Labula Davies," National Portrait Gallery, accessed July 9, 2019 at https://www.npg.org.uk/collections/search/person/mp71778/james-pinson-labulo-davies

11. In the newspaper account of their wedding, Sarah's surname is misspelled as Bonotta and her husband's surname is misspelled as Davis. Other information in the entry confirms that the account is related to the wedding of Sarah Forbes Bonetta to James Davies. The entry reads in full as follows: "A coloured lady – Miss Ina Sarah Forbes Bonotta – of Royal descent, and who had had the good fortune to be adopted by an English Captain of the Navy and to be educated at the expense of her Majesty, was led to the alter by a coloured gentleman, Mr. James Davis, a Sierra Leone merchant. She was escorted by a bevy of dark beauties, and he was honoured by the attendance of coloured grooms. They were married by the Bishop of Sierra Leone, assisted by an African clergyman." This entry appears under "Country News," *Illustrated London News*, August 23, 1863, 199.

The couple's marriage also was announced in the London newspaper *The Examiner* dated August 16, 1862. See "A Negro Marriage in Brighton," *The Examiner*, August 16, 1862, 519.

12. In respect of her decision to rename herself Ina, in the analysis that follows I have used the name "Ina Sarah."

13. "Camille Silvy," The J. Paul Getty Museum, accessed July 23, 2019. http://www.getty.edu/art/collection/artists/1532/camille-silvy-french-1834-1910/

14. These images can be seen on the collection portal for the National Portrait Gallery of London.

15. For more on this topic see Anne Hollander, *Seeing Through Clothes* (Berkeley: University of California Press, 1993).

16. See Jennifer Craik, "The Cultural Politics of the Uniform," *Fashion Theory* 7, no. 2 (2003): 134.

17. Hollander traces the genesis of the man's suit as a product of modernity in which the once colorful clothing of the male peacock of the eighteenth century was replaced with a dark sober uniform of power that in its "carefully simplified dynamic abstraction" expresses the ideals of masculinity. See Anne Hollander, *Sex and Suits* (New York: Alfred A. Knopf, 1994), 113.

18. Anne M. Lynden, *A Royal Passion: Queen Victoria and Photography* (Los Angeles, Getty Publications, 2014), 139.

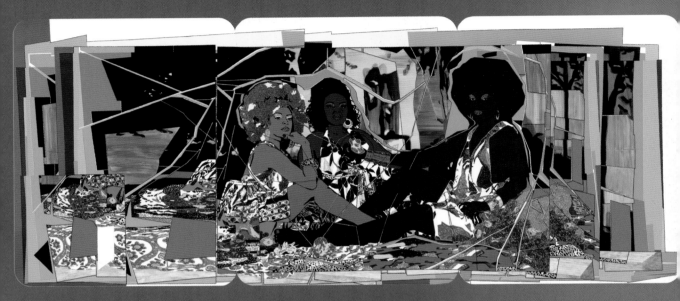

Figure 4.1

Mickalene Thomas, *Le déjeuner sur l'herbe: Les trois femmes noires*, 2010. Rhinestones, acrylic, and enamel on wood panel, 304.8 × 731.5 cm.

4 Reflection

INTRODUCTION

The second phase of research—Reflection—is a phase of thoughtful contemplation that is separate and distinct from the Observation stage. In this phase, the researcher considers the evidence gathered so far and then seeks out additional research materials in order to be able to appreciate the context within which the work was created, and to consider the choices made by the artist in the fashioning of the body. This additional evidence may include a wide range of materials, including (but not limited to) other works by the same artist or his/her colleagues; examples of comparable surviving garments or accessories from museum collections; fashion illustrations or photographs; as well as textual accounts like records, diaries, letters, periodicals, reviews by art critics, and exhibition catalogues. This process of gathering evidence is necessary in order to identify and later interpret what the artist is trying to communicate in the work. In this chapter, the researcher is guided accordingly with questions that help direct and systematically organize their efforts.

In each section of the Reflection Checklist (Appendix II), the researcher is asked to analyze the evidence from the work or material related thereto to help illuminate the choices made by the artist. This is distinctly different from the documentation work in the Observation phase, because analysis involves critical thought. The end goal of this second and distinct phase of research is the deeper understanding of the choices made by the artist as well as the gathering of contextual evidence that will facilitate interpretation in the next phase. The researcher is also encouraged to thoughtfully document their reactions to the work using the checklists, as this can be very helpful in the last phase of interpreting the work. Reactions to artworks are often deeply personal and worthy of introspection; a strong emotive response to a work can be a clue to dig deeper to understand how and why that feeling arose.

The Reflection Checklist is comprised of twenty-five questions and is divided into five parts:

A. Formal Qualities of the Artwork: analysis of the composition and material qualities of the work
B. Elements of Dress: identification and analysis of specific elements of the fashioning of the body
C. Personal Reactions: exploration of the effects/feelings produced by the work
D. Artist: identification and analysis of other works by the artist to situate this work within their oeuvre
E. Contextual Information: identification and consideration of supporting evidence that helps identify the choices made by the artist in rendering elements of dress in this work

In the material that follows, each question on the checklist is explained and a sample response is provided in italics for the painting **Le déjeuner sur l'herbe: Les trois femmes noires** by Mickalene Thomas (Figure 4.1). At the end of the chapter, a sample reflection summarizes the material gathered during this stage and also identifies the additional research necessary to move forward.

REFLECTION CHECKLIST (25 QUESTIONS)

A. Formal Qualities of the Artwork

In this part, the questions ask the researcher to identify and consider the material qualities of work as well as contemplate the significance of the formal qualities of the work. In art history, this is described as formal analysis.

1. **What does the artist emphasize visually? What does this signify?**

 In Le déjeuner sur l'herbe: Les trois femmes noir *(Figure 4.1), Mickalene Thomas has reinterpreted the 1863 painting by Édouard Manet (Figure 4.2). Like Manet, Thomas gives emphasis to the three central figures. However, Thomas inserted three women of colour, and also added a colorful and richly textured landscape.*

Identifying what the artist has chosen to emphasize in the work is the first clue to unpacking its significance.

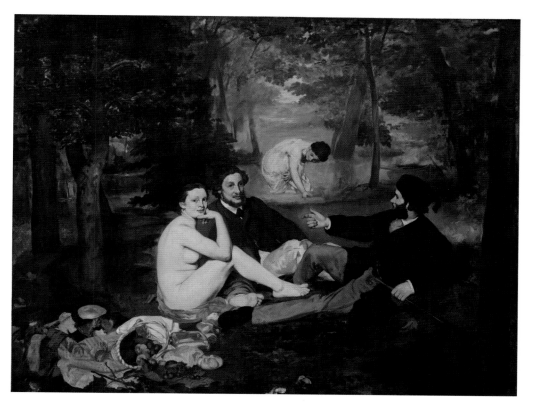

Figure 4.2

Édouard Manet. *Le déjeuner sur l'herbe*,
1863. Oil on canvas (208 × 264.5 cm).

2. **How does the artist emphasize this aspect? Through scale, line, color, etc.?**

 Mickalene Thomas uses scale to create a sensation of monumentality in this work. The forms of the three women are outlined with a narrow band of brilliant turquoise blue which contrasts with their dark skin. This forms a unified shape that connects the figures, framing them within the complex, fragmented background of irregular shapes. The juxtaposition of colors, patterns, and textures creates optical vibrancies. The use of rhinestones and glitter in certain places, including the women's hair, their clothing, and the related drapery and textiles used in the background, gives visual emphasis to these shapes.

An artist composes a work, leaving some things out of the picture plane, while giving emphasis to others. The eye can be directed around the work through formal compositional elements that delineate space and give emphasis to certain parts of the figure.

3. **Is there an underlying rhythm, pattern, or geometric structure to the composition?**

 There is a rhythm of rounded shapes created by the three female heads in the central portion of the work. The irregular shapes that form the background create a vibrant energy in the work.

An artistic choice to develop a sense of rhythm and pattern in a work may create dynamic movement as well as underline a mood or affect.

4. **Is there a sense of balance or has the artist deliberately chosen to destabilize the composition?**

 The composition is balanced but in a complex manner. Certain colors and shapes are mirrored on both sides of the work. For example, there are two lines of brilliant turquoise blue on the right side of the painting that are echoed in a slightly different format on the left side. Slivers of orange on the left are repeated on the right. However, the shapes are not repeated in quite the same way, such that the eye is constantly moving.

Many figurative works are stable compositions; however, when figures are situated on one side of the work or cropped in some way, this is a clue as to an artistic narrative that incorporates the landscape or the setting.

5. **Does the composition seem unified? Do the elements appear integrated or separate from each other?**

 There is a sense of energy and vibrancy in this work. The fragmentary nature of this collage-like work also adds an element of tension.

Here again the researcher is seeking out elements that do not fit or destabilize the composition as clues to the artist's intent.

6. **What do you think the artist is trying to express in this artwork? How is this achieved visually?**

With this monumental work, Mickalene Thomas has claimed her place in art history by recasting Manet's infamous work through a contemporary lens. I feel that the artist is articulating her vision of modern beauty; each of the three confident black women is beautiful in her own way.

In an artist statement Thomas wrote: "Just like my first muse, my mother, all of my muses [mostly friends and family members] possess a profound sense of inner confidence and individuality. Most importantly, they are real, and one of the things I look for in a subject is a unique and sometimes unexpected interpretation of what it means to be a woman. By portraying real women with their own unique history, beauty and background, I'm working to diversify the representations of black women in art."[1]

This reflective question documents the researcher's initial response to the work and connects it to the composition itself. Artist interviews and statements may also be helpful in forming your response.

7. **Does the choice of medium impact the work in a material way?**

This painting is rendered in acrylic, rhinestones, and enamel on wood panel. This choice of materials adds rich textures, visual interest and effervescence.

Each medium—whether painting, photography, sculpture, or installation—has unique properties as well as limitations in terms of facilitating realistic representations. For example, the use of oil paint makes it easier to portray the luster of silk.

B. Elements of Dress

Depending on the researcher's familiarity with dress history, completion of this section may entail some additional research, using scholarly dress history texts as required to aid in the identification of specific elements of dress. See for example, the books by Janet Arnold and other dress history texts listed in the bibliography. For the contemporary dress references, online sources, including the Bloomsbury Fashion archive, and the Vogue archive, might also be helpful.

8. **How has the artist used dress to define the profession, class, status, racial, or gender identity of the sitter?**

Each of the three women is dressed in a sleeveless summer dress. Two of the women wear short, mid-thigh length dresses and the woman in the background is wearing an ankle-length dress. There is a suggestion of informality with the choice of summer dresses, suggesting that the women are relaxed and comfortable in their skin.

This step requires careful identification of each element of dress worn by the sitter. A *slow approach to seeing* can be particularly helpful in taking time to absorb the nuances of the sitter's dress. See for example, chapter 2 and the annotation of the study drawing shown in Figure 2.3.

9. **Is the dress of each sitter consistent with his or her gender, age, class, and occupation?**
Yes. Their dresses are youthful and glamorous.

Dress reflects identity. If something seems out of the ordinary, this may be a significant clue that the artist is exploring some aspect of identity.

10. **Are the garments stylistically consistent with the period in which the artwork was created?**
In terms of contemporary attire, these summer dresses are chic and fashionable, but also reminiscent of the vibe of the late 1960s and early 1970s with their bold graphic prints. This reference may be deliberate, since Thomas' mother was a model in the 1970s. However, contemporary fashion often borrows from the past and later analysis will show that these prints were also popular in the summer of 2010.

This question alerts the researcher to pay attention to whether or not the artist has taken liberties with the clothing worn by the sitter, as was discussed in chapter 1.

11. **Do the garments depicted have stylistic, religious, artistic, or iconic references?**
Not specifically. However, the bold graphics and vibrant colors of the cloth suggest a link to African textiles.

Elements of a garment, such as use of gold or silver cloth, can be embedded with symbolic meanings, especially if the artwork was created during a period in which sumptuary laws were in effect. Similarly, in religious works, certain colors or symbols may be meaningful, such as the blue robe typically worn by the Virgin Mary. The artist may include such iconographic references to visually link the work to cultural symbols.

12. **How does the clothing shape and fashion the body? Does it disguise, conceal, or reveal the body?**
In each case, the dress of the women is body revealing. There is no alteration of the body with shapewear.

Each period in history defines a certain way in which the body is shaped by clothing and this may reveal or conceal the wearer. The artist may use his or her knowledge of what is fashionable at that moment to give emphasis to certain parts of the body or articulate ideals of masculinity or femininity.

13. **Has the artist taken liberties with the visual representation of the sitter(s)? Is the body elongated or distorted in any way? If so, consider whether this distortion reflects norms of beauty for the period.**
There does not appear to be any distortion of the figures. Their bodies are celebrated as they are rather than conforming to a slender ideal.

The artist can render the sitter taller or more attractive than they are in real life. Sometimes this is evident to the viewer of the work, say for example if one part of the body, like the neck, is elongated. Looking at additional works or other products

from visual culture of the time period may be helpful in identifying when an artist has taken artistic liberties or whether this distortion of the body is reflective of fashionable norms for the time period.

C. Personal Reactions

Art evokes deeply personal responses; two people can look at the same work and have different reactions. Exploring the nature of your personal reactions to the work and the reasons behind it can be fruitful in identifying aspects of the work that reveal marked shifts in cultural beliefs or other connections.

14. What was the impetus to examine this artwork? Were you interested in the artist, elements of the dress, or the person(s) in the image?

I first saw this work in the exhibition "Mickalene Thomas: Femmes Noires" at the Art Gallery of Ontario (November 29, 2018–March 24, 2019). I found this work particularly compelling because of its link to art history, its monumental scale, and the artist's vision of modern beauty.

This question asks the viewer to consider their motivations for the research, which can be helpful in selecting a lens of interpretation in the next phase.

15. Do you have an emotive reaction to the image? Does it appeal to you or repulse you? Does it remind you of something else?

Yes. I felt joyous when I stood in front of this work—feeling the power of the artist's vision by upending traditional representations of beauty and celebrating diversity.

A strong response to an artwork—whether that reaction is positive or negative—is worth exploring further.

16. Do your personal reactions indicate that cultural beliefs have shifted?

Yes. As art historian Denise Murrell observed in her book Posing Modernity: The Black Model from Manet and Matisse to Today, *cultural institutions have "largely been constructed in a manner that sustains myths of white cultural superiority."[2] As a consequence, the depiction of black people in art has been largely overlooked, deemed "unimportant, unworthy of attention."[3] However, in this case, Mickalene Thomas has asserted her place as a black, lesbian artist.*

Your reaction to the work may suggest that additional research is necessary.

17. Can you identify a personal connection to this work or a bias that should be acknowledged in your research?

Not only do I have a strong desire to support women artists, but I also have several black friends and colleagues. This sensitivity to gender, race, and representations was the impetus that led me to include this work in this book.

Acknowledging the source of one's connection to a work can enrich the research process. If the researcher has familial connections to the artist or the sitter, there may be opportunities to explore unpublished material and deepen the research.

D. Artist

The biographical information about the artist's beliefs, working practices, and legacy are highly relevant to the analysis of a specific work. The following questions are intended to focus the researcher's attention on how a specific work fits into the artist's oeuvre. The researcher might consider doing additional research about an artist if it is relevant to their overall research goals.

18. **Is this a single work or part of a series? If it is a series, how many are in the series?**

 There is a photographic version of this work. Thomas staged the photo in the sculpture garden of the Museum of Modern Art in 2010. The title given to the photograph and the painting by Mickalene Thomas directly reference Manet's infamous painting Le déjeuner sur l'herbe *from 1863 (Figure 4.2).*

A singular work stands alone, whereas a work that has been copied may show slight variations between copies. Knowing this allows the researcher to consider whether these differences are material or not.

19. **Has the artist created other works that are not part of a series but are otherwise similar to this work? If so, list them here and consider what might be learned from this comparison.**

 Studying the photographic version of this work reveals aspects of the artist's working process.[4] Thomas created a staged environment akin to a glamourous fashion photo spread that directly references the picnic scene in Manet's painting from 1863. Although the poses of the black female models echo the figures in Manet's painting, these women are not demure but confidently sit like queens. The lighting in the photograph captures the soft sheen of the skin of the models from the heat of that warm summer evening. The artist then manipulated the image to create a version with less depth and a heightened sense of fragmentation. The work was then scaled up, rendered in acrylic paints and embellished with rhinestones, giving emphasis to the models' hairstyles and the rich textures of their clothing and drapery.

 Other works by the artist from 2010, such as I Learned the Hard Way *and* Love's Been Good to Me, *depict only a single woman in each work.[5] These smaller-scale paintings also use photographic manipulation of the source image to create a collage-like effect but do not specifically reference iconic works by other artists.*

 In the works by Thomas from 2010, the black female models project a strong sense of self and their identity. They are confident and compelling in their posture, gaze, and poses. The colorful and richly textured backgrounds, reminiscent of living rooms, are rendered as collage-like fragments that convey what has been described by others as a "Black aesthetic" that is both "glamourous and impoverished, structured and improvisational, naive and sophisticated, brash and abject."[6]

Studying other works by the artist facilitates comparison, leading to a more nuanced understanding of the artist's working process and motivations.

20. **Are there any exhibition catalogues or biographies of the artist? Using these sources, as well as artist statements, diaries, or published reviews from the time period (if available), consider whether or not this work is consistent with the artist's oeuvre. Is there something notable or exceptional about this work?**

There are several exhibition catalogues on Thomas, including Mickalene Thomas: Femmes Noires, *edited by Andrea Andersson and Julie Crooks (Fredericton: Art Gallery of Ontario with Goose Lane Publications, 2018) and* Mickalene Thomas: I Can't See You Without Me, *edited by Michael Goodson et al. (Columbus: Wexler Centre for the Arts with Artbook, 2018).*

These two exhibition catalogues offer additional background to the development, motives, and stylistic tendencies of the artist. In terms of her training, Goodson describes Thomas' transformative experience in the Yale MFA program in which she began to "investigate portraiture's relationship to power" that led her to challenge the prevailing representations of black women, replacing them with depictions that were "undeniable, bold, and beautiful."[7] Thomas herself reveals that her familial experiences shaped her work:

> *When I started making the paintings and the installations, I started thinking about how my grandmother used different materials to reupholster her furniture . . . or patch it up. I was taking elements that I remembered as very powerful, like the Afro, the faux paneling, the patterns that I was surrounded by, and putting that into my work.[8]*

In contextualizing the artist's practice, Julie Crooks situates Thomas' collage-like work within the context of other artists who experimented with collage, including Pablo Picasso (1881–1973) as well as the lesser known Black artist Romare Bearden (1911–1988), who "depicted a wide range of Black experiences in the diaspora,"[9] and also identifies pop culture references that have influenced her artistic outputs. Beverly Guy-Sheftall links Thomas' work to other female artists including "the creative and political work of queer black women such as Audre Lorde, Cheryl Clarke, and Barbara Smith, who resisted heteronormative scripts in their quest for a more complex rendering of womanhood."[10] Thus, it becomes apparent that the stylistic tendencies of Mickalene Thomas draw from art history and pop culture but are strongly connected to her identity as a female artist of color.

The monumental scale of this work of more than seven meters wide sets it apart from the other works by Thomas, marking it as particularly significant within her oeuvre. Antwaun Sargent notes that in this work:

> *These three, unlike other women in the history of art, are given pride of place and real respect. . . . Despite the distorting forces of art and history, these women are shown as desirable; beings who know*

what they want, introducing a new negotiable tension between how art and history have represented them and how they might present themselves.[11]

Mickalene Thomas recasts Manet's infamous work in a contemporary way, linking it to her identity as a black female artist, such that the viewer must consider their views on women, race, representation, and identity.

An artist's work, style, and practice may evolve over time. Situating a particular work within a career adds meaningful context to the analyses thereof.

21. **Is it known whether or not the artist worked with artist's mannequins, live models, and/or owned or hired costumes?**
 Yes, the artist works with models, many of whom include her family and friends. She often uses her partner Raquel in her works. In this work, the models are identified by first name: Moniladae, Din and Qusuquzah.[12]

This question alerts the researcher to consider the effect of the artist's studio practices on the work, as was discussed in chapter 1.

E. Contextual Information

An analysis of contextual information often is focused on understanding historical events that may have shaped the artist's beliefs, practice, or stylistic tendencies. While this is highly relevant (and covered to a degree in the previous section), this part of the questionnaire focuses on the contextual information related to the fashioning of the body in a figurative work. The clothing and stylization of the body in a figurative work is critical to understanding the cultural beliefs represented therein. This part helps the researcher gather evidence to know whether or not the artist has represented fashions of the time period or imaginatively reinterpreted the figure in costume or classical dress (as was discussed in chapter 1).

22. **Identify possible search terms for the dress in the artwork. Are there any unique terms related to the dress that may help refine the search parameters? Consider using a dictionary of dress or costume history texts to help identify precise search terms.**
 Dress

 Halter dress

 1960s dress

 1970s dress

 Graphic prints

It can be difficult to identify search terms for elements of historic dress, because terms change over time and also differ between countries. For example, a long loose garment worn to cover the top half of the body might be catalogued in a collection as a coat, a cloak, a dolman, or a mantle. Using multiple search terms will aid in the search for similar extant garments.

23. Can you locate images depicting the similar garments and the related fashioning of the body in other visual media such as fashion plates, newspapers, journals, film, or television? If so, list them here and consider the similarities and differences and what this might mean.

Although contemporary fashion no longer ascribes to a singular look, in browsing the June 1, 2010 issue of Vogue *(New York), it becomes evident that the fashions for graphic prints in the summer of 2010 were popular.*

An advertisement for DKNY on page 63 shows two women, one a light-skinned black and the other white, dressed in colorful graphic prints.

The "Talking Fashion" column on page 84 discusses the fashion inspiration of the summer coming from 1960s psychedelic tie-dye prints and includes three photographs of women wearing bold vibrant prints that are riffs on tie-dye.

An advertisement for Carlos Miele on page 93 includes a photo of a model wearing a one-shouldered thigh-high minidress embellished from breast to thigh with silver sequins.

The column "Style Ethics" on page 98 features Ethiopian-born model and designer Liya Kebede wearing a summer dress of her own design. The textile for this dress features orange and white horizontal stripes woven and embroidered by traditional craftspeople from Addis Ababa.

A feature profile on Net-a-Porter founder Natalie Massenet by Sarah Mower titled "High Clicks" includes a photograph of Massenet with her staff on page 162. All the women are dressed in colorful, vibrant, body-revealing printed summer dresses.

This analysis indicates that in the summer of 2010 the fashion of vivid and colorful printed summer dresses was widely adopted.

The June 1, 2010 issue of Vogue *(New York) included models of color on the following pages:*

An advertisement for Cover Girl on page 29 shows Dana Ramirez sitting with children of color. The tagline "Help Clean make the world more beautiful" references the introduction of makeup in varied skin tones to women of color.

An article on "It Girl Joan Smalls" on pages 81–82 describes the recent runway debut of model Joan Smalls. Born to a father from St. Thomas and mother from Puerto Rico, her skin tone is light caramel in color.

An advertisement for Garnier Nutrisse hair products on page 107 features a black woman with natural curly hair.

In each case the models are light-skinned blacks. Since the issue is mostly dominated by tall, slender, white women, the inclusion of women of color in this issue is insufficient to be considered more than a token gesture towards diversity and inclusion. For this reason, this work by Mickalene Thomas can be seen as a radical gesture towards celebrating black female identity.

This step is crucial to understanding the choices that the artist has made in depicting the fashioned body. If the fashioned body in the artwork differs significantly from the products of visual culture in the period—such as fashion plates or photographs—then this choice is intended to communicate something worthy of further analysis by the researcher.

24. **Identify any related or similar garments from dress history texts, Janet Arnold's pattern books or other online dress collections such as The Met, the V&A Museum, the Los Angeles County Museum of Art, the Rijksmuseum, or a university study collection. Consider how you might use such material to enrich your understanding or analysis, especially of any parts of the dress that are distinctive or unusual in some way that may indicate whether or not the garment was fashionable at the time the image was created.**

 The dresses worn by the models have a 1970s vibe; these summer dresses reveal the shoulders, skim the body, and suggest a sense of ease. Contemporary fashion often draws on inspiration from the past making it somewhat challenging to date precisely, but similar dresses with bold graphic prints from the 1970s can be found in museum and study collections. The chic dress worn by the central figure in the painting is a sleeveless floor-length halter dress with a bold black and white print. A similar summer dress from the 1970s (Accession #1987.02.008) was identified in the Ryerson Fashion Research Collection (Figure 4.3). Another dress dated to the early 1970s by the designer Donald Brooks (Accession #2014.07.058) in the Ryerson Fashion Research Collection (Figure 4.4) illustrates the colorful prints and sequin embellishment that were popular during this time. The skin tones of the mannequins in Figure 4.3 and Figure 4.4 have been digitally manipulated.[13]

In seeking out extant examples of garments that are similar to those depicted in a work, the researcher is better able to discern whether or not the artist has rendered the sitter in fashionable attire or otherwise taken artistic liberties in order to communicate something else through dress.

25. **Does this work reflect a specific event from history or mark a notable shift in attitudes about gender, beauty, or identity?**

 Yes. As discussed earlier, the work of Mickalene Thomas is grounded in her identity as a black female artist. The women in this image are given agency; their skin tones are not uniformly "black" but convey a range of colors from deep brown to caramel. In each case, their hairstyle, makeup, and dress are unique, reflecting their individual identities as black women. Their bodies are soft but powerful and each is dressed in glamorous and colorful attire. This is a modern vision of beauty, one that celebrates diversity rather than a singular vision of beauty.

Figure 4.3

Unknown maker, summer
dress in graphic black
and white print, 1970s.

Figure 4.4

Donald Brooks, dress
with sequins, 1970s.

This is a deceptively simple question that requires the researcher to reflect on all the evidence gathered so far to consider what the artist has captured in terms of cultural beliefs and attitudes embodied in the sitter's dress at a particular moment in time. Completing the checklist does not mean that the research process is finished; instead it marks a time to pause and reconsider what needs to happen next, as is illustrated in the sample reflection.

SAMPLE REFLECTION (ABOUT 500 WORDS)

Mickalene Thomas draws on her identity as a queer black female artist to assert her place amongst the leading figures in art history. In her monumental 2010 painting *Le dejeuner sur l'herbe: Les trois femmes noires*, Thomas casts three black women in a tableau vivant that directly references Manet's infamous 1863 work. Although Moniladae, Din and Qusuquzah are posed in the same manner as the figures in Manet's painting, they are not demure but radiate confidence with their posture and gaze. This work also departs from its referent with the use of bold, vibrant colors, collage-like effects, and embellishment with rhinestones and glitter.

The artist initially photographed her models in a manner reminiscent of a glamorous fashion shoot in the sculpture gardens of MOMA New York on a warm summer night in 2010.[14] Thomas then used her photograph to make the painting, manipulating the image to create a collage-like effect in which the picture plane is fragmented by cracks, lines, or colored shapes that disrupt the path of the eye. In using collage-like effects in her work, Thomas's work can be contextualized alongside collage experimentations of Pablo Picasso (1881–1973) as well as the lesser-known black artist Romare Bearden (1911–1988). However, in the case of Thomas, the fissures and cracks in the work creates a tension that, for me, seems to allude to the charged politics associated with race, especially for blacks in America today.

Thomas focuses on the representation of black women in her artistic practice, inviting her friends and acquaintances to be models. In the painting *Le dejeuner sur l'herbe: Les trois femmes noires*, three black women are depicted as unique individuals. Their skin tones depict variations in what is described as "black" skin and include caramel, mid-brown, and deep-brown tones. Their curly hair has not been straightened to a "white" ideal and their makeup and jewelry choices are bold. Their chic sundresses draw on the inspiration of the 1970s with bold graphic prints, but each is slightly different in cut and style, underlining that each woman is an individual. Their bodies are revealed, but they are not naked. Elements of their dress (as well as parts of the textiles used in the background) have been embellished with rhinestones, including their hair, makeup, jewelry, and dresses. This sparkle, especially when seen in person, draws the eye to these elements and is suggestive of a "Black aesthetic" that Kerry James Marshall has described as "glamourous and impoverished, structured and improvisational, naïve and sophisticated, brash and abject."[15]

In this painting by Mickalene Thomas, fashion has been used to celebrate a modern vision of beauty that is not limited to a single look of the white, thin, blonde, and demure female. This monumental work challenges norms of beauty and celebrates diversity in presenting a modern iteration of Édouard Manet's infamous 1863 painting. The iconic scale of this painting created by Mickalene Thomas invites the viewer to (re)consider their views on women, race, identity, and beauty. The interpretation could be developed further with reference to theories on black identity as discussed by Jamaica-born cultural theorist Stuart Hall and American feminist, social activist, and scholar bell hooks.[16]

ENDNOTES

1. Mickalene Thomas quoted in Elizabeth Anne Bilyeu (ed.), *Witness: Themes of Social Justice in Contemporary Printmaking and Photography* (Salem: The Jordan D. Schnitzer Family Foundation in association with the Hallie Ford Museum of Art, 2018), 75.

2. Denise Murrell, *Posing Modernity: The Black Model from Manet and Matisse to Today* (New Haven: Yale University Press, 2018), 3.

3. Ibid.

4. The photograph is included in the AGO exhibition catalogue. See Andrea Andersson and Julie Crooks (eds.), *Mickalene Thomas: Femmes Noires* (Fredericton: Goose Lane Editions, 2018), 20. Accessed June 1, 2019, at https://artsandculture.google.com/asset/le-d%C3%A9jeuner-sur-l-herbe-les-trois-femmes-noires/rQEufReZTVODGQ?hl=en-GB&avm=3.

5. These works are included in the AGO exhibition catalogue noted above on pages 75 and 83.

6. Julie Crooks, "Mickalene Thomas: Femmes Noires," in *Mickalene Thomas: Femmes Noires*, edited by Andrea Andersson and Julie Crooks (Fredericton: Goose Lane Editions, 2018), 18.

7. Michael Goodson, "Introduction: Pleasure and Reckoning," in *Mickalene Thomas: I Can't See You Without Me* (Columbus: Wexler Centre for the Arts with Artbooks, 2018), 10.

8. Mickalene Thomas quoted in *Mickalene Thomas: Femmes Noires*, edited by Andrea Andersson and Julie Crooks (Fredericton: Goose Lane Editions, 2018), 16.

9. Julie Crooks, "Mickalene Thomas: Femmes Noires," in Mickalene Thomas, edited by Andrea Andersson and Julie Crooks (Fredericton: Goose Lane Editions, 2018), 17.

10. Beverly Guy-Sheftall, "Rebel Woman," in *Mickalene Thomas: I Can't See You Without Me* (Columbus: Wexler Centre for the Arts with Artbooks, 2018), 82.

11. Antwaun Sargent, "Sisterhood Is a Behaviour: Mickalene Thomas's Restaging of Womanhood," in *Mickalene Thomas: Femmes Noires*, edited by Andrea Andersson and Julie Crooks (Fredericton: Goose Lane Editions, 2018), 65.

12. Ibid.

13. These images were digitally manipulated to match the skin tones of the models in the painting by Mickalene Thomas. Unless custom ordered, mannequins are generally only available in white or black, and do not reflect a range of skin tones. This manipulation by the photographer was done at the author's request to highlight the lack of diversity in mannequins and question the hegemonic norms of fashion display in the museum.

14. The photographic image can be found online on the MOMA PS1 website. Accessed July 9, 2019 at https://www.moma.org/calendar/exhibitions/3790?locale=en

15. Kerry James Marshall quoted in Julie Crooks, *Mickalene Thomas*, 18.

16. See for example: bell hooks, *Black Looks: Race and Representation* (New York: South End Press, 1992). See also: *Representation*, edited by Stuart Hall, Jessica Evans, and Sean Nixon (London: Sage Publications, 2013).

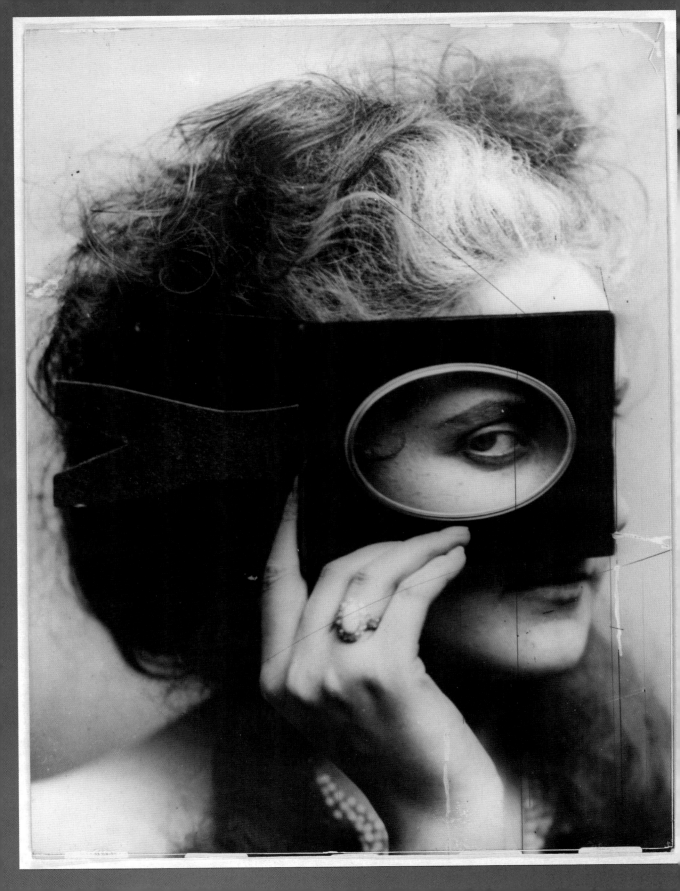

5

Interpretation

INTRODUCTION

Interpretation is the act of explaining or showing your understanding of something. In a university setting, this often takes the form of an essay, blog post, oral presentation, or podcast. In this third phase of research, the researcher draws from the observations and evidence gathered in the first two phases, fills in any gaps in their research, and brings this material together into a coherent narrative that articulates a specific point of view. There are many possible ways to interpret an artwork, and this phase is the most creative and imaginative aspect of research.

The interpretative phase is driven by critical thought and analysis. This requires consideration of the evidence gathered during the observation and reflection stages of research, supplementation of additional material if needed, and then a focused application of a theoretical lens of analysis to articulate an argument. Theory—the system of ideas or framework used to explain something—can seem highly abstract, not to mention difficult to understand, interpret, and then incorporate into an analysis. It can be helpful to think of theory as the lens that gives focus to an argument, allowing the researcher to develop a well-reasoned argument that illuminates aspects of the artwork in relation to fashion. Here I cheekily equate the use of theory to the researcher looking through a frame or viewfinder as a way of narrowing one's focus and illustrate this idea with a photograph of the celebrated French beauty Virginia Oldoini, Countess de Castiglione (1837–1899) looking through a viewfinder (Figure 5.1).[1]

The study of fashion in art is inherently interdisciplinary and for that reason, this final phase of the research process, and the related checklist, is not prescriptive. If unfamiliar with theory as it intersects with fashion, the reader is advised to consult a foundational text such as *Thinking Through Fashion: A Guide to Key Theorists*, edited by Agnès Rocamora and Anneke Smelik. This book provides a general guide to key scholars, including Roland Barthes on the semiotics of fashion; Walter Benjamin on fashion and modernity; Sigmund Freud on fashion and psychology; Karl Marx on fashion and capitalism; Georg Simmel on conspicuous consumption; and many other leading thinkers. However, it is also acknowledged here that a researcher may identify other scholars, not normally associated with fashion but rather with art history or art criticism, as a way to support their analysis. For example, in analyzing a photograph like the image of Virginia Oldoini, the Countess de Castiglione, posing for the camera while wearing a mask in Figure 5.2, a researcher may wish to scaffold their interpretation using the writings of Roland Barthes' 1981 book *Camera Lucida*, John Berger's 1967 book *Understanding a Photograph*, or Susan Sontag's 1977 book *On Photography*. Scholars from other fields such as memory studies might be useful in interpreting the work of a contemporary artist like Sarah Casey who sees clothing as a metaphor of the ephemerality of human presence and creates drawings that depict the haunting absent presence that clings to historic garments (Figure 5.3). Casey's work suggests that clothing not only has interesting stories to tell about

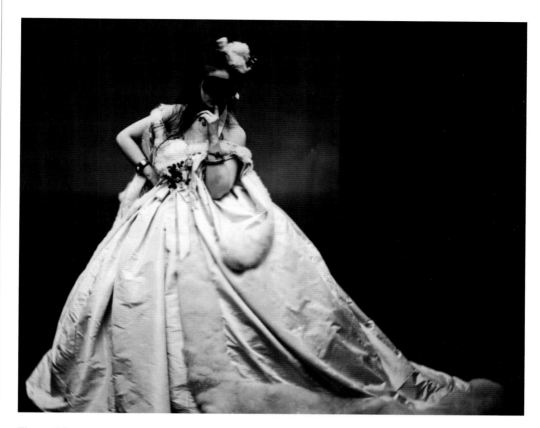

Figure 5.2

Pierre-Louis Pierson and Virginia Oldoini, *One Sunday*, ca. 1861–1867.

how it has been made, worn, and stored, but also invokes memory and echoes the evanescence of life.[2]

The selection of a theoretical framework of analysis is generally driven by the artwork in relation to the researcher's interests, background, and focus. The five brief questions presented in the Interpretation Checklist (Appendix III) are not prescriptive. The reader should consider each question as an invitation and provocation for further thought and reflection on the next steps required to develop their analysis. The interpretation phase is iterative, typically requiring additional research and reflection as well as multiple drafts in order to develop a coherent argument that illuminates the meaning of fashion in a work of art. This process cannot be fully articulated by a checklist and I advise researchers to embrace research as a way to learn and engage with new material as well as express their creativity and point of view.

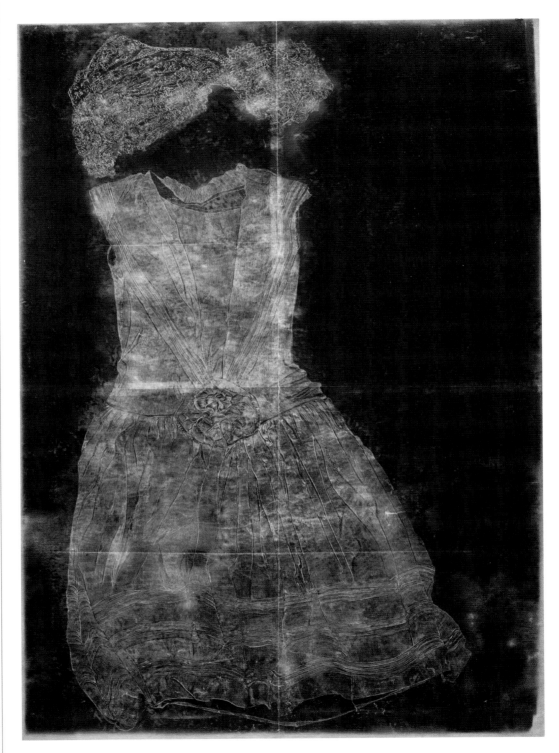

Figure 5.3

Sarah Casey, *Absent Presence (Wedding Dress front)*, 2018–2019. Drawing, wax on paper (100 × 140 cm).

INTERPRETATION CHECKLIST

1. **Review the material that you have recorded in your observation and reflection on the artwork. What stands out for you?**

Identifying what caught your attention and is interesting to you as a researcher helps you find a point of entry. The best essays come from a place of genuine curiosity.

2. **Does this work provoke an emotive reaction, connect to your background or interests, or otherwise inspire a research question or questions?**

Reactions, whether positive or negative, are clues as to your underlying belief systems. Ask yourself what that reaction might mean in terms of your personal beliefs in relation to the work. Do your beliefs reflect conformity or opposition to societal norms? How does this relate to the artwork you are analyzing?

3. **What does the work have to say about the artist and the visual traditions of the period in which it was made?**

No artwork is created in isolation. Learning about the artist and his or her working practices and relationships to other artists and traditions of the period can offer fascinating insights into the work under consideration. Interpreting a work without reading related material can lead to erroneous conclusions.

4. **What does the depiction of fashion in the artwork say about the culture of the period?**

Every dress tells a story and while dress cannot be read like a text, it offers clues as to the dominant cultural paradigms of a specific time and place. The way a body is dressed in a work of art is meant to communicate something about the sitter at that time. Have views on beauty, race, gender, politics, or morality changed since the work was created?

5. Consider the artwork and the fashions depicted therein in relation to a conceptual framework or lens of interpretation that is linked to your research focus. Identify that framework here and briefly consider one or more key texts related to that theory. The suggested frames of reference include, but are not limited to:

 Status

 Modernity

 Ideals of beauty

 Identity, including gender, sexuality, or ethnicity

 Politics of representation

 Globalization

This question is directed towards finding a theoretical framework for your analysis. Additional texts related to theory will need to be consulted here in order to properly answer this question, as was mentioned earlier. And of course, other lenses of interpretation are possible, since this list has deliberately been left incomplete.

A written response to each of the five questions in the Interpretation Checklist (Appendix III) is suggested but not essential. The researcher might use these questions in conjunction with a colored pen or highlighter to markup interesting passages in their written observations and notes, or possibly document their responses in a voice memo, or perhaps even draw as a way of engaging the brain in reflective thought. This final stage should be seen as iterative and thus the researcher should anticipate that the process of developing the argument requires multiple drafts and time. The desired end product is a fluid and integrated analysis of the fashioned body in an artwork that expresses a clear argument that is supported by evidence from within and outside of the artwork.

THE CASE STUDIES

The following five case studies offer sample interpretations that serve to illustrate the application of the checklists to selected paintings and photographs.

Chapter 6 presents the case study of Thomas Gainsborough's *The Portrait of Mr. and Mrs. Andrews*, dated ca. 1750 from the National Gallery, London to consider the relationship between **fashion and status**. I argue that this oil painting is not only a portrait of Robert Andrews and his wife Frances Mary Carter but also a portrait of their property in reflecting the romanticized notions of the English landscape.

Chapter 7 presents the case study of Eugène Boudin's small-scale oil painting *La plage de Trouville à l'heure du bain* or *On the Beach Near Trouville*, dated to 1864 from the collection of the Art Gallery of Ontario, Toronto to consider the relationship between **fashion and modernity**. In this work, I argue that in Boudin's beach scene paintings, modernity is reflected in the setting, in the style of painting, and in the elegant fashions of the crowd.

Chapter 8 presents the case study of *La Mondaine* or *The Woman of Fashion* by James Jacques Tissot from his series of works entitled *La Femme à Paris* and dated 1883–1885 to consider the relationship between **fashion and beauty**. In this essay, I will analyze how Tissot has used the dress of *la mondaine* to communicate the ideals of Parisienne beauty in the latter part of the nineteenth century.

Chapter 9 presents the case study of the photograph of Marcel Duchamp dressed as his alter ego Rrose Sélavy made in collaboration with Man Ray in 1920 to consider the relationship between **fashion and gender identity**. In analyzing this image, I link this work to queer theory and contextualize Duchamp's gender play within the framework of the fashionable modern woman known as *la garçonne*.

Chapter 10 presents the case study of the 2008 large-scale commissioned oil painting *The Academy* by Cree artist Kent Monkman to explore the relationship between **fashion and politics**, particularly as it relates to issues of racial and gender identity as well as colonization.

The case studies presented in this book are offered as examples of how the researcher might use the checklists in developing material through three distinct phases of research to present a polished and fluid narrative that articulates a distinct point of view. In writing the case studies for this book, I aimed to write a sample essay of about 2,500–3,500 words appropriate for undergraduate studies, and recognize that each one of these essays might be developed further. Each sample essay articulates a focused argument about the meaning of fashion in a specific work of art.

Tips on Developing Your Essay

1. Complete the observation and reflection checklists as carefully as possible. Although it might be tempting to skip these steps, the checklists are designed to help you document and process your research.

2. Focus on what interests you in relation to a specific work if that is permitted within the scope of your assignment. Although many others may have already written about an artist and his or her work, each of us has a unique background and perspective that can bring fresh insight into a work.

3. Make friends with theory and use it as a tool to focus your analysis.

4. Prepare an outline. Having a rough guide aids in developing your argument.

5. Keep track of your sources as you write. Leaving the citations until the end can result in errors and much wasted effort.

6. Allow sufficient time for reflection, rewriting, and editing. Creating a fully polished essay takes multiple drafts.

ENDNOTES

1. The fascinating photographs of Virginia Oldoini, the Countess de Castiglione (1837–1899), made in collaboration with Paris photographer Pierre-Louis Pierson (1822–1913) defy the norms of portraiture and conventions of femininity and propriety. Considered one of the most beautiful women in Paris at one time, the Countess offered a direct and confident gaze to the camera, made remarkable choices of clothing and often used unusual props like frames and mirrors. She also sought to orient the camera to selected parts of her body, such as her feet. Although the Countess distributed these images only amongst her intimate circle of friends and lovers, her experiments with photography might be seen as a "pre-history" for the work of Cindy Sherman and other pioneering female photographers from the twentieth century.

2. Sarah Casey and I have worked on a number of projects related to clothing and drawing. See the exhibition catalogues for *Ruskin's Good Looking*, Brantwood (February 8–April 7, 2019) and *Absent Presence: A Wedding Dress and the Drawings of Sarah Casey*, MLC Gallery (May 9–July 5, 2019). Also see her website, accessed March 22, 2019, https://www.sarahcasey.co.uk/exquisite-corpses

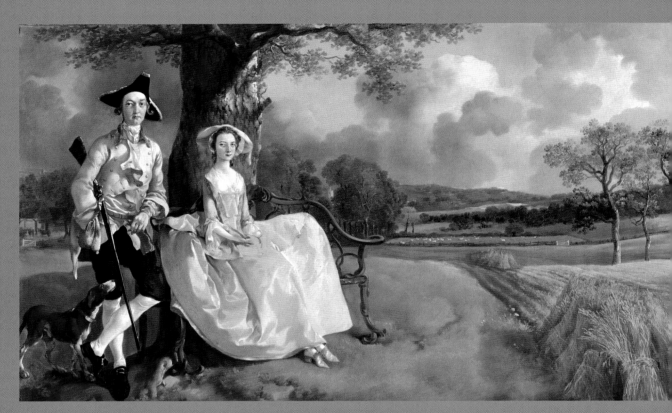

Figure 6.1

Thomas Gainsborough,
Mr. and Mrs. Andrews, 1750.
Oil on canvas (69.8 × 119.4 cm).

6 | Fashion & Identity

Fashion has long been associated with wealth and status, offering nonverbal signals as to class and occupation. For example, in the late fourteenth century, sumptuary laws in Nuremburg mandated hairstyles such that "no burgher, young or old, shall wear his hair parted; they shall wear the hair in tufts, as it has been worn of old."[1] Subtle details of how the body is fashioned signal membership in a social class, especially when frozen in time through portraiture. In commissioning a portrait, most sitters hope for a flattering representation and will carefully select their clothing (sometimes in conjunction with the artist as was discussed in Chapter 1), and this allows the dress detective to analyze the portrait to consider the sitter's self-presentation of social identity through dress.

Although the idea that fashion trickles down from the upper classes to the lower classes has been perpetuated by the writings of Theodore Veblen and others,[2] emulation also works the other way, with the upper classes adapting styles that originated in the more functional outfits of the working class, but refashioning the looks in more expensive materials. Such is the case with the portrait of Robert Andrews and Frances Mary Carter, painted by Thomas Gainsborough in the mid-eighteenth century.

CASE STUDY: THOMAS GAINSBOROUGH'S PORTRAIT OF MR. AND MRS. ANDREWS

In or about 1750, Thomas Gainsborough painted a commissioned portrait of Robert Andrews and his wife Frances Mary Carter that has come to be known as *Mr. and Mrs. Andrews* (Figure 6.1). The rectangular format and size of this oil painting is unusual at 69.8 × 119.5 cm (27.5 × 47 inches), and this may suggest that it was intended to be hung over a mantel. The work is also distinctive from other portraits of the time since there is equal emphasis given to both the figures and the landscape. During his career, Gainsborough was lauded for his abilities in both portraiture and landscape with one critic writing at the time: "'Tis hard to say in which branch of art Mr. Gainsborough excels, landscape or portrait painting."[3] In this essay, I shall show that this painting is not only a portrait of Robert Andrews and his wife, but also a portrait of their property in reflecting the romanticized notions of the English landscape. Gainsborough has used the sitters' dress to convey the privileged status of these landowners as well as ideals of grace and beauty of the period.

In this portrait, Mr. and Mrs. Andrews are depicted on their country property in Suffolk, England. Portraits of this period often portray full figures posed in a landscape, but this work illustrates a specific place rather than a fictional romanticized background. Robert Andrews had recently become the owner of a large estate following the death of his mother in 1749 and may have commissioned this work in celebration of his inheritance.[4] The artworks of this

time period in England show "a decisive rejection of pretentious artificiality."[5] Authors and poets presented the English countryside as an "idealized landscape" and expressed longing for a romanticized "life of pastoral simplicity" that linked beauty and grace to nature and naturalness.[6] This sentiment of nostalgia for the country is evident in the emphasis that Gainsborough gives to the landscape as well as the fact that the couple are dressed in a restrained and refined manner that is suitable for their country lifestyle.

The sense of space in this work is highly developed with a foreground that includes the main figures, a middle ground that includes a flock of sheep, and a background that illustrates a rolling countryside. This perspective reflects what the eye might see in viewing a country landscape. The landscape does not reflect the stylistic tendencies of the Rococo period; instead this painting illustrates a real place and a stable compositional structure that creates a sense of harmony and unity. The figures are situated on the left half of the painting (Figure 6.1). The areas of highest contrast are the figures, especially the faces, which adds visual emphasis to this area. The shapes around the couple—the branches of the tree and the arm of the bench—frame them within this space. There is a rhythm of rounded shapes that repeats the curved form of Mrs. Andrew's skirt that is echoed in the arm of the chair, the branches of the tree, the shapes of the trees in the distance, and the clouds, as well as the sheaves of wheat in the fields. The balanced composition suggests that the couple's status as landowners is an important part of their identity.

Robert Andrews is dressed in a manner befitting a country landowner. He stands in a relaxed pose with his dog at his feet and looks confidently towards the viewer (Figure 6.2). His weight is shifted onto one leg with the other leg crossed at the ankle, and he leans slightly and rests one elbow on the bench where his wife is seated. He wears a double-breasted wool hunting jacket with a green velvet collar and white cravat; his jacket hangs open to reveal a plain waistcoat.[7] He wears one buckskin glove while holding the other, with the other hand thrust into the pocket of his black wool breeches. He wears white stockings and his small-heeled black leather shoes have gleaming silver buckles. His hair is unpowdered and he wears a black tricorn hat trimmed with white. His garments are made of high-quality materials and are suitable for the country. The artist has created an area of high contrast with his black breeches and white stockings, which gives particular emphasis to his calves. This is an area of the male body that was in this period associated with virility,[8] and Robert Andrews' left leg is turned at the knee giving a side view of his calf to show the gentle swell of a finely turned leg.

Frances Mary Carter is seated on an ornate ironwork bench next to her husband (Figure 6.2). Her gaze is demure, and she has the rigid upright posture associated with the wearing of stays underneath her pale blue silk day dress ensemble. She is wearing the informal ensemble known as a *casaquin* which consists of a jacket with back pleats worn over a matching skirt also known as a

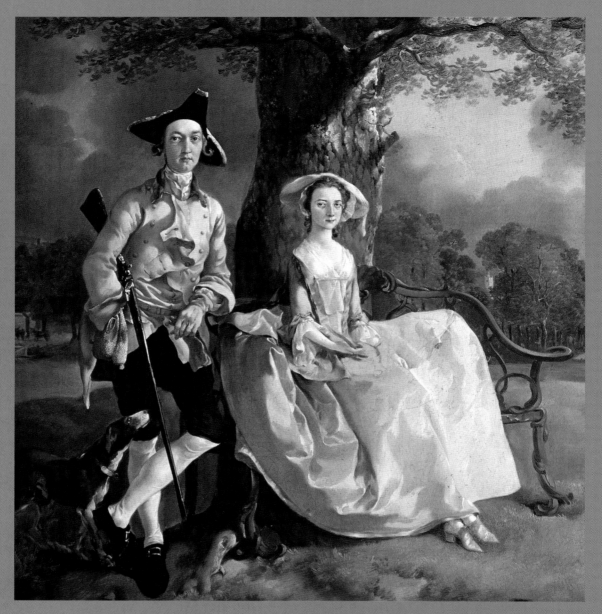

Figure 6.2

Thomas Gainsborough,
cropped image of Robert
Andrews and Frances Mary
Carter, 1750. Oil on canvas.

petticoat.[9] A band of vertical ruffles forms a V-shaped column at the front of the jacket. The narrow elbow length sleeves are trimmed with a small decorative bow and finished with gauzy white undersleeves. The neckline of the jacket is filled in with a white handkerchief fichu and is worn with a plain white stomacher. The expansive skirt of her ensemble is made of a matching fabric and is supported by hoops. A second creamy yellow petticoat is barely visible underneath the pale blue skirt. Frances wears white stockings under brocade shoes with a small heel and a pale pink bow. Her hair is unpowdered and is topped with a white cap and straw bonnet. The pale blue of her silk dress ensemble was one of the popular color choices of the period that also included pink and bright clear yellow.[10] Blue was also considered the "colour of true faith and continued affections" at the time and in fact was described thus in an article from 1745 that promoted Gainsborough as a "justly esteemed eminent master."[11]

The wide hoops worn by Frances Mary Carter are the key element denoting the fashionable norms for elite English women in the early to mid-eighteenth century.[12] Her hooped skirt dramatically extends the line of her hips into a flat, oblong shape such that her dress fills the entire span of the bench.[13] Even though hoops were often mocked in the press for keeping men at a distance, this style of dress remained popular until the 1760s, and continued to be worn at court for several decades longer.[14] Despite their impracticality, the wearing of such wide hoops in the country was an essential component of fashionable attire. Anne Hollander notes that the skirt "hid women from the waist down and thus permitted endless scope for the mythology of the feminine, had become a sacred female fate and privilege, especially after it became firmly established as a separate garment."[15] In this way, this portrait illustrates how an idealized form of femininity was manifested in dress during this period in history.

In analyzing examples of dresses from this period in museum collections, we see that many have elaborate trimmings, because these gowns were intended for weddings or court appearances. For example, the Rijksmuseum has a mantua made of a similar pale blue silk (Figure 6.3); this dress (Accession #BK-1978-247) was worn by Helen Slicher to her wedding in 1759 and is richly ornamented both front and back with elaborate floral motif embroidery in colorful silk thread.[16] The Met has a British court mantua in pale blue silk ornamented with silver floral motifs and lace (Figure 6.4) dated to 1750 (Accession #C.I.6513.1a-c). The hoops or panniers on this dress are very wide, at least as wide as or wider than the dress of Frances Mary Carter. Very few examples of the informal gown known as *casaquin* exist in museum collections, and The Met has only one example (Accession #1993.17ab) that is dated to ca. 1725-1740 (Figure 6.5 and Figure 6.6). This type of ensemble was derived from working-class costume,[17] and offered the wearer a little more ease since the cut of the jacket is looser. The Met's example is similar in cut to that depicted in Gainsborough's portrait of Frances Mary Carter, but is embellished with rich embroidery, suggesting that it was intended for a special occasion.

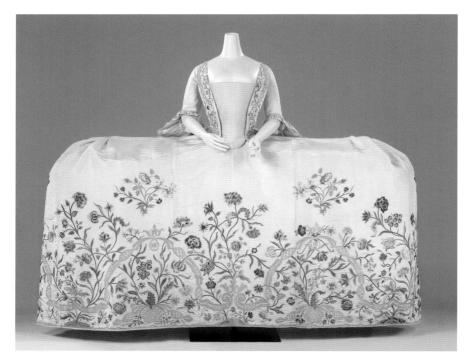

Figure 6.3

Unknown maker,
wedding dress worn
by Helen Slicher,
ca. 1750–1760.

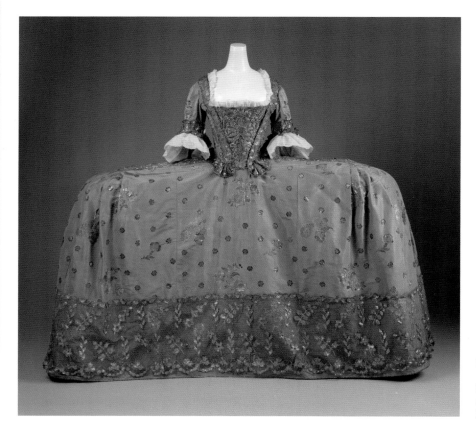

Figure 6.4

Unknown maker,
court dress,
British, ca. 1750.

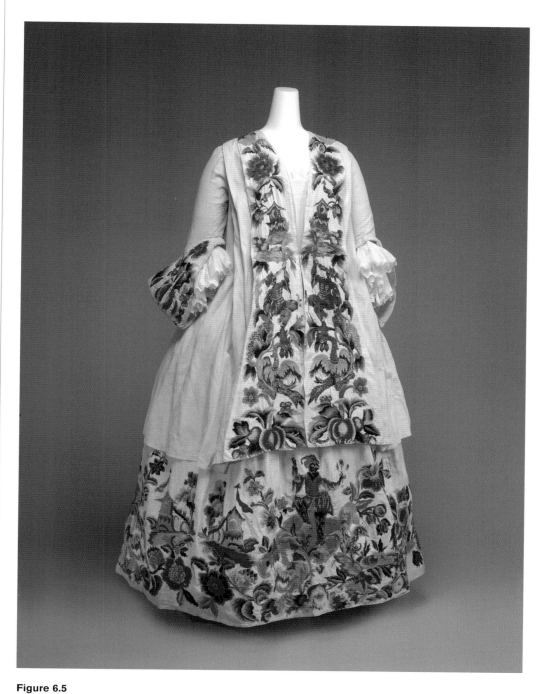

Figure 6.5

Unknown maker,
casaquin and petticoat
front, ca. 1725–1740.

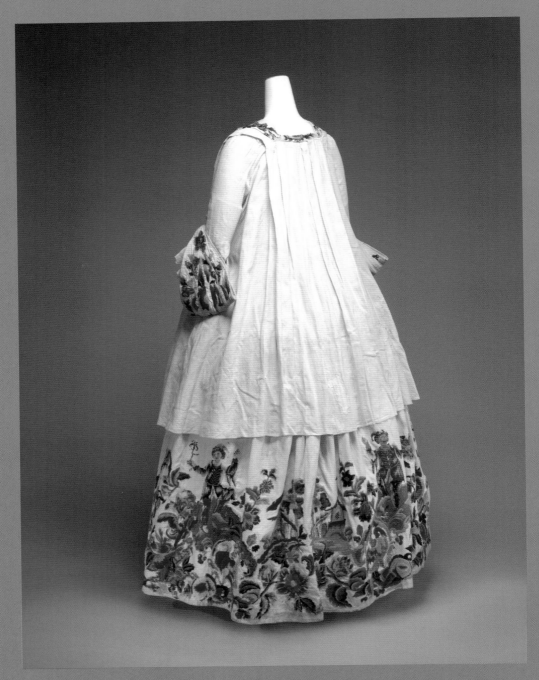

Figure 6.6

Unknown maker,
casaquin and petticoat
back, ca. 1725–1740.

The survival of these particular gowns in museum collections is likely linked to the significance of these garments to the original owner, and as Jane Ashelford notes, extant examples of dresses from this period are usually associated with special occasions such as weddings or court appearances.[18] The dress ensemble worn by Frances Mary Carter is made of plain blue silk but is unornamented. Her hooped skirt is as wide as a court dress, marking her as belonging to the fashionable elite, but the relative ease of the *casaquin* illustrates her place as the wife of a country landowner. According to Ashelford, the nostalgia for the simple life was manifested in "picturesque pseudo-rustic dress."[19] Gainsborough depicts Frances as an elite woman of quiet refined elegance.

The relationship between Mr. and Mrs. Andrews indicates a traditional relationship of husband and wife. She is seated while he is more relaxed and has a possessive air. Their body language suggests an element of detachment or formality. The Andrews are cool, detached and stiff, but whether or not this is a reflection of their personalities or a limitation of the artist's skill (as one of his early works) is unclear. Gainsborough often made use of the artist's lay figure, a jointed wooden mannequin that could be dressed and posed to take the place of the sitters.[20]

Although Gainsborough often made preparatory drawings or sketches, there are no known preparatory drawings for this work, and the artist did not create any additional portraits of this couple.[21] The unfinished area on Frances Mary Carter's lap near her hands possibly indicates that Gainsborough intended to add something, possibly a bird, an animal, a child, or a bouquet of flowers.[22] Art historian James Hamilton indicates that this is "one of the most famous blanks in art history" and suggests that this is evidence that there was a dispute of some kind between the artist and Robert Andrews that resulted in the painting being left unfinished.[23] During Gainsborough's lifetime, the painting was not given a title, and nor did the artist ever refer to it.[24] Hamilton also notes that even though this painting is "the clearest and most specific populated landscape view that Gainsborough painted," the painting did not hang in public until 1927 and it only became famous after the National Gallery purchased it in 1960.[25]

Gainsborough painted several similar works with groups of figures in the landscape including two self-portraits with his wife from ca. 1746 (Figure 6.7) and ca. 1748 (Figure 6.8) as well as a portrait of the Gravenor family from 1754 (Figure 6.9). It is interesting to note that he did not complete his wife's hands in the 1748 portrait, but the figures in these three paintings are less stiff, are more connected to each other and have a more relaxed feel. As well, the backgrounds of these other works are romanticized as imaginary landscapes, while the landscape in the Andrews portrait reflects its specificity in the British countryside.[26] Nonetheless, this portrait of Mr. and Mrs. Andrews fits within the artist's oeuvre. Gainsborough later developed a more fluid style in which the sitters are integrated into the landscape as seen in another portrait of a married couple with a dog, *Mr. and Mrs. Hallet* (ca. 1785-1786), also known as *The Morning Walk* (Figure 6.10).[27]

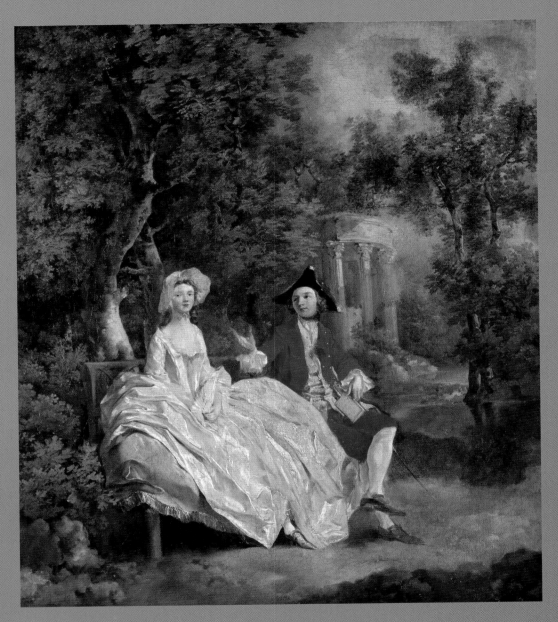

Figure 6.7

Thomas Gainsborough,
Conversation in a Park:
Thomas Gainsborough
and His bride, Margaret.,
ca. 1746. Oil on
canvas (73 × 63 cm).

Figure 6.8

Thomas Gainsborough,
*Portrait of the Artist and
His Wife and Daughter*,
ca. 1748. Oil on canvas
(92.1 × 70.5 cm).

Figure 6.9

Thomas Gainsborough,
The Gravenor Family,
1754. Oil on canvas.
(90.1 × 90.1 cm).

Unlike his long-time rival Joshua Reynolds, portrait painter Thomas Gainsborough encouraged his sitters to wear "modern, fashionable dress."[28] In the analysis of dress in Gainsborough's unfinished portrait of Mr. and Mrs. Andrews from 1750, it becomes evident that the artist was attuned to the fashionable norms of the period. Although this work gives considerable emphasis to the landscape, the couple are dressed in a manner that echoes the significance of their status as landowners. Their finely made garments are elegant and understated, but appropriate for country living. Their dress also serves to convey the fervent affection of the English for the countryside that is documented in poetry and diaries of the period.[29] In this iconic work by Gainsborough, the landscape is reflected in the attire of the sitters and conveys their privileged status as owners of property.

Figure 6.10

Thomas Gainsborough,
Mr. and Mrs. Hallett
or *The Morning Walk*,
ca. 1785–1786. Oil
on canvas (236.2
× 179.1 cm).

ENDNOTES

1. As quoted by Malcolm Barnard, *Fashion as Communication*, (London: Routledge, 2002), 62.

2. Theodore Veblen discusses the idea of conspicuous consumption, in which the upper classes use their consumption of luxury goods, including fashion, to signal their social status and wealth. As these looks trickle down to the lower classes, the upper classes seek novelty and change in new fashions and the cycle perpetuates itself. See Theodore Veblen, *The Theory of the Leisure Class: An Economic Study of the Evolution of Institutions* (London: Macmillan, 1899).

3. Quoted by Martin Postle, *Thomas Gainsborough* (London: Tate Publishing, 2002), 54.

4. James Hamilton, *Gainsborough: A Portrait* (London: Weidenfeld & Nicholson, 2018), 97.

5. Eva-Gesine Baur, "Rococo and NeoClassicism: The Painting in the 18th Century," *Masterpieces of Western Art*, ed. Ingo F. Walther (London: Taschen, 2002), 386.

6. Jane Ashelford, *The Art of Dress: Clothes Through History 1500-1914* (London: National Trust, 1996), 123-124.

7. A coat suitable for country wear dated to about 1750 is housed in the dress collection of the Kent State University Museum. According to Director Jean Druesedow, who wrote the 25th Anniversary exhibition label copy: "This coat is an exceptional example of the English gentleman's use of sturdy fabrics in both country and city. The combination of fibers in camlet makes the fabric very nearly waterproof, and the dense texture could resist both the mud and brambles encountered when riding in the English countryside. With its elegant color and metallic silver braid, it is possible that this coat could have been worn at fashionable gatherings in London or at home in the country." See object ID#1995.068.0002, accessed June 18, 2019 at https://www.kent.edu/museum/online-collection

8. Susan J. Vincent, *The Anatomy of Fashion: Dressing the Body from the Renaissance to Today* (Berg: New York, 2009), 97.

9. Norah Waugh, *The Cut of Women's Clothes 1600-1930* (Theatre Art Books: New York, 1968), 70. Waugh notes the confusing terminology of dress during the eighteenth century. The part of the gown that is visible under the gown during this period was known as a petticoat. As well, the underskirt that was not intended to be visible under the gown was similarly known as a petticoat.

10. Waugh, *The Cut of Women's Clothes*, 70.

11. James Hamilton, *Gainsborough: A Portrait* (London: Weidenfeld & Nicholson, 2018), 87.

There are many paintings by Gainsborough from this time period in which the female figures are dressed in blue. See for example: *Lady Lloyd and Her Son, Richard Savage Lloyd, of Hintlesham Hall, Suffolk* ca.1745–46; *Portrait of the Artist and his Wife and Daughter* from 1748; *The Gravenor Family* 1754; *Sarah, Lady Innes* 1757.

12. Waugh, *The Cut of Women's Clothes*, 68.

13. Gainsborough's grasp of the spatial qualities of hoops is clearly evident in his studies for the portrait of Miss Lloyd, dated to the late 1840s in the collection the Morgan Library in New York. These studies can be seen on the Morgan Library collection website. Accessed June 18, 2019 at https://www.themorgan.org/drawings/item/123042 https://www.themorgan.org/drawings/item/363323

14. Vincent, *The Anatomy of Fashion*, 81-83.

15. Anne Hollander, *Sex and Suits: The Evolution of Modern Dress* (New York: Alfred A. Knopf, 1994), 36.

16. I examined this dress in the Rijksmuseum stores on March 28, 2017.

17. See the curatorial notes for this dress (Accession #1993.17ab) on The Met's collection portal.

18. Ashelford, *The Art of Dress*, 125. In her analysis of the fashions from 1720-1780, Ashelford also notes that many gowns from the 1740s and 1750s were generally remade in the decades that followed since the long lengths of fabric in these styles facilitated unpicking and remaking. This explains why so few examples exist today.

19. Ashelford, *The Art of Dress*, 124.

20. John Hayes, *The Drawings of Gainsborough* (London: A. W. Zimmer Ltd, 1960), 35. In a subsequent publication, Hayes takes note of Gainsborough's use of lay figures and his fashioning of landscape scenery on his kitchen table. See John Hayes, *Thomas Gainsborough* (London: The Tate Gallery, 1980), 25.

21. Many of the early texts on Gainsborough make no mention of this portrait of Mr. and Mrs. Andrews. See Ronald Sutherland Gower, *Thomas Gainsborough* (London: George Bell & Sons, 1903). See John Hayes, *The Drawings of Thomas Gainsborough* (London: A. Zwemmer Ltd., 1960).

22. Hugh Belsey suggested that the space was left for a cock pheasant shot by Mr. Andrews. See Hugh Belsey, *Thomas Gainsborough: A Country Life* (Munich: Prestel, 2002), 44.

23. Hamilton, *Gainsborough*, 99-101.

24. Hamilton, *Gainsborough*, 101.

25. Hamilton, *Gainsborough*, 101.

26. Hayes notes that following this work, the backgrounds in Gainsborough's portraits become generally more artificial and deliberately Rococo in character. See Hayes, *Gainsborough*, 76-77.

27. Many of Gainsborough's early drawings illustrate a lightness of touch and fluidity not seen in his early paintings; see for example the studies for the portrait of Miss Lloyd mentioned in note 11.

28. Lucy Davis, "Interacting with the Masters: Reynolds at the Wallace Collection," in *Joshua Reynolds*, 36.

29. For examples of poetry by William Cowper and Robert Lloyd that express longing for the countryside, see Ashelford, *The Art of Dress,* 123.

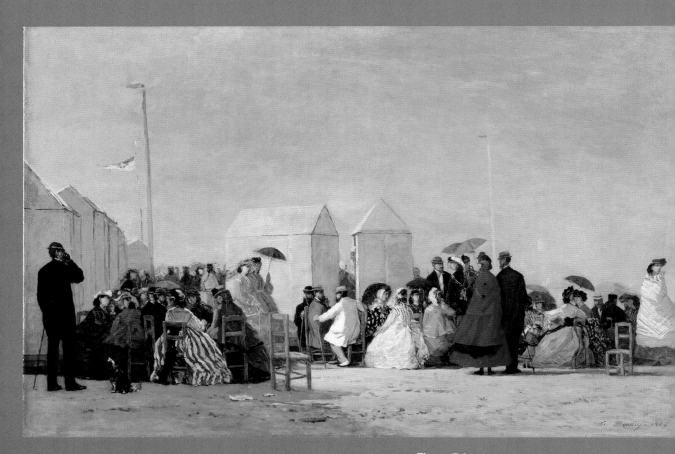

Figure 7.1

Eugène Boudin, *La plage de
Trouville à l'heure du bain*
(*On the Beach Near Trouville*), 1864.
Oil on canvas (67.5 × 104 cm).

7

Fashion & Modernity

Driven by the forces of capitalism, fashion embraces the notion of change and novelty, endlessly recycling styles and silhouettes from the past to suggest the "right" look for a particular time and place. In Elizabeth Wilson's seminal work *Adorned in Dreams*, she argues that fashion is central to the idea of modernity in manufacturing "both dreams and images as well as things."[1] When an artist represents dressed bodies in a work, they may capture these fleeting moments, allowing the viewer to reconsider their significance in the timelines of history. In the case study that follows, the relationship between fashion and modernity is considered in the *plein-air* paintings of French artist Eugène Boudin (1824–1898).

CASE STUDY: EUGÈNE BOUDIN'S CRINOLINE PAINTINGS

In the small-scale oil painting *La plage de Trouville à l'heure du bain* or *On the Beach Near Trouville* dated to 1864 from the collection of the Art Gallery of Ontario (Figure 7.1), French artist Eugène Boudin depicts a fashionable crowd on the beach under an expansive blue sky in a small coastal town near Normandy, about an hour's train ride from Paris. Painted *en plein-air*, the painting is an impressionistic image rather than a highly polished rendering. The bathing machines and the broad swath of sand littered with seaweed and other remnants of the tide in the foreground signal that this is a beach, even though the fashionable attire of the crowd would also be appropriate in an urban setting.[2] Boudin's *plein-air* paintings of the elegant bourgeoisie at the seaside illustrate the concept of modernity—the idea of novelty, rapid change, and progress brought about by the processes of industrialization—and thus modernity will be the lens of analysis in this case study. In this essay, I will show that in Boudin's beach scene paintings, modernity is reflected in the setting, in the style of painting, and in the elegant fashions of the crowd.

This painting is one of many beach scenes that Eugène Boudin created during his lifetime (see also Figure 7.2 and Figure 7.3). In the summer of 1862, after several years of despair and relative poverty while living in Paris, Boudin traveled to Trouville and took notice of the well-dressed crowds flocking to the beaches of this coastal town. Boudin preferred painting in the open air and once wrote in his notebook, "Everything that is painted directly on the spot has always a strength, a power, a vividness of touch that one doesn't find again in the studio."[3] His small luminous paintings rendered on site captured the fashionable bourgeoise taking their leisure on the beaches in the Normandy region and quickly brought him financial success in serving as "the visual equivalent of a social column" in documenting the travels of the upper classes.[4] In a letter to a friend dated February 12, 1863, Boudin wrote, "They love my little ladies on the beach, and some people say that there's a thread of gold to exploit there."[5]

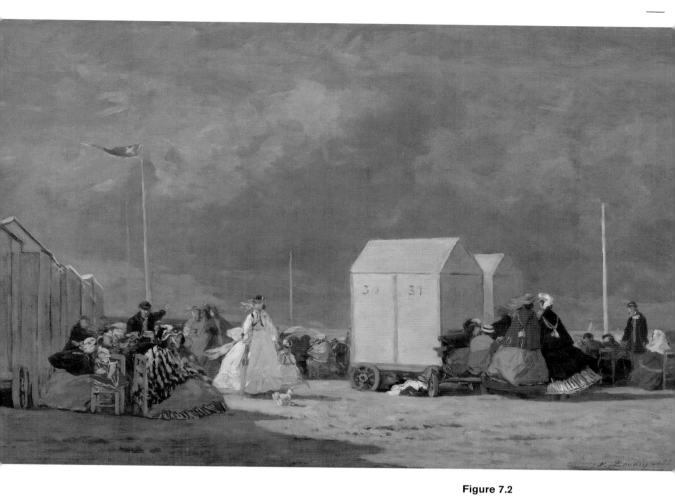

Figure 7.2

Eugène Boudin,
Approaching Storm,
1864. Oil on cradled
panel (36.3 × 57.9 cm).

In the mid-nineteenth century, the rise of railroad as a form of transportation opened up new vistas and forms of leisure to the middle class, making coastal towns like Trouville and Deauville accessible for leisure or holiday excursions. During the Second Empire (1852–1870), these Normandy seaside resorts became increasingly chic, attracting crowds of elegant Parisians dressed in the most up-to-date looks. Although a number of artists including Caillebotte, Courbet, Degas, Manet, and Monet were all drawn to the region, it was Boudin who achieved initial acclaim for his seascapes. Art critic Jules-Antoine Castagnary wrote at the time, "He [Boudin] has made himself a charming little niche from which no one can dislodge him."[6] And while the railroad is not visible in his beach scene paintings, the idea of modernity is reflected in Boudin's works by the setting—it was the railway as the mode of transport that made such scenes possible, by facilitating journeys to the seaside as a form of leisure. Before the relative speed and ease of train travel, such a journey would have taken several days by horse and carriage.

In 1859, Eugène Boudin along with two other artists had a chance encounter with art critic and poet Charles Baudelaire that led to a leisurely dinner in Le Havre.[7] Later that year Baudelaire wrote about Boudin's landscape sketches in his review of the Salon de 1859, remarking that, "These studies, so quickly and so faithfully sketched from the elements in nature which are the most inconstant and elusive in form and colour: waves and clouds."[8] This link to Baudelaire is notable and suggests a possibility that the artist might have known of Baudelaire's essay "The Painter of Modern Life" following its publication in *Le Figaro* in installments on November 26 and 28 and December 3, 1863. In this treatise Baudelaire argued that painters should endeavor to capture the fleeting and ephemeral aspects of modernity in their works, embracing the "depiction of bourgeois life and the pageant of fashion,"[9] rather than dressing their subjects in garments from the past, as was generally the norm at the time. For Baudelaire, fashion was an emblem of modernity in conveying a "transitive fugitive element, whose metamorphoses are so rapid," and he encouraged painters to embrace this "mysterious beauty" if they wished their work to one day be worthy of "taking its place as antiquity."[10] Baudelaire expressed the idea of the woman—her fashionable dress, her pose, and the angle of her head—as composing a harmonious and indivisible whole. He argued that the artist should take notice "if a fashion or the cut of a garment has been slightly modified," specifically mentioning the raising of waistlines and the fullness of skirts supported by crinolines, as well as changes in hairstyle, as elements of a woman's dress that required the artist's attention.[11]

In Boudin's beach scene paintings, the brushwork is rapid, rendering an impression rather than a photographic-like representation. As such, the artist did not typically aim to identify his sitters in these works, seeing the painted portrait as being supplanted by another product of modernity—the invention of the photograph. Boudin said, "The portrait is in fashion, that was the genre in which I began . . . [but] the daguerreotype had just been invented and because of this the painted portrait was stopped in its tracks, and was given up altogether."[12] However, he did make at least one exception when he captured the impressionistic likeness of one of the most fashionable women of the time, the Princess Pauline von Metternich, dressed in an elegant summer ensemble of jacket and crinoline skirt made of white cotton gauze with black trim over a red petticoat, and worn with a jaunty straw boater (Figure 7.3). Metternich was a friend and confidante of Empress Eugénie as well as a notable patron of couturier Charles Frederick Worth.[13] Boudin included her name in the title for the work, perhaps in hope of selling it to her even though her facial features are rendered indistinct with his rapid brushwork.

In his beach scene paintings (Figure 7.1 and Figure 7.2), Boudin depicts crowds of fashionably dressed men and women at the seaside, and the artist gives emphasis to the figures interacting in small groups rather than focusing on the landscape. The figures are small and mostly indistinguishable and Boudin uses color and form to direct our eyes around the canvases.

In *On the Beach Near Trouville* (Figure 7.1), the focal point of the painting is a woman in red standing beside her partner on the right side of the painting. The eye is drawn to the seated man and woman dressed in white-colored clothing in the center of the work and continues across to the grouping of figures on the left of the work, with a woman wearing an ensemble in sky blue catching our attention. There is a small black and white dog visible in the foreground to the left of the painting, looking towards the elegantly dressed man in black, who seems to be calling to someone in the distance. Grouped into small clusters, most of the men and women are sitting on wooden chairs with cane seats and are looking at each other, while others stand or walk in couples or small groups.

The work conveys the energy of a crowd at the seaside. Art critic Arsène Alexandre took notice of Boudin's affinity for the crowd when he wrote, "the beings with which he populates his landscapes are nearly always represented as groups of many people. Corot often places a solitary figure in his silver pictures: Boudin likes swarms."[14] In this work, the crowd scene is not static; each of the small groups of people is engaged in conversation or activity. For Charles Baudelaire, the crowd was a source of energy for "the lover of universal life" who would enter "into the crowd as though it were an immense reservoir of electrical energy."[15] The figures are shown only from the back or in profile, and in viewing the work, we are set back from the crowd, taking the place of Boudin at his easel. In this way we are cast as Baudelaire's *flâneur* or "passionate spectator."

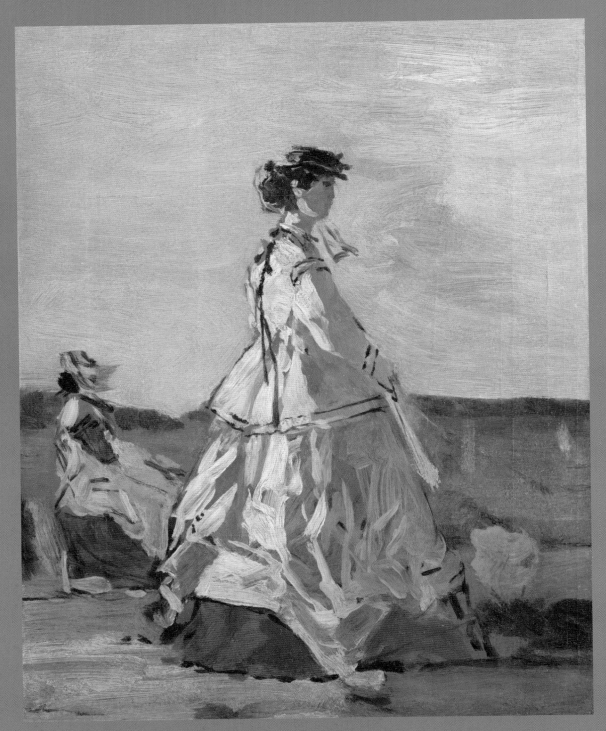

Figure 7.3

Eugène Boudin, *Princess Pauline von Metternich on the Beach*, ca. 1865–1867. Oil on cardboard, laid down on wood (29.5 × 23.5 cm).

The crowd is not made up of locals, but consists of bourgeois women and men, who need not worry if they soil their dresses or suits while spending a leisurely day at the seaside. In this painting, the men—dressed in neutrals of black, brown, gray, or white lounge suits—seem to be a counterpoint to the women. The women take up more space and are more visible in their fashionable day dresses— long-sleeved bodices and full-length skirts supported by crinolines. The women's dresses come in an array of colors including brown, blue, red, violet, and yellow, as well as some vibrant patterns in black and white combinations of checks or stripes. The most noticeable figures in the painting are dressed in white, blue and red, the colors of the French flag. Boudin strove to keep his colors fresh and he once wrote to his friend some words of advice to "use tones in their full freshness" and also "avoid dirty tones."[16] All the figures in the painting wear hats: bonnets with ribbons for the women and straw boaters or bowler hats for the men. Parasols and walking sticks are the fashionable accessories of choice as markers of class and status.

One of the most striking dresses in the painting is the cherry red ensemble worn by the woman standing with her back to the viewer on the right (Figure 7.1). Her red dress is trimmed in black, and she wears a red shawl with a matching black bonnet trimmed with black. Her skirt hovers just above her ankles and illustrates a style made popular by Charles Frederick Worth, who around this time devised a walking skirt that reached only to the ankle for the Empress Eugénie because she was "very fond of long country walks and of promenading by the sea, but found ground-length skirts a hindrance."[17] The red color of this ensemble is distinctive and is also seen on another woman in Figure 7.2. This same color of red is evident in the portrait of Princess Pauline von Metternich standing on the beach and wearing a cherry red petticoat under her looped-up skirts (Figure 7.3). Adrienne Munich notes that red petticoats were very popular in the mid-nineteenth century, especially in France where Empress Eugénie "fell in love with it and all the ladies of rank were seized with the violent scarlet fever epidemic, *scarlentina*."[18] An extant example of a red crinoline petticoat can be found in the collection of the Los Angeles County Museum of Art (Accession #M.2007.211.386) and is shown in Figure 7.4.

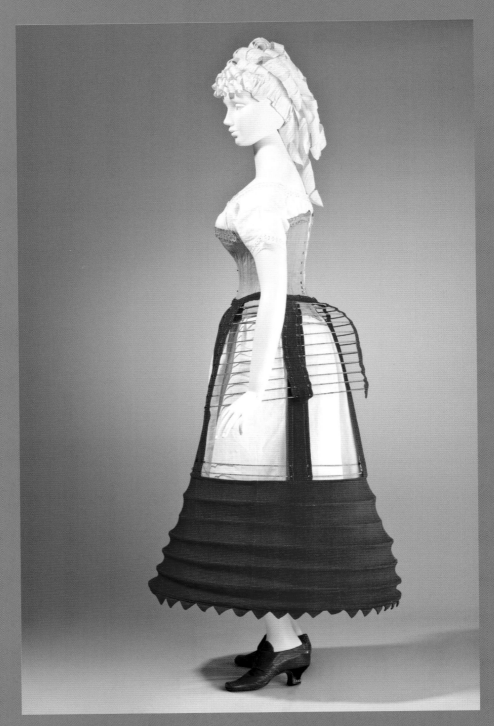

Figure 7.4

Unknown maker, woman's bustle cage crinoline,
England, 1862–1870.

Similar styles of dresses to those depicted in the painting can be found in fashion plates and photographs from the period as well as extant garments in museum collections. In a fashion plate dated to 1864, two women wear dresses with wide skirts supported by crinolines and accessorized with bonnets and gloves (Figure 7.5) A *carte de visite* photograph of Empress Eugénie dated to 1864 shows her wearing a dark-colored silk dress with close-fitting bodice with long sleeves and an expansive skirt supported by a crinoline (Figure 7.6). Her dress is like that of several women in darker-toned dresses in Boudin's works. The Met Costume Institute Collection has a blue silk dress of French origin dated to circa 1864 (Accession #C.I.40.183.2) that clearly illustrates the style of the period (Figure 7.7) and is very similar to the dress worn by the woman seated at the far left of Boudin's painting (Figure 7.1). In the vibrant blue silk dress belonging to The Met collection, the bodice is close fitting, with a natural waist. The skirt is gathered at the waist and is fashioned with tapes or loops that draw up the hem of the skirt to reveal the petticoat beneath. The dress hovers just above the floor, making it most suitable for a trip to the beach.[19] The Los Angeles County Museum of Art has several outfits identified as seaside ensembles made in lightweight cotton, including a jacket, bodice, and skirt dated to 1864–1867 with machine embroidery in black (Accession #M.2007.211.944 a-c) shown in Figure 7.8. This ensemble is fitted through the bodice and has an expansive skirt that would have been supported by a crinoline. Accessorized with a jaunty straw boater and gloves, the dress resembles those worn by some of the women in Boudin's seaside paintings.[20]

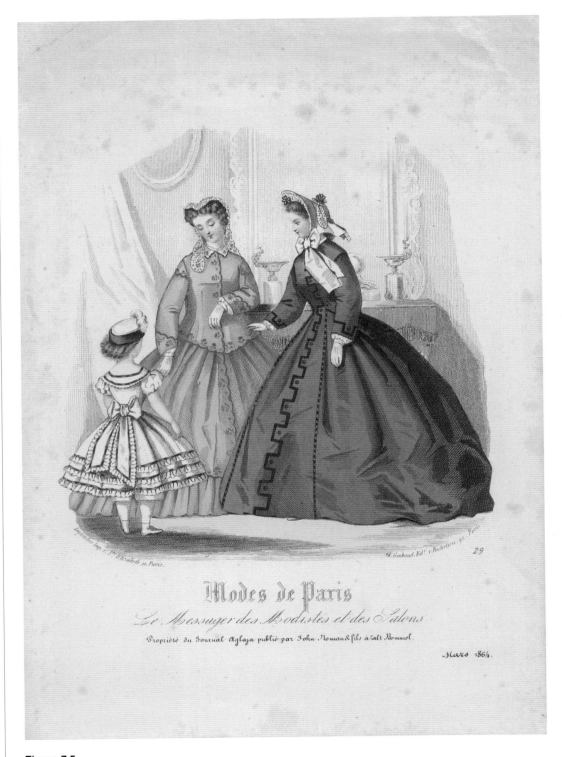

Figure 7.5

Artist unknown, *Modes de Paris*, March 1864.

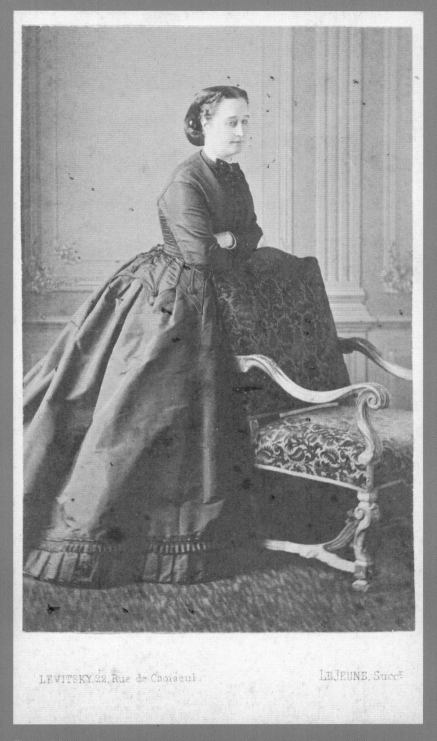

LEVITSKY, 22, Rue de Choiseul. LE JEUNE, Succʳ

Figure 7.6

Sergei Lvovich Levitsky, *Portrait of Empress Eugénie*,
ca. 1864. Albumen silver print (10.5 × 6 cm).

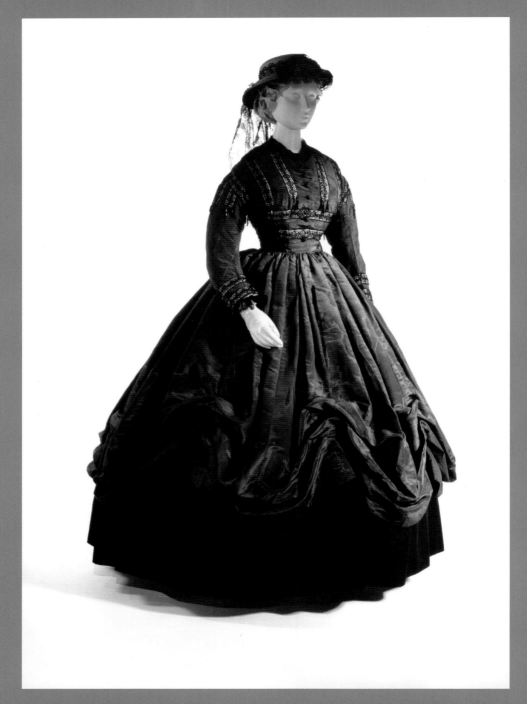

Figure 7.7

Unknown maker, blue silk day dress,
probably French, ca. 1864.

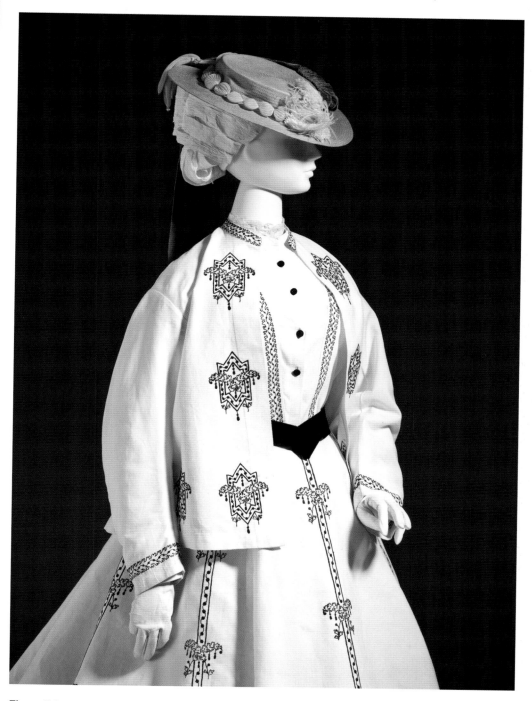

Figure 7.8

Unknown maker (France), woman's seaside
ensemble (jacket, bodice, and skirt), 1864–1867.

Although the specific details of the dresses in Boudin's painting are not readily distinguishable, what is most noticeable is the expansiveness of the women's skirts supported by the crinoline, which represented the height of fashion at the time. The word *crinoline* was initially used to describe a petticoat made of *crin* (French for horsehair) interwoven with *lin* ("linen"); after the 1850s the word *crinoline* came to describe a "foundation garment composed of graduated steel or whalebone hoops that distended skirts and preserved their shape."[21] With advancements in technology allowing for the manufacture of low-cost, flexible, lightweight steel hoops to support the skirt structure, the cage crinoline allowed women to wear the fashionable wide skirts of the time without enduring the weight or warmth of multiple layers of petticoats. With the endorsement of leading Parisian couturier Charles Frederick Worth, the crinoline hoop reached "breathtaking proportions" in the 1860s.[22] One of the most fashionable women of the time, Empress Eugénie was called the "Queen of the Crinoline."[23] Legend has it that after seeing the play *Les Toilettes Tapageuses*, in which the main character appeared in a giant crinoline held up by an "enormous steel cage," the Empress sent her maid "to obtain the measurements of the actress's showy dress."[24] In the 1855 painting of Empress Eugénie with her ladies by Franz-Xavier Winterhalter (see cover image), the Empress wears an evening gown of white tulle trimmed with lilac silk and ribbon. The poses taken by the Empress and her ladies showcase the expansive skirts of their fashionable gowns. In a later photograph dated to 1864 in Figure 7.6, Eugénie wears a day dress with a bell-shaped skirt supported by a cage crinoline. Cage crinolines became hugely popular in spite of the many difficulties and dangers caused by wearing enormous skirts.[25, 26]

Boudin was so successful with these beach scene works of "luxurious idleness at the Normandy coast," that this series of paintings, "accurate in their depictions of up-to-the-minute fashions were dubbed *crinolines*."[27] Boudin expressed some ambivalence about his success when he realized that the beach had become for him a "dreadful masquerade," and he complained, "It needs something like genius to make anything of this bunch of lazy 'poseurs.'"[28] Boudin painted seascapes for a while but returned to his beach scenes in 1881 after art dealer Paul Durand-Ruel bought the entire contents of his studio.[29]

Boudin acknowledged that these works were an authentic reflection of that time when he wrote, "if not great art, at least a fairly sincere reproduction of the world of our time."[30] At the present, Boudin's works are held in many private collections as well as art museums including the Musée d'Orsay in Paris, the Art Gallery of Ontario, the Art Institute in Chicago, The Metropolitan Museum of Art in New York, the Boston Museum of Fine Arts, and the National Gallery of Art in London, but as a minor artist of the nineteenth century, he is better known for his influence on Claude Monet in encouraging him to paint from real life. In this essay I have argued that Eugène Boudin's beach scenes, his "crinolines" as they are called, are worthy of being revisited and re-interpreted as visual representations of modernity.

ENDNOTES

1. Elizabeth Wilson, *Adorned in Dreams: Fashion and Modernity* (London: I.B. Tauris, 2011), 14.

2. Bathing machines were small wooden or canvas boxes that would be drawn into the water by a horse, enabling those that wished to change into a bathing dress and dip into the water for refreshment to do so with some privacy.

3. Eugène Boudin quoted in Gérard Jean-Aubry, *Eugène Boudin* (London: Thames & Hudson, 1969), 155.

4. Christoph Heinrich, "Eugène Boudin, A Vividness of Touch," in *Nature as Muse, Inventing Impressionist Landscape from the Collection of Frederic C. Hamilton and the Denver Art Museum* (Norman: University of Oklahoma Press, 2013), 48.

5. Eugène Boudin quoted in Jean-Aubry, *Eugène Boudin*, 50.

6. Jules-Antoine Castagnary quoted in Jean-Aubry, *Eugène Boudin*, 60.

7. Jean-Aubry, *Eugène Boudin*, 27–28.

8. Charles Baudelaire quoted in Jean-Aubry, *Eugène Boudin*, 32.

9. Charles Baudelaire, "The Painter of Modern Life," in *The Painter of Modern Life and Other Essays*, trans. Jonathan Mayne (New York: Phaidon Press Inc., 2010), 4.

10. Baudelaire, "The Painter of Modern Life," 12–13.

11. Baudelaire, "The Painter of Modern Life," 10.

12. Eugène Boudin quoted in Jean-Aubry, *Eugène Boudin*, 155.

13. Diana de Marly, *The History of Haute Couture 1850–1950* (London: B.T. Batsford Ltd., 1980), 28. De Marly identifies the Empress Eugénie in one of Boudin's paintings, *The Beach at Trouville* from 1863, and writes, "The empress, in white in the centre of the group of ladies, is wearing it [the walking skirt] for a seaside promenade." However, many of Boudin's paintings from this period have similar titles and the painting with the Empress Eugénie described by de Marly was not found in the catalogue raisonné of Boudin's work. Marly did not identify the location of the painting.

14. Arsène Alexandre quoted in Jean-Aubry, *Eugène Boudin*, 166.

15. Baudelaire, "The Painter of Modern Life," 10.

16. Eugène Boudin quoted in Jean-Aubry, *Eugène Boudin*, 170.

17. De Marly, *The History of Haute Couture*, 28.

18. Adrienne Munich, *Queen Victoria's Secrets* (New York: Columbia University Press, 1996), 184.

19. In Figure 7.2, Boudin paints several women in versions of the "beach-length" dress.

20. The Victoria & Albert Museum collection also has examples of light summer dresses from this time period including a summer-weight cotton muslin dress trimmed with satin dated to 1869 (Accession #T.12 to B-1943) that I examined at the Clothworkers' Centre for the Study and Conservation of Textiles and Fashion at Blythe House in London on October 11, 2018.

21. Lucy Johnston, *Nineteenth-Century Fashion in Detail* (London: V&A Publications, 2005), 128.

22. Harold Koda, *Extreme Beauty: The Body Transformed* (New York: Metropolitan Museum of Art, 2001), 125.

23. James Laver, *Costume and Fashion: A Concise History* (New York: Thames & Hudson, 2002), 185.

24. Cecil Saint-Laurent, *The Great Book of Lingerie* (New York: The Vendome Press, 1986), 108.

25. Natalie Rothstein, *Four Hundred Years of Fashion* (London: V&A Publications, 1984), 39.

26. Although crinolines were much maligned in the press, especially in publications like *Punch*, the mass manufacture of the cage crinoline became an important industry and the largest firm, W.S. & E.H. Thomson, had factories in England, France, Germany, and the United States. With additional technical advances, manufacturing costs dropped such that the crinolines were within reach of all social classes.

27. Christoph Heinrich, "Eugène Boudin, A Vividness of Touch," in *Nature as Muse, Inventing Impressionist Landscape from the Collection of Frederic C. Hamilton and the Denver Art Museum* (Norman: University of Oklahoma Press, 2013), 48–52.

28. Heinrich, "Eugène Boudin," 52.

29. Heinrich, "Eugène Boudin," 52.

30. Eugène Boudin quoted in Jean-Aubry, *Eugène Boudin*, 173.

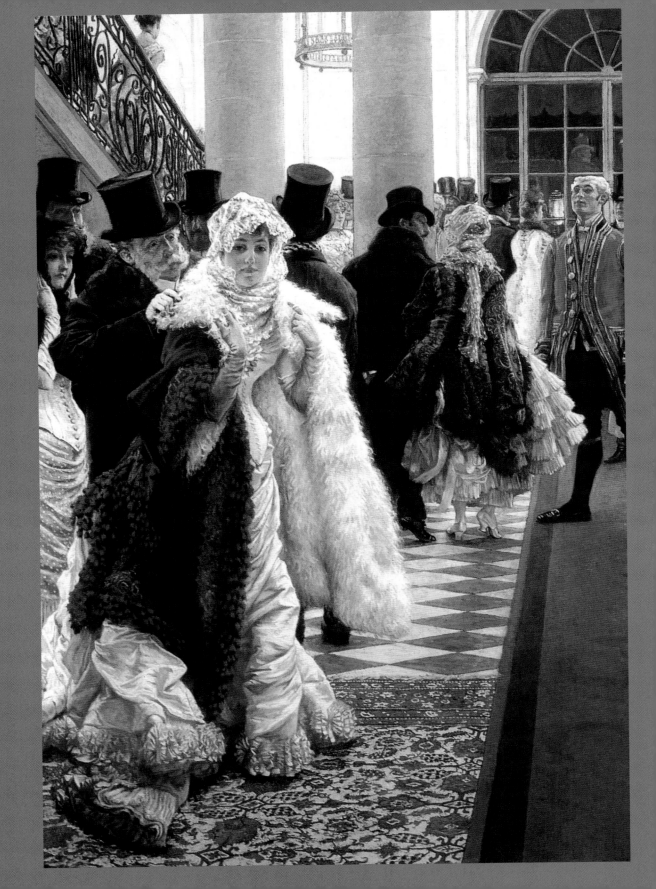

8 Fashion & Beauty

OPPOSITE
Figure 8.1

James Jacques Tissot, *La Mondaine*
(*The Woman of Fashion*), 1883–1885.
Oil on canvas (146.1 × 101.6 cm).

The dictionary definition of beauty, "the quality of a thing which is highly pleasing to the senses generally," suggests that there is a general consensus amongst a group of people who experience pleasure in regard to a work of art, a person, an object, or a thing. Yet defining what is beautiful at a particular moment in time is complicated, because beauty is not an inherent property of the object, but rather an aesthetic judgment.[1] As German philosopher Immanuel Kant observed in his writings on beauty and morality, when describing something as beautiful, "we believe ourselves to be speaking with a universal voice, and lay claim to the concurrence of everyone," even though this judgment is personal.[2] Nonetheless, figurative artworks have long been associated with prevailing notions of beauty, allowing the dress detective to explore the relationship between fashion and beauty captured in a specific place and moment in time.

As an aesthetic medium, fashion expresses cultural ideas about beauty, but this itself is a paradox since a new fashion can "embrace what was previously considered ugly."[3] The notion of what is beautiful in fashion is, as Charles Baudelaire explains, linked to "the philosophic thought with which that age was most preoccupied or concerned."[4] And it is this association that allows the viewer to consider the expression of ideals of beauty in figurative artworks as a reflection of prevailing cultural beliefs, which has until recently celebrated the slim, demure, able-bodied white female as the ideal.[5] In the case study that follows, I will consider James Jacques Tissot's efforts to capture the ideals of Parisienne beauty in the latter part of the nineteenth century.

CASE STUDY: JAMES JACQUES TISSOT'S *THE WOMAN OF FASHION*

The chic Parisienne represented the ideals of feminine beauty in the nineteenth century. To become a true Parisienne was "only slightly less difficult than to enter the kingdom of heaven,"[6] but that did not discourage provincials and foreigners from emulating the ideal. Many artists were inspired by the idea of *la Parisienne*, including Pierre Auguste Renoir, Édouard Manet, and Charles Giron, all of whom created paintings with the title *La Parisienne*, and thus represented an abstract idea rather than a portrait of a specific woman. In James Jacques Tissot's oil painting *La Mondaine* or *The Woman of Fashion* (1883–1885), a beautiful woman pauses as she is about to leave an elegant house party (Figure 8.1).[7] She has turned towards the viewer, bringing us into the picture plane, as she dons her fur mantle with the help of her lover or husband, while the other guests depart under the haughty gaze of a liveried footman. Although the vestibule is crowded with people, she dominates the picture. She smiles slightly as a woman of *la monde*—the world—conveying confidence in her beauty and position. The contrast between her youth and beauty against the aged countenance of her elderly lover or husband suggests that she has used her beauty to rise in society. In this essay, I analyze how Tissot has used the dress of *la mondaine* to communicate the ideals of Parisienne beauty in the latter part of the nineteenth century.

La Mondaine or *The Woman of Fashion* is one of fifteen large-scale paintings by Tissot created between 1883 and 1885 for a series he entitled *La Femme à Paris*. Tissot depicted his vision of the modern Parisienne, including shop girls (Figure 8.2), performers, and society women in a variety of settings including public spaces like a boutique, a park, and a circus.[8] Tissot intended to issue a series of etchings based on the paintings accompanied by short stories commissioned from leading authors of the time, including Émile Zola, Charles Gounod, and Alphonse Daudet, but later abandoned the plan.[9] The series was shown at the Galerie Sedelmeyer in Paris in 1885 (*Exposition J.J. Tissot: Quinze Tableux sur La Femme à Paris*) and at the Arthur Tooth and Sons Gallery in London (*Pictures of Parisian Life by J.J. Tissot*) in 1886.

This series was not well received by critics, many of whom compared the works to illustrations. In the June 1886 issue of *The Magazine of Art*, an anonymous critic noted Tissot was catering to the "English love for anecdote and incident" by a man "who can use paint and can give something of the real aspect of a scene," and also critiqued *The Woman of Fashion* as one of several works in the series in which "the figures are all jammed together, with no air between them, and no sense of value in their reliefs."[10] Another critic argued in the June 12, 1886 issue of *The Saturday Review* that Tissot had ignored the "real appearance of things" and was dammed for his "coarse perception of effect, false relief among the figures and masses, a general flatness" in the "worst specimens" of the series (including *The Woman of Fashion* and *The Shop Girl*).[11] The critic for *The Academy* was more thoughtful in his analysis of the series, noting Tissot's skill in rendering the beautiful *toilettes* of the *haute monde* of Paris:

> The men in these visions of real life are but foils to the women – beetles to butterflies! M. Tissot's women are of Paris. . . . Here from the centre of each composition the true Parisienne looks out upon us, smiling, chattering, conquering, pouting, sight-seeing, and money-getting – always pretty, never beautiful; always fascinating, never satisfying. . . . M. Tissot is perfectly at home in rendering the air of distinguished frivolity, the rich textures of the perfectly fitting '*toilettes*', and the luxurious surroundings of the '*haute monde*' of politics or fashion. . . . We see the outer woman only; but, there are no hidden depths of character behind the pretty masks.[12]

Attempting to capture the essence of the chic Parisienne was somewhat of a risky undertaking for an artist in the latter part of the nineteenth century because this was "a highly contested field" with the word *Parisienne* linked to a "series of well-rehearsed narrative associations, expectations and assumptions grounded in nineteenth-century gender ideology."[13] In writing a biography of Tissot in 1936, James Laver attributes the failure of the series to Tissot's refusal to develop his style in line with his contemporaries and writes, "To the eyes of the cultivated French people, familiar with the paintings of Manet, the canvases of Tissot seemed like coloured photographs."[14] Unlike his friend Manet and the other impressionists, Tissot chose not to engage in experiments with the effects of light or abstraction.

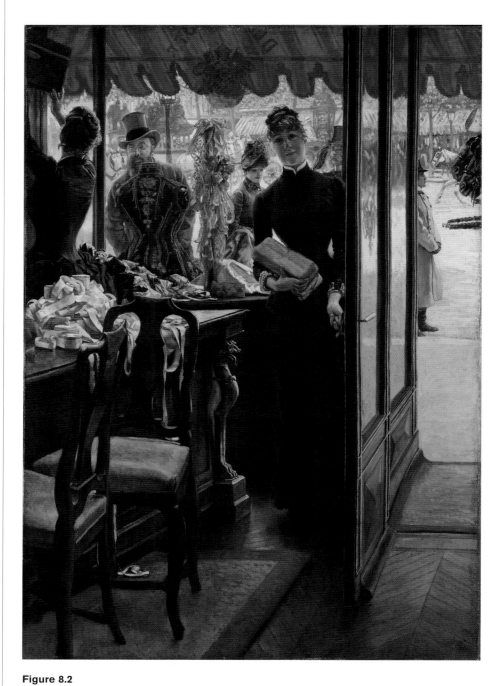

Figure 8.2

James Jacques Tissot, *La demoiselle de magasin* (*The Shop Girl*), 1883–1885. Oil on canvas (146.1 cm × 101.6 cm).

Tissot's acute attention to detail adds the dimension of color to a time when portrait photography required relatively long exposure times, principally took place in the confines of a studio, and was absent of color unless painted over. The vibrant colors and rich textures in Tissot's paintings make them valuable windows into another time.

In the 1880s, fashions were changing rapidly, but as the son of a wholesale linen-draper and a milliner, Tissot would have had exposure to and knowledge of the nuances of fashion as well as familiarity with the popular colored fashion plates that disseminated the latest looks.[15] This may be the reason that many of the women in this series have similar features—brown hair in an up-do with a fringe and doe-like eyes—a look that was replicated in many fashion plates of the decade (see for example Figure 8.3, Figure 8.6, and Figure 8.7). When Tissot began the paintings in 1883, the bustle was relatively modest but by the time the paintings were exhibited in Paris in 1885 and in London in 1886, the bustle projected backwards in such a way that it gave the impression that "the woman is saddled with a shrouded bird cage which sticks out monstrously behind her."[16] The shelf-like projection created by the bustle can be seen in the side view of the brown silk satin evening gown from Costume Institute Collection of the Met dated to the 1880s in Figure 8.4 (Accession #C.I.57.15.4a,b).

Art historian Krystyna Matyjaszkiewicz argues that in this series Tissot did not pay sufficient attention to the nuances of fashionable dress between 1882–1885 and cites several critics who had remarked that some of the clothes were "out of date."[17] Tissot's depiction of an outmoded dress is obvious in the painting *L'Ambitieuse* or *The Political Woman* in which the model wears an outdated frothy pink dress with a black velvet girdle that closely resembles the dress, pose, and composition of his 1878 painting *The Ball*.[18] Matyjaszkiewicz also argues that the clothing in the painting *La Mondaine* or *The Woman of Fashion* could "just as well be those of the mid and late 1870s,"[19] but does not offer any evidence or analysis to support her commentary. Although the clothing in some of the works in the series may have been out of date, I will argue that in this particular painting, Tissot took care to render *la mondaine* sufficiently fashionable that we can read this work as Tissot's representation of the ideals of Parisienne beauty for its time.

In his 1863 essay "*Le Peintre de la Vie Moderne*" ("The Painter of Modern Life"), Charles Baudelaire articulated an aesthetic manifesto in which he linked fashion, beauty, and taste. He asserted the gravity of fashion as an emblem of modernity.[20] Baudelaire articulated how beauty is reflected in a particular moment of time and declares that it is far more important to acknowledge that fashions embody "the moral and aesthetic feeling of their time."[21] Baudelaire links beauty to fashion as predominantly a feminine attribute. For a woman, striving for beauty is "a kind of duty, when she devotes herself to appearing magical and supernatural; she has to astonish and charm us . . . as an idol, she is obliged to adorn herself in order

Figure 8.3

Unknown artist, theatre
headdress (*capuchon de
theatre*), *La Mode Illustrée,
Journal de la Famille*,
November 5, 1882.

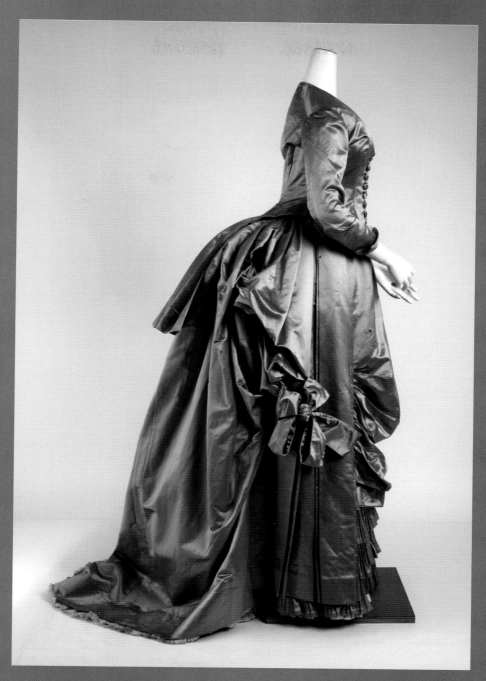

Figure 8.4

Unknown maker,
evening dress, 1880s.

to be adored."[22] Baudelaire defined beauty as being composed of two elements: one that is an "eternal, invariable element, whose quantity it is excessively difficult to determine" and a second changeable element that is representative of its time in terms of expressing "the age, its fashions, its morals, its emotions."[23] He described this fleeting element as being captured within the small details of fashion such as the way a woman's hair is pinned at the back of the neck, the trimming of ribbons on her dress, or in her wearing of an expansive crinoline.[24]

Baudelaire's writings had a powerful influence on many artists of the period, including James Whistler and Edgar Degas,[25] and very likely on their friend James Jacques Tissot. In Tissot's painting *La Mondaine*, fashion is explicitly linked to beauty in the English title *The Woman of Fashion*. The central character—*la mondaine*—wears a two-piece evening dress of pink silk satin with a train (Figure 8.1). Although we cannot see her *decolleté* underneath the lace *capuchon* that covers her neck and shoulders, there is a pink floral rosette at center front of the dress neckline. The bodice is close fitting and trimmed with a soft ruffle at its lower edge that ends in a sharp V near the hips, pointing to her sex. The dress skirt is softly draped at the front creating deep folds, and the hem is edged in a heavy fringe of either corded silk or silk ribbon. The back is bustled and the edge of the train is visible with its protective leather edging that lines the hem.

Although the title of the painting indicates that Tissot wanted the viewer to read the dress of *la mondaine* as fashionable, a comparison to extant dresses and fashion plates is necessary to properly make that assessment, especially in light of the fact that Tissot was known to have rendered the same dress in more than one work.[26] A very similar pink dress designed by Parisian designer Charles Frederick Worth and dated to 1882 was identified from the collection of the Costume Institute at the Met (Accession #2009.300.635ab). At this time in history, Worth not only sold his elaborate gowns to *la mondaine* of Paris, but he had an international clientele as "the designer of choice for American society."[27] Worth's pink evening gown with a short train and ornamentation at the hem with floral trim, soft draping, and tiers of sheer ruffles from The Met's collection (Figure 8.5) is much like the gown depicted by Tissot. Pink evening gowns with bustles can also be found in fashion plates for the period, providing additional evidence to the fashionability of the gown worn by *la mondaine* in Tissot's painting. The January 14, 1883 issue of *Revue de la Mode* includes a fashion plate with a similar pink evening gown with a small bustle and trimmed with pink flowers (Figure 8.6), as does the December 13, 1885 issue of *Revue de la Mode*, which includes another pink evening gown with an open neckline trimmed in lace, a draped skirt front, tiered ruffles, and a modest bustle (Figure 8.7). Even though the extreme shelf-like bustle was *a la mode* in 1885 and 1886, there was some variation in the size of bustles worn at that time.

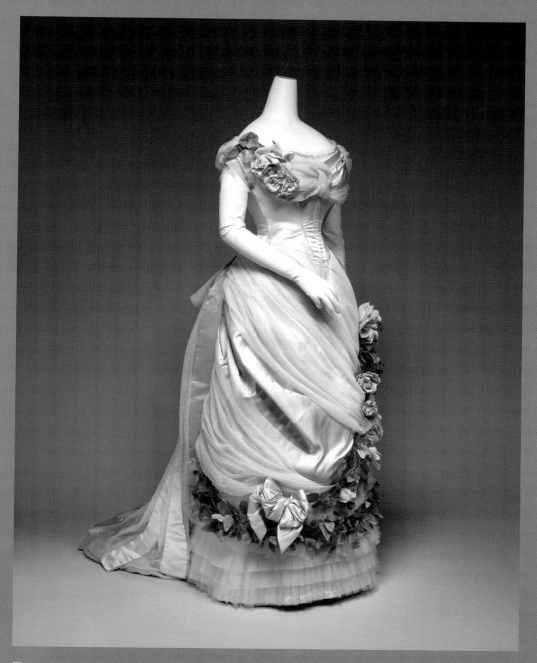

Figure 8.5

Charles Frederick Worth,
evening gown, 1882.

Figure 8.6

Artist unknown, *Revue de la Mode, Gazette de la Famille,* January 14, 1883.

Figure 8.7

A. Chaillot, *Revue de la Mode, Gazette de la Famille,* December 13, 1885.

The back of the dress in the case study painting is substantially concealed by *la mondaine*'s velvet and fur mantle. She has not yet put her left arm through the sleeve and holds her left hand to the collar as she turns to look at us. Her elderly husband or lover stands just behind her helping her don the mantle but also protectively guarding her from the handsome and younger men nearby. This mantle is not a simple cloak for warmth, but a lush mantle of silk velvet that is lined with thick fur and trimmed with a long thick brown silk fringe that mimics the upholstery and decorations of the period. A similar mantle of satin brocade and trimmed with fringe can be seen in the fashion plate from *La Mode Illustrée* in Figure 8.8. The Costume Institute at the Met has several lavish mantles in their collection dated to this time including an evening mantle trimmed with fur by the House of Worth, shown in Figure 8.9 (Accession #2009.309.127). This luxurious mantle by Worth symbolizes class and privilege, as does the mantle in Tissot's painting.

The term *la mondaine*, as historian Caroline Weber explains, was used to describe a woman of the world, the "it girl" of her time in embodying the ideals of beauty, elegance, style, and glamor.[28] In her book *Proust's Duchess: How Three Celebrated Women Captured the Imagination of Fin-de-Siècle Paris*, Weber documents the lives of three Parisienne women from the latter part of the nineteenth century: Élisabeth de Riquet de Caraman-Chimay, Comtesse Greffulhe; Geneviève Halévy Bizet Straus; and Laure de Sade, Comtesse Adhéaume de Chevigné. Weber suggests that these three women served as the inspiration for Marcel Proust's composite character Duchesse de Guermantes in his masterwork *In Search of Lost Time*. According to Weber, each of these women used her position of privilege along with a seemingly modern aptitude for self-promotion to command respect in a society "founded on the traditions of hereditary privilege and courtly elegance."[29] Fashion was a tool by which these women expressed their status. Élisabeth Greffulhe (Figure 8.10) once expressed her philosophy as a woman of fashion:

> She concerns herself with fashion not by following it, but by dictating its course; it is she who decrees new forms and twists surprised fabrics into new functions. She commissions new styles at will and unveils them to the world, offering up her beauty in the whim of her caprice. . . . Eyes and hearts, love and hate fly to her, the unique woman, the woman nonpareil – no one dares to emulate her.[30]

Greffulhe was known to have spent enormous sums on her wardrobe as a regular customer at Worth. Her glorious wardrobe, including several gowns by Worth, has survived and has been exhibited in Paris and New York.[31]

Figure 8.8

Artist unknown, evening coat in satin and brocaded velvet
(*manteau en satin broché de velours*), *La Mode Illustrée,
Journal de la Famill*e, November 12, 1883.

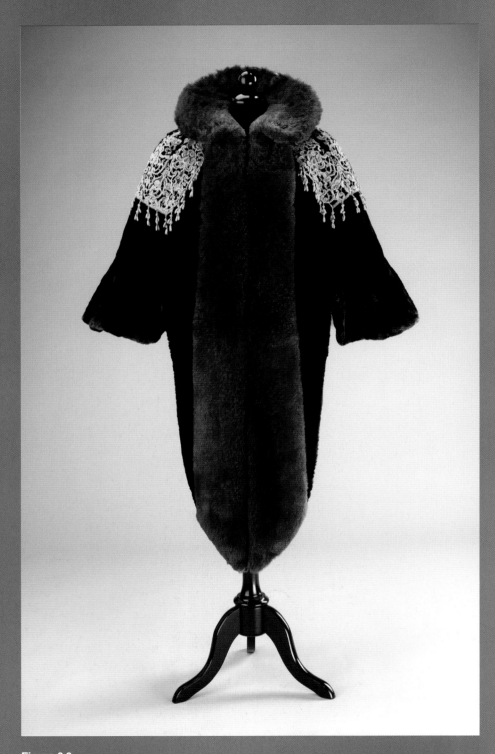

Figure 8.9

House of Worth (1858–1956), evening mantle, ca. 1887.
Front view.

Like Proust's composite construction of the Duchesse de Guermantes, Tissot attempted to illustrate the archetype of the quintessential Parisienne *la mondaine* rather than paint a portrait of a specific woman. Tamar Garb points out that Tissot's *mondaine* is literally shrouded in "an abundance, even an excess, of lace, fur and cloth" such that she becomes "the admired, cherished jewel of which fantasies are made."[32] And yet, as art historian Marie Simon points out, *la mondaine* knew "full well that, more than her face, which after all was known to everyone, it was her dress that would arouse excitement and comment."[33] This glamourous creature knows she is on display and she looks directly at us, challenging us with her confident gaze in a manner that seems to mirror the haughty gaze of Élisabeth Greffulhe in her portrait by Paul Nadar as seen in Figure 8.10. Greffulhe once articulated the pleasurable feelings she experienced in being the center of attention as follows: "I don't think there is any pleasure in the world comparable to that of a woman who feels she is being looked at by everybody, and has joy and energy transmitted to her."[34] In Tissot's painting, a woman dressed in pale gray with a black headscarf standing just to the left of *la mondaine* looks timidly in the direction of *la mondaine*, perhaps wishing she were in her shoes. The expansive train of *la mondaine* gives her space from the others and she stands out in the sea of elegant men dressed in black. Her youth and beauty act as a foil to her husband or lover since his wealth and position are mirrored by the obvious expense of her magnificent ensemble.

Ulrich Lehmann argues that it was in the late nineteenth century that clothes were used symbolically to represent "beauty, open or repressed sexuality, social aspiration or moral deviation."[35] In this painting, Tissot has depicted *la mondaine*'s husband or lover as an elderly man with gray hair whiskers. There is the suggestion that he has bought her youth and beauty through his status and position, giving this painting a moral undertone. It was at society balls and the races in which *la mondaine* and *demi-mondaine* or courtesans rubbed shoulders, and they were generally indistinguishable from one another in that they were dressed by the same dressmakers, with the "only distinction that the demi-mondaines seemed a little more chic."[36]

In the series *La Femme Parisienne*, Tissot attempted to capture the essence of the Parisienne. Although the series was at the time deemed an abject failure by critics, his body of work has come to be appreciated today for its acute attention to detail. Although in some of his works he reused dresses or failed to pay sufficient attention to the rapidly changing fashions, his body of work can today be read as a reflection of a period in which fashion reflected women's objectification as decorative mirrors of their father's, husband's, or lover's wealth. In *La Mondaine* or *The Woman of Fashion*, fashion is presented as the mechanism by which a young and beautiful woman has elevated her position in society, and she conveys the ideals of feminine beauty in the late nineteenth century in her close attention to her toilette, her elegant countenance, and her confidence. In this series, Tissot brings us into the picture plane and in this image, we feel her discerning gaze and wonder whether we measure up.

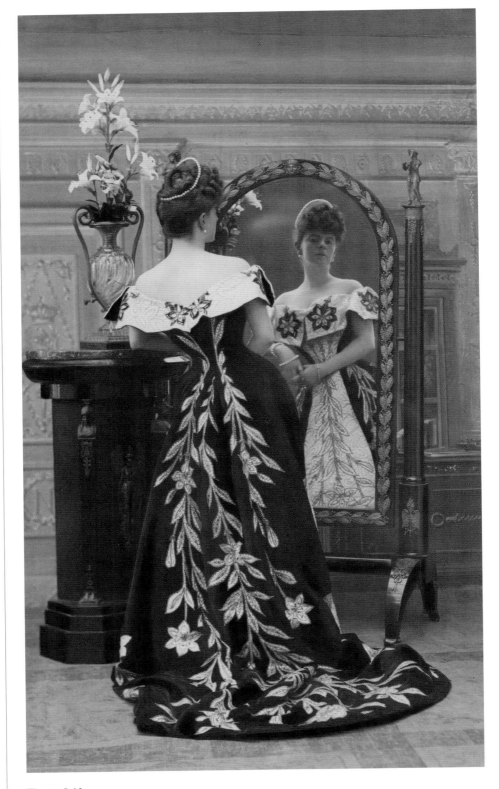

Figure 8.10

Paul Nadar, *Portrait of Élisabeth, Countess Greffulhe (1860–1952),*
née de Riquet de Caraman–Chimay, 1896.

ENDNOTES

1. German philosopher Immanuel Kant (1724–1804) considers the nature of beauty and its relationship to taste and desire as philosophical constructs of morality; he links aesthetic judgment to taste and the feeling of pleasure or displeasure. See Immanuel Kant, *Critique of Judgement*, edited by Nicholas Walker, translated by James Creed Meredith (Oxford: Oxford University Press, 2007), 41–47.

2. Kant, *Critique of Judgement*, 47.

3. Elizabeth Wilson, *Adorned in Dreams: Fashion and Modernity* (London: I.B. Tauris, 2011), 9.

4. Charles Baudelaire, "The Painter of Modern Life," in *The Painter of Modern Life and Other Essays*, trans. Jonathan Mayne (New York: Phaidon Press Inc., 2010), 3.

5. Contemporary artists, including Mari Katayama, a disabled artist of Japanese heritage, are challenging prevailing notions of beauty in their works. See Julia Friedman, "Dismantling Beauty Through Extreme Self-Portraiture," *Hyperallergic*, July 16, 2019. Accessed July 23, 2019 https://hyperallergic.com/502327/dismantling-beauty-through-extreme-self-portraiture/

6. P. Perret quoted by Michael Wentworth, *James Tissot* (Oxford: Clarendon Press, 1984), 160.

7. The setting suggests an evening at a fashionable ball—perhaps the home of what is now Musée Jacquemart-Andres—which was the site of many fashionable events and parties in the latter part of the nineteenth century. The home of Édouard André (1833–1894) and Nélie Jacquemart (1841–1912), now a museum, is located at 158 Boulevard Haussmann in the eighth arrondissement of Paris. Designed by the architect Henri Parent, the main reception hall includes several features that are similar to those rendered by Tissot in the case study painting, notably the ironwork railing, the columns, and the tiled floor.

8. The titles of the paintings in English are as follows (listed in order of their exhibition at the Galerie Sedelmeyer Paris in 1885): *Political Woman*; *The Ladies of the Cars*; *Without Dowry*; *The Mystery*; *The Fashionable Beauty*; *The Tight-Rope Dancer*; *The Gossip*; *The Woman of Fashion*; *The Bridesmaid*; *Painters and Their Wives*; *The Amateur Circus*; *Provincial Women*; *The Spinx*; *The Shop Girl*; and *Sacred Music*. See Appendix X

of Michael Wentworth, *James Tissot* (Oxford: Clarendon Press, 1984).

9. Following the exhibitions of this series, Tissot abandoned his plans to create etchings of the paintings and the short stories that were to accompany the series were never written. The primary focus of his paintings became religious subjects and portrait commissions.

10. Anonymous, "Art in June," *The Magazine of Art*, June 1886, 9.

11. Anonymous, "Minor Galleries," *The Saturday Review*, June 12, 1886, 33.

12. Anonymous, "Tissot's 'Pictures of Parisian Life,'" *The Academy*, August 28, 1886, 142.

13. Tamar Garb, "Painting the Parisienne: James Tissot and the Making of the Modern Woman," in *Bodies of Modernity, Figure and Flesh in Fin-de-Siècle France* (London: Thames and Hudson, 1998), 83.

14. James Laver, *Vulgar Society: The Romantic Career of James Tissot, 1836–1902* (London: Constable, 1936), 54.

15. Krystyna Matyjaszkiewicz, "Costume in Tissot's Pictures," in *James Tissot* (Oxford: Phaidon Press and Barbicon Art Gallery, 1984), 62.

16. Charles H. Gibbs-Smith, *The Fashionable Lady in the 19th Century* (London: Victoria & Albert Museum, 1960), 7.

17. Matyjaszkiewicz, "Costume in Tissot's Pictures," 77.

18. Tissot's painting *The Political Woman* from this series is in the collection of the Albert-Knox Art Gallery in Buffalo, New York. Tissot's 1878 painting *The Ball*, also known as *Evening*, is in the collection of Musée d'Orsay in Paris, France.

19. Matyjaskiewicz, "Costume in Tissot's Pictures," 76.

20. Baudelaire, "The Painter of Modern Life," 3.

21. Baudelaire, "The Painter of Modern Life," 2.

22. Baudelaire, "The Painter of Modern Life," 33.

23. Baudelaire, "The Painter of Modern Life," 3.

24. Baudelaire, "The Painter of Modern Life," 10.

25. Alice Mackrell, *Art and Fashion: The Impact of Art on Fashion and Fashion on Art* (London: Batsford, 2005), 93.

26. In his essay on Tissot, Edward Maeder notes that the artist had a collection of costumes that he used as studio props and often used the same costume in numerous works. See Edward Maeder, "Decent Exposure: Status, Excess, the World of Haute Couture, and Tissot," in *Seductive Surfaces: The Art of Tissot*, edited by Katharine Lochnan (New Haven: Yale University Press, 1999), 83–85.

27. Françoise Tétart-Vittu, "The Origins of Haute Couture," in *Paris Haute Couture*, ed. Olivier Saillard and Anne Zazzo, trans. Elizabeth Heard (Paris: Flammarion, 2012), 19–20.

28. Caroline Weber, *Proust's Duchess: How Three Celebrated Women Captured the Imagination of Fin-de-Siècle Paris* (New York: Knopf, 2018), 2–3.

29. Weber, *Proust's Duchess*, 5.

30. Élisabeth Greffulhe quoted in Weber, *Proust's Duchess*, 229. Ellipsis added.

31. The Palais Galliera in Paris held an exhibition of the wardrobe of the Vicomtesse called *La mode retrouvée: Les robes trésors de la comtesse Greffulhe* in 2015. This exhibition was replicated in part under the title *Proust's Muse, the Countess Greffulhe* at the Museum at FIT in New York (September 23, 2016–January 7, 2017).

32. Garb, "Painting the Parisienne," 83.

33. Marie Simon, *Fashion in Art: The Second Empire and Impressionism* (London: Philip Wilson Publishers Ltd., 1995), 39.

34. Translated by author from the original French, "*Je ne crois pas qu'il y ait au monde de jouissance comparable à celle d'une feeme qui se sent l'object de tous les regards, lui communiquant de l'allégresse et de l'energie.*" Élisabeth Greffulhe quoted by Valerie Steele, "L'aristocrate comme oeuvre d'art," in *La Mode Retrouvée: Les Robes Trésors de la Comtesse Greffulhe*, ed. Olivier Salliard (Paris: Palais Galeria, 2015), 62.

35. Ulrich Lehmann, *Tigersprung: Fashion in Modernity* (Cambridge: MIT Press, 2000), 282.

36. Valerie Steele, *Paris Fashion: A Cultural History* (New York: Oxford, 1998), 170.

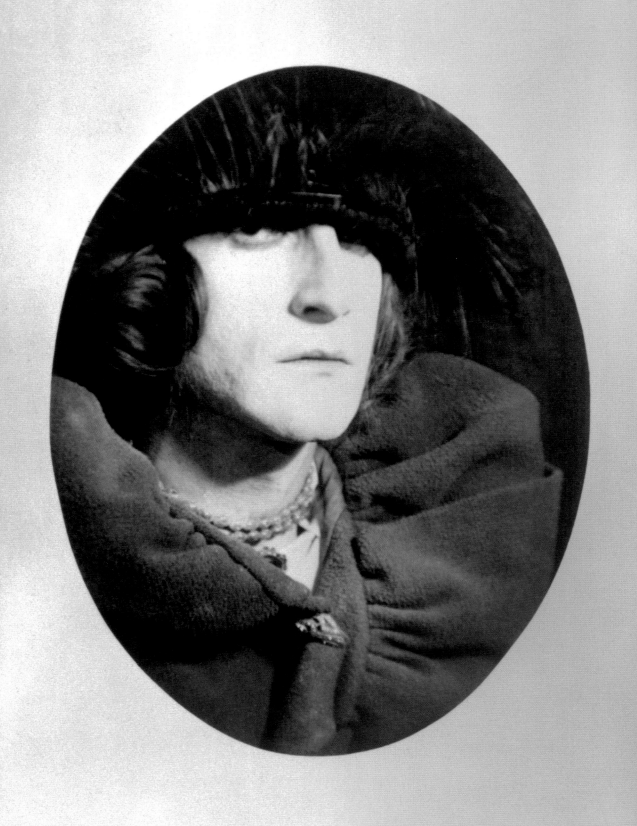

9

Fashion & Gender

Fashion continually redefines the visual clues that signal masculinity and femininity. In western cultures, dresses are associated with femininity, although women have long incorporated elements of male dress, including elements of uniforms, waistcoats, top hats, and trousers into their wardrobe.[1] In some cases, such garments do not obscure gender but may serve to emphasize the curves and markers of femininity. However, when western men adopt elements of feminine dress, this is often seen as a form of subversion or challenge to gender norms, even though Judith Butler and others have argued that gender is a cultural construction.[2] In the case study that follows, the idea of using fashion to express notions of gender play is explored using the photographs of one of the twentieth century's most influential artists, Marcel Duchamp (1887–1968), dressed as a woman.

CASE STUDY: MARCEL DUCHAMP AS RROSE SÉLAVY

In *Seeing Through Clothes*, Anne Hollander argues that in analyzing works of art, clothes are often dismissed as trivial, when clothes should "be seen and studied as paintings are seen and studied," because clothes "make, not the man, but the image of man."[3] In the photograph *Portrait of Marcel Duchamp as Rrose Sélavy*, artist Marcel Duchamp wears a woman's hat, wig, necklace, and cloth coat (Figure 9.1). The black and white image, made in collaboration with the American photographer Man Ray (1890–1976), is tightly cropped in an oval frame and Duchamp turns his head slightly but offers a direct gaze. The image is in soft focus, but this does not obscure the fact that Duchamp is a man dressed as a woman. This image is one of at least three poses of Duchamp dressed in this way from a series made by Duchamp and Man Ray in 1920–1921 that have been given various titles such as *Rrose Sélavy* or *Marcel Duchamp as Belle Haleine*.[4] Duchamp did not leave any notes that explain his appearances as Rrose, and during his lifetime he would also adopt other guises in photographs including that of a monk, an old man, and a devil.[5]

In this case study, I contextualize Duchamp's gender play and engagement with fashion (Figure 9.1). Although Marcel Duchamp expressed indifference to matters of taste and did not claim to be inside or outside of fashion, Elizabeth Wilson points out that no one is outside of fashion, even if they claim to be so, because "to be unfashionable is not to escape the whole discourse, or to get outside the parameters."[6] Duchamp, considered one of the most important artists of the twentieth century in authoring the readymade and challenging the notions of what art could be, signed many of his works with pseudonyms. For his female alter ego, he adopted the name Rose or Rrose Sélavy, a play on the French phrase, "*Eros, c'est la vie.*" Her signature first appeared in 1920 as a copyright notice on Duchamp's work *Fresh Widow*, and was later inscribed on other works, including another series of images in which he dressed as Rrose and was photographed by Man Ray in 1921.

In *Portrait of Marcel Duchamp as Rrose Sélavy*, by Man Ray (Figure 9.1), Duchamp wears a black velvet hat, a brown wig in a fashionable chin-length bob, a double-strand necklace and a cloth coat with a large portrait collar. Each of these components signifies femininity, and it is a deliberate masquerade or performance of "other." His choice of clothing—a coat and a hat—is somewhat utilitarian, in that they cloak the body rather than reveal it. Duchamp did not don a dress or otherwise reveal his body, even though he might have done so given that his slender frame would have suited the angular shapes of the early 1920s fashions.

The transformation of Duchamp into his female alter ego in this series of images began with a wig of chin-length curls that softened the lines of his angular face. This shorter style of hair, known as bobbed hair, was, at the time, a recent and notable change in hair fashions for women.[7] In an article called "The Beneficent Rule of Bobbed Hair" in the March 15, 1921 issue of *Vogue*, readers were informed of the freedoms afforded by bobbed hair. Readers were also instructed to curl their hair and to wear smaller hats that would frame the face:

> The small head size we must have, because the bobbed hair demands it. But becomingness requires that, first and foremost, the hat should make the face and features look small, and sometimes this can only be accomplished by filling out the line of it . . . [with] curled hair. Bobbed hair has brought in the close-fitting hat, and bobbed hair makes the close-fitting hat becoming.[8]

Duchamp's use of a wig echoes this new fashion for bobbed hair as can be seen in the photos that accompany this article and other photographs from the time. It is also worth noting that Duchamp was closely acquainted with several women who cut their hair in this style, including the artist and illustrator Clara Tice, who was described as among the first in avant-garde circles to bob her hair.[9]

For this series of images in which he presents himself as Rrose Sélavy, Duchamp wears a woman's black velvet hat low on his head in a manner that frames his face and gives emphasis to the eyes. Ornamented with glycerized ostrich feathers or possibly monkey fur, this hat is highly fashionable and is similar to that worn by couturier Paul Poiret's wife Denise in a photograph from 1919 shown in Figure 9.2. There are many such hats illustrated in *Vogue* and other fashion journals in 1920–1921, and the collection of the Los Angeles County Museum of Art (Accession #48.30.5) includes a silk velvet hat ornamented with dyed ostrich feathers by House of Reboux, ca. 1920s. (Figure 9.3). As well, the collection of the Costume Institute at the Met also includes several comparable examples such as a black hat with feathers by the designer Kurzman, New York (Accession #C.I.45.77.4).[10]

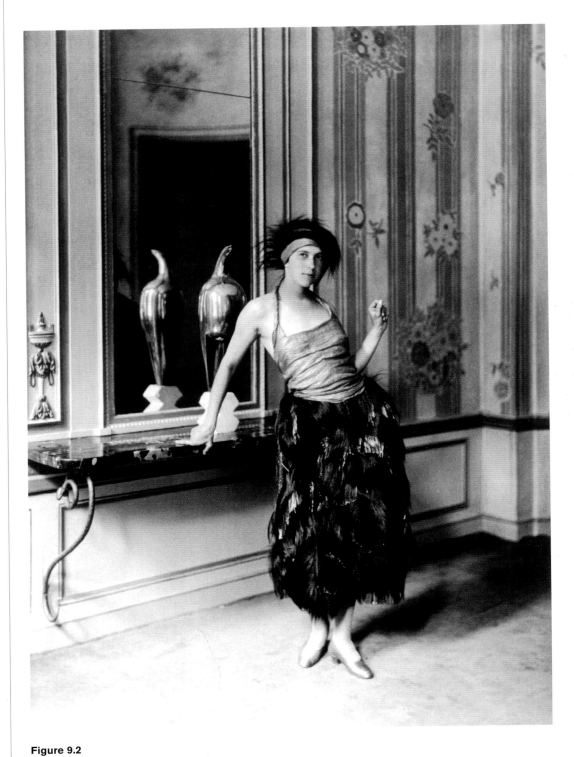

Figure 9.2

Photographer unknown,
Denise Poiret, 1919.

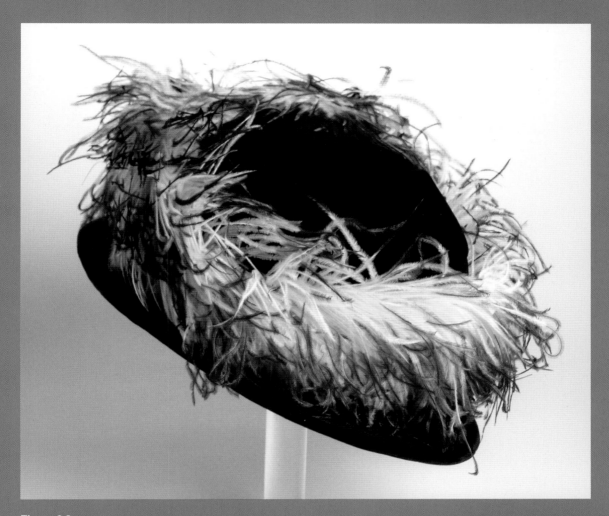

Figure 9.3

Caroline Reboux, silk velvet hat
with ostrich feathers, ca. 1920s.

Coats with high stand collars that framed the face were highly fashionable in 1920 and 1921, and appear on the cover and through the pages in *Vogue* in those years. Although the most stylish coats were made of silk brocade or velvet and ornamented with fur, chic coats were also made of cloth, as is shown in the illustration *Walking the Dog* published in *Art Gout Beauté* (Figure 9.4). Duchamp wears such a coat to signify his transformation into a woman, and the softly ruched collar of this coat distinguishes it from the notched lapel of a man's coat. Similar examples of women's cloth coats with high collars in museum collections include a Gabrielle Chanel coat dated to the 1920s made of dark brown velveteen in the Kyoto Costume Institute Collection (Accession #AC3645 80-30-1) as well as a silk coat by Maria Gallenga from the collection of the Costume Institute at the Met (Accession #1989.165.1). The collar of this latter coat is remarkably like the one worn by Duchamp and even though the coat is dated to 1926, it serves as a signal of the artist's sensitivity to the nuances of fashion.

Also meaningful in the construction of this image is the double-strand bead necklace that resembles natural pearls and a shell-shaped broach at the neck, since jewelry is a notable signifier of femininity. In spite of these fashionable markers of femininity, the transformation is not complete. The high contrast lighting creates a strong shadow on Duchamp's neck that emphasizes his Adam's apple as well as the whiskers on the right side of his chin (i.e., the left side of the image). Duchamp gazes directly at the viewer and is unsmiling, confronting the viewer with his transformation. In another version of this image in the collection of the Israel Museum,[11] Duchamp's face is turned in a different direction and the collar is pulled higher to frame and flatter the face. In all three versions of this image, it is evident that this is a man dressed as a woman, and there is a discomforting sense of ambiguity.

Later in 1921, Duchamp sat for Man Ray in Paris for another series of photographs of Rrose.[12] In this series, Duchamp wore makeup including smoky eye shadow and lipstick. Instead of a wig, his head is topped with a dark felt hat with a wide brim that is encircled with a geometric-patterned scarf. Duchamp is again dressed in a woman's cloth coat; this one is expansively trimmed with fur at the neckline and cuffs. The coat was apparently borrowed from Francis Picabia's girlfriend Germaine Everling, who also inserted her hands into the image. Although the lighting was softer and more diffuse imparting a more flattering texture to his skin, the transformation from man into woman is incomplete.

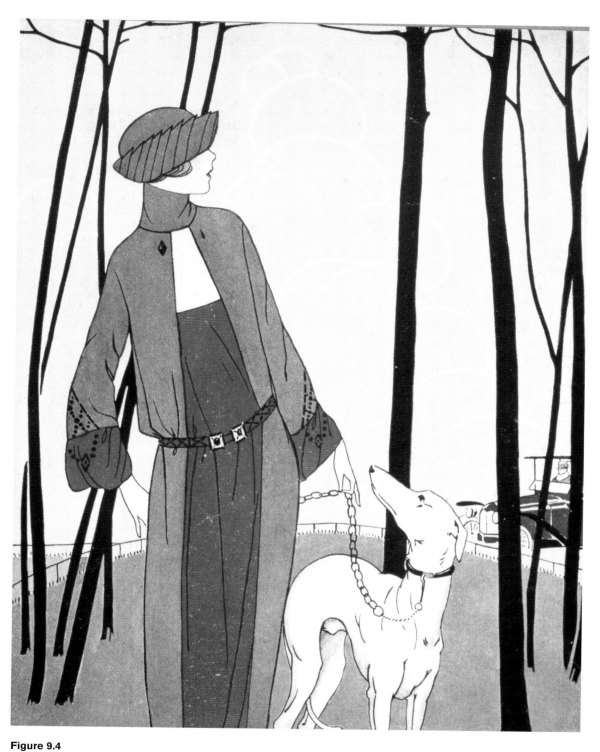

Figure 9.4

Artist unknown, *Walking the Dog*,
ca., 1920–1921. Pochoir print.

Art historian Wendy Wick Reeves situates Duchamp's gender play within the context of new ways of thinking about the concept of identity around the turn of the century. Influenced by the writings of Freud, Jung, and others, the notion of a fixed character was replaced with the notion of identity being "multiple, mutable, fractured, invented or disguised."[13] These ideas were embraced in new forms of portraiture that included masks and portrait dolls, word portraits, musical portraits, machine portraits, and mathematical approaches to drawing portraits. During an age of high cultural anxiety, portraiture "was celebrated as an exciting and flexible paradigm, brimming with innovation" and the idea of the mask was embraced as a form that served to "imply concealed complexity or, indeed to magnify and exaggerate specific elements of identity."[14] Reeves thus reasons that the portraits of Duchamp were created at a time in which many artists were exploring the notion of fractured or multiple identities and should be read within that context. Although Reeves reminds us that Duchamp did not create this work in isolation, she does not connect his gender play to the modes of dressing or the behavior of women at the time, even though it is through fashion that gender is manifested in a visual form.

As Elizabeth Wilson reminds us: "Fashion is obsessed with gender, defines and redefines the gender boundary."[15] Each period in history has expressed this gender boundary through the articulation of acceptable choices of clothing, accessories, hairstyles, and other forms of body adornment; this serves to emphasize or minimize the differences between men and women. At the end of the nineteenth century (when Duchamp was a teenager), fashionable women's dress emphasized femininity with an S-shaped corseted silhouette that was ornamented with lace, feathers, frills, and bows. A woman's dress was central to her identity and status within society, and codes of femininity dictated strict rules of what was considered appropriate attire. When Duchamp created this image in 1920, women's dress had radically changed from bourgeois ideals of femininity, and for that reason, I argue that the portraits of Rrose Sélavy must be examined within the context of *la garçonne* or the flapper in the late 1910s and early 1920s.

In *Gender Trouble*, Judith Butler argues that gender is a cultural construction that is learned over time. This "stylization of the body" through a "set of repeated acts within a highly rigid regulatory frame" is influenced by political and social ideology to produce a "natural sort of being."[16] Masculinity and femininity are thus social constructs that are visually manifested through the fashioning of the body as an articulation of identity. In engaging in cross-dressing, the body is refashioned into "the Other." Queer theory suggests that the gender doubling seen in images of Duchamp dressed as his female alter ego is a performance that highlights "the electivity of gender" which serves to "destabilize gender binaries," as Deborah Johnson writes.[17]

Duchamp attempts to disguise his male body with clothing, makeup, and accessories to become his female alter ego, but the transformation is incomplete. In these images, Duchamp's outside appearance reads as feminine but his masculinity remains intact. This transformation becomes a parody, and Duchamp lets us in on his joke in constructing a parody of the flapper or *la garçonne*. This new modern woman—the flapper or *la garçonne*—embraced an androgynous style of dress and ignored the staid bourgeoisie codes of manners, dress, and morality that had governed a woman's dress and behavior in the first decade of the twentieth century. She cut her hair, applied makeup in public, went without stockings, and also danced, drank, and smoked with abandon. Although the word *flapper* was initially associated with young English girls in that awkward stage between girl and woman, by 1917, the term was used to describe the "new" modern woman who embraced new styles of behavior and dress. She was described in the editorial pages of *Vogue New York* in February 1917 as follows:

> She is a fantastic grotesque, pretty in the modern manner, which is a wild mixture of Paris, futurism, the primitives, and a little rouge. She is quite small, inconceivably fragile; she has a delicate chin, audacious eyes, and a candid forehead. She is feverishly interested in two things, herself and her clothes. Everything else in the world quite frankly bores her to tears.[18]

The author identifies the slender, youthful, and uncorseted flapper as an anomaly—a *grotesque*—and notably links her to Paris and futurism. In France, this type of woman was called *la garçonne*.

Whether described as *la jeune fille américaine*, *la garçonne*, or the flapper, the spirit of the liberated androgynous gamine profoundly influenced fashion in the late 1910s and 1920s. The fashionable silhouette of the early twenties emphasized straight lines rather than curves, and clothes were shown to best effect on a lean, angular, and boyish figure that was hipless, bust-less, and waist-less. For some women, emancipation was interpreted as freedom to dress "as much like a man as possible—in a smoking jacket, waistcoat, necktie, tailored suit, stout shoes or pyjamas. Some chose the masculine manner to underline their political views or to hide their sexuality."[19] In 1922, an anonymous writer for *Vogue* wrote: "Men and women are becoming every year more indistinguishable. The distinction between the sexes has been discovered to be grossly exaggerated."[20] The androgynous gamine was liberated in all respects. Not only could she dress as she wished, she was free to embrace her sexuality, and she became immortalized in 1922 by Victor Margueritte's scandalous novel *La Garçonne*. It is within this context that Duchamp chose to dress as a woman for his collaboration with Man Ray.

Dress historians have identified Denise Poiret, muse and wife of French fashion designer Paul Poiret, as "the prototype of *la garçonne* with her slim, youthful and uncorseted figure."[21] In a photograph of Denise Poiret from 1919, she conveys the sensual appeal of *la garçonne* (Figure 9.2). The open neckline and low back of the dress reveals her slender and boyish figure. Although she was married, her posture is open and erotically suggestive. What is perhaps most interesting is that her headdress is very similar to that worn by Duchamp in his cross-dressing transformation into Rrose; made of monkey fur, the strands stand stiffly away from the head and create a bird-like visage. A similar hat, also by Poiret but made of silk, metallic thread, and feathers, is in the collection of the Costume Institute at the Met (Accession #2005.191) and the curatorial notes read, "In concept, it is similar to a more widely known example of a gold lamé and black monkey fur, worn by Denise Poiret with her 'Paris' evening coat. Both recall eighteenth-century depictions of the headdresses of the allegories of the Continents, notably of Africa and the Americas." This type of headdress was highly fashionable and remained so into 1921, appearing in an illustration of the fashionable Duchess Sjorsa in *Vogue* in September 1921.[22] It is conceivable and even probable that Duchamp knew of the Parisian fashion designer Paul Poiret, and as art historian Nancy J. Troy has observed, there were numerous instances in which the artist and designer might have met in the 1910s and early 1920s.[23]

Another woman who embraced the look of the new woman during this time was Berenice Abbott, who was known for her "bobbed hair and boyish figure."[24] Born in Ohio, Abbott cut her hair in 1917 while still in high school, calling it her "first ever act of rebellion" that let her feel "lighter and freer."[25] After moving to New York, she, like many other liberated women of the time living in the Village, "adopted a code of free behavior and manner, dress, and relationships that set them apart from convention."[26] Abbott became friends with Man Ray, working as his assistant in Paris for several years before launching her career as a photographer. It was through Man Ray that Abbott became friends with Duchamp. Abbott's styling of her hair and manner of dress, seen in Figure 9.5, exemplifies the spirit of *la garçonne*. Her gaze is direct and confident, and although she is wearing a skirt, her jacket is narrow and not overtly feminine.

These two women and many others adopted the aesthetic of androgyny and the spirit of *la garçonne* in the decade following World War I, and it is likely that Duchamp was aware of or influenced by his circle of female friends and avant-garde artists who adopted the fashionable look of androgyny in the 1920s. In reference to the American woman, Duchamp once said in an interview:

> Not only has she intelligence but a wonderful beauty of line is hers possessed by no other woman of any race at the present time. And this wonderful intelligence . . . is helping the tendency of the world to completely equalize the sexes, and the constant battle between them in which we have wasted our best energies in the past will cease.[27]

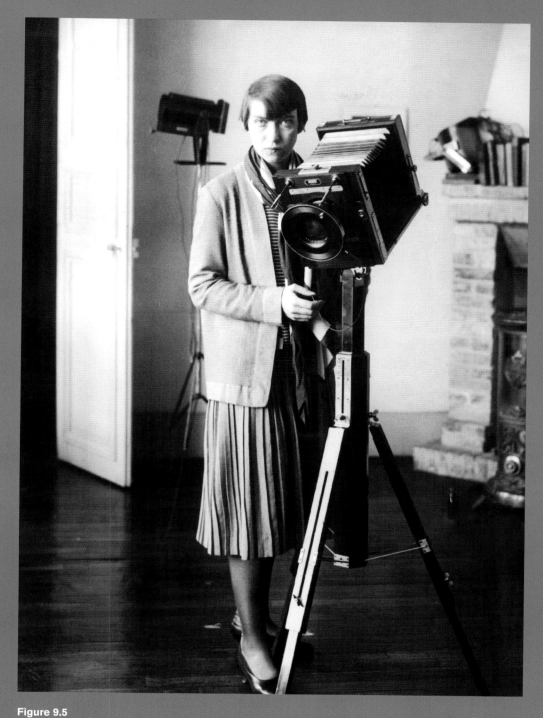

Figure 9.5

Photographer unknown,
Berenice Abbott, ca. 1920s.

In this quote, Duchamp expresses his admiration for the intelligence of women, and I argue that Duchamp, in donning the guise of a woman and authoring his works as Rrose Sélavy, engaged in parody as a strategic intervention into patriarchal gender hierarchies.[28]

Parody is a strategy by which the creator engages in imitation with deliberate exaggeration for comedic or dramatic effect. In these photographs of Duchamp dressed as a woman, I suggest he engaged in parody. As Butler and others have observed, dressing in drag may impart a sense of giddiness or pleasure that is experienced with the subversion of cultural norms.[29] In cross-dressing, the notion of "natural" gender is subverted through the fashioning of the body to adopt the signifiers of masculinity, femininity, or androgyny. Gender parody is itself a paradox, "a fantasy of a fantasy" that serves to reveal "that the original identity after which gender fashions itself is an imitation without an origin."[30] The imitation is a circular displacement of identity without resolution, which offers "a fluidity of identities" allowing for "resignification and recontextualization" that according to Butler denies "critics of the claim to naturalized or essentialist gender identities."[31] In Duchamp's incomplete transformation from man into woman in this series of photographs from 1920–1921, he is neither man nor woman, but man as woman and a parody of himself that displaces the original. With this work and like his readymades that challenged and subverted the notion of the original and the copy, Duchamp as Rrose Sélavy mocks the myth of originality, such that the notion of the "original" is recontextualized.

ENDNOTES

1. See for example, the painting of Marie Antoinette wearing trousers while riding a horse by Louis Auguste Brun, 1783, in the collection of the Musée du Chateau de Versailles. Also see Figure 1.6, in which Lady Worsley wears an ensemble that emulates a British military uniform for her portrait by Sir Joshua Reynolds.

2. Judith Butler, *Gender Trouble: Feminism and the Subversion of Identity* (New York: Routledge, 2007).

3. Anne Hollander, *Seeing Through Clothes* (Berkeley: University of California Press, 1993), xv.

4. These photographs of Duchamp dressed as a woman were not circulated as artworks, but rather were used in other mediums, including as the cover image of *New York Dada*, edited by Man Ray and published in April 1921, as well as Duchamp's perfume bottle readymade *Belle Haleine, Eau de Violette* (1921). For more on the significance of the size and circulation of these images, see chapter 3 in Ingrid E. Mida, "Refashioning Duchamp: Analysis of the Waistcoat Readymade Series and Other Intersections of Art and Fashion," 68–110, PhD dissertation, York University, 2019.

5. For more on this topic, see Mida, "Refashioning Duchamp," 68–110.

6. Elizabeth Wilson, *Adorned in Dreams: Fashion and Modernity* (London: I.B. Tauris, 2011), 5.

7. The American dancer Irene Castle is generally credited for being the first to cut her hair in this style in May 1914, although Peggy Baird claimed she had done so prior to Castle; see Marlis Schweitzer, "Accessible Feelings, Modern Looks: Irene Castle, Ira L. Hill, and Broadway's Affective Economy," in *Feeling Photography*, ed. Elspeth H. Brown and Thy Phu (Durham: Duke University Press, 2014), 204–238.

8. Anonymous, "The Beneficent Rule of Bobbed Hair," *Vogue* (New York), March 15, 1921, 42–43.

9. A portrait of Tice with her distinctive bobbed hair appeared in the same issue of *Vanity Fair* that announced Duchamp's arrival in New York in September 1915. A year later, in September 1916, Tice and Duchamp both attended the Rogue Ball, where Tice won first prize for her costume while Duchamp won the booby prize. Tice also participated in the Independents Exhibition of 1917 and contributed an illustration to *The Blind Man*, May 1917. See Francis M. Naumann, *New York Dada: 1915–1923* (New York: Harry N. Abrams, 1994), 118–119.

10. See the online collection portal for the Metropolitan Museum of Art to see this example and other similar hats in the collection of the Costume Institute.

11. See *Marcel Duchamp as Belle Haleine*, Marcel Duchamp and Man Ray (Emmanuel Radnitzky), 1921. Israel Museum (Accession #B98.0147). © ADAGP, Paris/Man Ray Trust, Paris.

12. See *Marcel Duchamp as Rrose Sélavy*, Philadelphia Museum (Accession #1957-49-1).

13. Wendy Wick Reeves, "Brittle Painted Masks: Portraiture in the Age of Duchamp," in *Inventing Marcel Duchamp: The Dynamics of Portraiture*, ed. Anne Collins Goodyear and James W. McManus (Cambridge: MIT Press, 2009), 10.

14. Wick Reeves, "Brittle Painted Masks," 15.

15. Wilson, *Adorned in Dreams*, 116.

16. Butler, *Gender Trouble*, 45.

17. Deborah Johnson, "R(r)ose Sélavy as Man Ray: Reconsidering the Alter Ego of Marcel Duchamp," *artjournal* 72 (Spring 2013), 93.

18. Mildred M. Cram, "The Extreme Adolescence of America," *Vogue* (New York) 49.3, February 1, 1917, 66.

19. Jane Mulvagh, *Vogue History of 20th Century Fashion* (London: Viking, 1988), 50.

20. Anonymous quoted in Mulvagh, *Vogue History of 20th Century Fashion*, 50.

21. Poiret "Exhibition Overview," Metropolitan Museum of Art, accessed June 11, 2018 at https://www.metmuseum.org/exhibitions/listings/2007/poiret, accessed June 11, 2018.

22. See for example, the illustration of Duchess Sjorsa in "The Parisienne and the Mode Take Tea Together," *Vogue* (New York), September 1, 1921, 60.

23. Nancy J. Troy, *Couture Culture: A Study in Modern Art and Fashion* (Cambridge: MIT Press, 2003), 380–381.

24. Julia Van Hafften, *Berenice Abbott: A Life in Photography* (New York: W.W. Norton & Company), 35.

25. Van Hafften, *Berenice Abbott*, 11.

26. Van Hafften, *Berenice Abbott*, 23.

27. Marcel Duchamp quoted in Calvin Tomkins, *Duchamp: A Biography* (New York: Thames & Hudson, 2014), 148–149.

28. For further analysis of this topic, see chapter 3 in Mida, "Refashioning Duchamp," 68–110.

29. Butler, *Gender Trouble*, 187. The observation that energy is derived from dressing in drag has also been noted by other scholars. See for example, Marjorie Garber, *Vested Interests, Cross-Dressing and Cultural Anxiety* (New York: Routledge, 2011), 159.

30. Butler, *Gender Trouble*, 188.

31. Butler, *Gender Trouble*, 188.

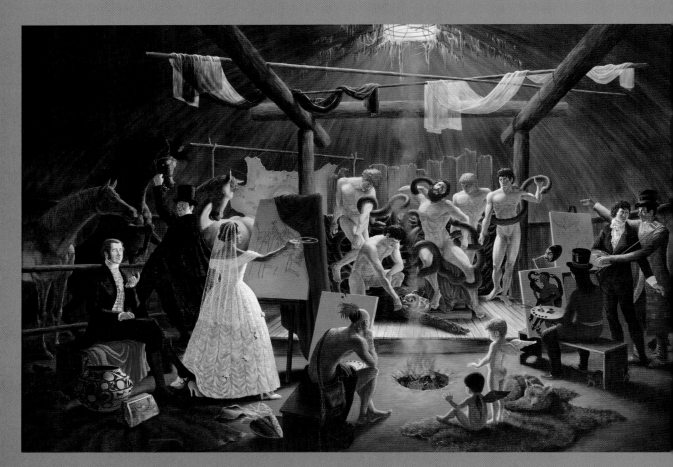

Figure 10.1

Kent Monkman, *The Academy*, 2008.
Acrylic on canvas (205.7 × 297.2 cm).

10

Fashion & Politics

Although politics is a term often associated with the workings of governments, it can also be used to describe the assumptions and principles by which society articulates power. In museums and art galleries, the politics of representation can be considered in terms of whose work is collected and shown, and whose stories are told. Women artists, artists of color, and artists of indigenous descent have largely been left out of the canon of art history, and contemporary artists have embraced representational politics in their work to assert their right to be seen and heard. Some artists have embraced fashion as an artistic tool in the exploration of the politics of gender and racial identities, and this is the lens of analysis for the case study of Kent Monkman's 2008 painting *The Academy*.

CASE STUDY: COLONIZATION AND KENT MONKMAN'S *THE ACADEMY*

Kent Monkman, a Canadian contemporary artist of Cree ancestry, uses parody in his paintings, installations, and performances to engage the viewer in a critical dialogue that disrupts and reinterprets the narratives of colonization that have marginalized the First Nations peoples of North America from the canon of art history. Monkman often includes his cross-dressing alter ego Miss Chief Eagle Testickle in his works (pronounced "Mischief"), and in so doing, signals his rejection of gender binaries and celebration of his two-spirit nature, as well as his knowledge of and homage to Marcel Duchamp's Rrose Sélavy.[1] Monkman has been described as an artist who "refuses to erase the stories of pain, but instead uses them to portray the power of resilience and future possibilities."[2] In his 2008 painting *The Academy*, a commissioned work for the Art Gallery of Ontario in Toronto (Figure 10.1), Monkman harnesses the complex, balanced, and harmonious composition structures of classical painting to create a large-scale acrylic painting that is embedded with multiple layers of meaning. In referencing works from art history, the artist aimed to "create a dialogue with indigenous artistic traditions and European art histories (and schools of thought) that have shaped the popular understanding of Aboriginal histories and identity."[3] In this painting, Monkman engages with the complex and sensitive issues of colonization, gender, ethnicity, and race, and this analysis reveals his use of dress and undress as an artistic tool to demarcate these aspects of identity.

The title of the painting, *The Academy*, links Monkman's work to the professional art societies in France (founded in 1648) and England (founded in 1768) that provided schools of instruction to artists and also held annual exhibitions in which artists could display their artworks and attract critical attention.[4] These gendered and hierarchical institutions held a "virtual monopoly on public taste and official patronage" until around the latter part of the nineteenth century, when the avant-garde challenged their dominance by offering alternate

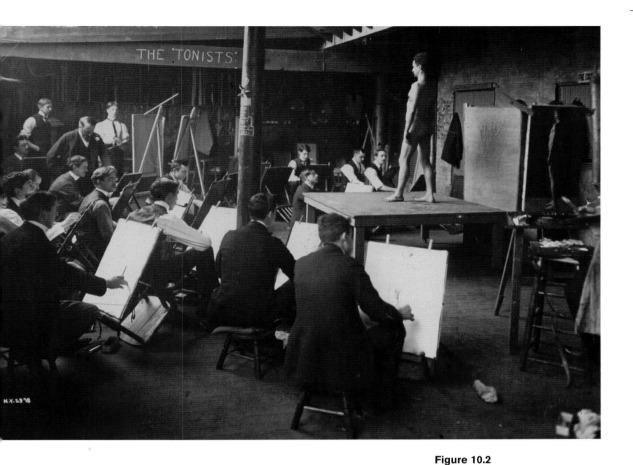

Figure 10.2

Photographer unknown,
Life Drawing Class, **1896.**

exhibition formats and venues.[5] In general, only men were allowed to participate in life drawing classes; women might be present, but only as models. In a photograph of a typical life drawing class from the late nineteenth century (Figure 10.2), the male students are formally attired in dress suits, marking this as a space of privilege. In Monkman's work, the life drawing class takes place inside a circular structure that resembles a traditional Anishinaabe lodge or roundhouse—a sacred space in which knowledge and education are passed along by Elders and Knowledge Holders to others in the community.[6] By reclaiming the place of artistic knowledge within a lodge, Monkman inverts the hierarchy and architecture of the traditional European academies.

Monkman further signals his knowledge of art history by referencing several celebrated art historical precedents. The pose of the naked bearded white men entwined with a serpent recalls the writhing agony of the figures in the infamous Greek sculpture from classical antiquity known as *Laocoön and His Sons*.[7] Monkman's crowded artist atelier as a scene of male homoeroticism echoes a rendering of the atelier of Jacques Louis David (1748–1825), a neo-classical painter and the leader in the French Academy of Art in the late eighteenth and early nineteenth centuries.[8] The contemplative posture of the First Nations artist seated near the fire echoes the pose of the iconic 1880 sculpture by Auguste Rodin (1840–1917) known as *The Thinker*. In a 2016 interview, Monkman said, "I develop ideas that draw inspiration from many sources and stitch them together. It could begin with a drawing, etching, sculpture or painting I've seen from art history in which I see some relevant themes that relate to contemporary experience."[9]

There are several stories going on in this painting, but the main focal point is in the central part of the painting in which five naked white European male models are posing on a platform (Figure 10.1). The scene is lit from above with the natural light coming from the hole in the roof of the roundhouse, and this mode of lighting serves to emphasize the whiteness of the models' skin and gives sharp definition to their muscular male bodies. Monkman accentuates the inversion of colonial stereotypes with the naked white men on the platform being painted by First Nations artists, instead of the other way around. By reversing the gaze, the artist reclaims the visual representations of First Nations peoples that were created by European artists like Irish-born Canadian painter Paul Kane (1810–1871), who characterized First Nations peoples as the "other" in works like *Falls of Colville in the Columbia River*, dated to 1846–1848 (Figure 10.3). These types of representations were intended to record the indigenous peoples of North America untainted by European influence and before these peoples were impacted by efforts to ensure their assimilation.[10] Monkman acknowledges the work of Paul Kane in his artist statement, but adapts those "classical European pictorial conventions" to subvert Kane's narrative.[11] As Jonathan Katz notes, Monkman's work has "the power to reach back in time and remodel their historical antecedents, revealing them in a new light" such that struggles over power, race, desire, and selfhood are unmasked.[12]

Figure 10.3

Paul Kane, *Falls of Colville on the Columbia River*, ca. 1846–1848. Oil on canvas (48.3 × 72.4 cm).

The instructor of the atelier is the artist Kent Monkman himself. He is dressed as a dandy in a finely tailored knee-length coat made of buckskin and ornamented to suggest elaborate beading and/or quillwork. His top hat, an emblem of male power and privilege, is customized with beads and feathers. On his feet, however, he wears traditional beaded moccasins (Figure 10.4), rooting his identity in his Cree heritage. Monkman's choice of attire illustrates a form of cultural hybridity in dress that can be traced to the influence of European explorers who came to the land in search of resources such as beaver pelts to sate the demand for top hats.[13] Some First Nations peoples adapted their dress to include more tailored styles such as European-style coats as well as incorporate different materials obtained through trading of fur pelts for glass beads, wool yarns, and ribbons.[14] A similar type of coat dated to the 1840s, believed to have originated from Cree or the Sioux-Métis peoples, can be found in the collection of the Canadian Museum of History (Figure 10.5). In this extant example (Accession #V-E-294a), the coat is closely fitted through the body with inset shoulders and a high stand collar; both front and back have been richly embellished with porcupine quillwork and fringe.[15] In a watercolor painting dated ca. 1825–1836 by J. Crawford Young from the McCord Museum (Figure 10.6), a British soldier is shown wearing a similar type of coat, revealing that settlers also incorporated elements of indigenous dress into their wardrobes.[16] By depicting himself as an artist dandy in wearing this finely tailored and ornamented coat that blends elements of European and indigenous dress, Monkman asserts his place in the writing of art history and the postcolonial narrative.

Figure 10.4

Unknown maker, beaded
moccasins, Cree in origin, 1938.

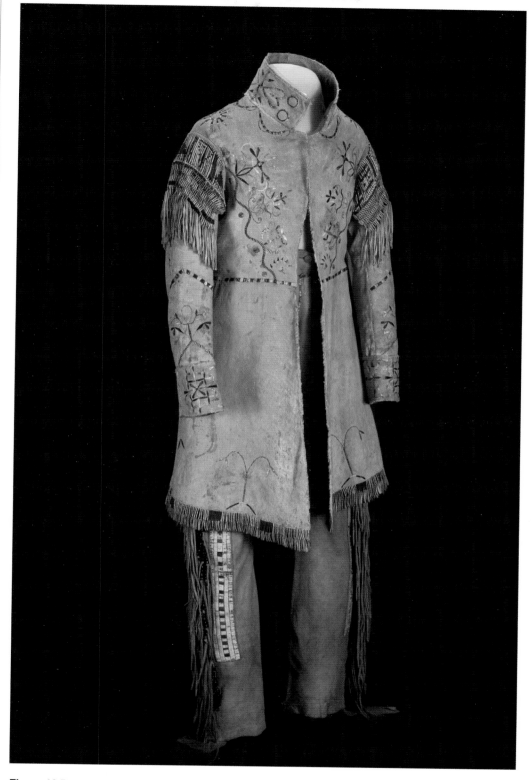

Figure 10.5

Unknown maker (Sioux-Métis),
coat, ca. 1840.

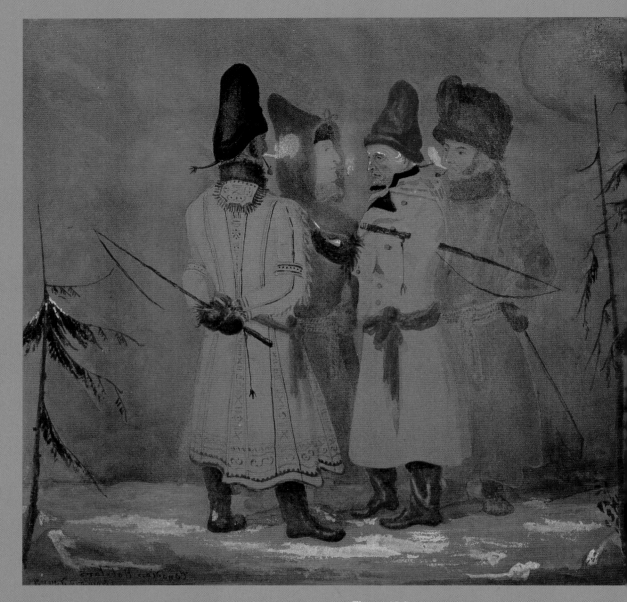

Figure 10.6

J. Crawford Young, *Canadian Habitants*,
ca. 1825–1836. Watercolor on paper
(22.6 × 24. 8 cm).

In his artist statement, Monkman also identifies some of the other figures in the painting by name and carefully articulates their dress to signal their identity. Monkman's student is Jacques Louis David; in this work the leader in the French Academy of Art has been demoted to the status of pupil. David is dressed in the close-fitting but sober dress adopted by men in the early nineteenth century following the "Great Male Renunciation,"[17] except that his jacket is trimmed with lush fur. Showing deference to his instructor, his posture is supplicant and he seems to gaze at Monkman with erotic longing.[18]

Adjacent to David is a seated artist whose face can be seen in the small round mirror clipped to his artist bench/horse. This is the late Norval Morrisseau (1932–2007), an Anishinaabe Canadian artist who was described as the "Picasso of the North."[19] Morrisseau's paintings depicted the stories of his people and were distinctive in their stylization, characterized by simplified forms rendered in bright colors with thick black outlines that came to be known as the Woodland School. The canvas in front of Morrisseau references his 1964 work *Self-Portrait Devoured by Demons* and according to Monkman is representative of Morrisseau's "personal struggle with sexual demons."[20] Like Monkman, Morrisseau is dressed in a manner that takes elements from both European and First Nations traditions. In the nineteenth century, British Army red coats with brass buttons and bullion braid were given as gifts to the Chiefs of First Nations tribes under the treaties made by the Canadian government and these red coats became symbols of rank amongst indigenous peoples. A similar coat dated to 1812 that is said to have belonged to Oshawana (John Naudee) of the Anishinaabeg (Ojibwa) nation can be found in the collection of the Royal Ontario Museum in Toronto (Accession #911.3.119).[21] Morrisseau is wearing such a coat, but it is belted with a traditional sash ornamented with beads or porcupine quills. He also wears blue wool trousers rather than traditional trousers made of mammal hides. His top hat is embellished with a beaded trim, ribbon, and feathers, and he wears beaded moccasins. Like Monkman as artist-dandy, Morrisseau's dress demonstrates cultural hybridity.

In front of the open fire, two small naked children with wings (*putti*) warm their hands. These cherubs reference another painting at the Art Gallery of Ontario by Paul Peel with the title *After the Bath* (1890), in which two young boys warm their hands in front of a hearth after bathing. Although *putti* have appeared as decorative elements in paintings and sculpture since antiquity, these cherubic figures have no fixed meaning but are often considered emblems of love, prosperity, or mirth. A coyote sleeps at their feet and Monkman indicates this is a "symbol of the Cree trickster figure, Weeseegachak."[22] As well, tiny bison and other miniature figures scamper through the image, adding further lighthearted levity to the scene.

A First Nations man is seated on an artist bench with his back turned to us and rests his head on his hand in the pose of Rodin's *The Thinker*.[23] Like this celebrated bronze sculpture that depicts the poet Dante deep in thought and contemplating his work while looking into the circles of hell, this figure is naked. A blanket is draped over his lap and he has a beaded bag slung over his shoulder. His hair is ornamented with brilliant red feathers and his face and body are adorned with tattoos that mark his achievements and life transitions. The canvas before him is blank and a palette of paints rests beside him as he considers the models on the platform. In his artist statement, Monkman identifies this man as the "noble savage," a trope that fused the idea of colonial superiority over the exotic and animalistic "other."[24] However, in posing this figure in the same manner as Rodin's *The Thinker*, Monkman subverts the stereotype.

A feminine personage dressed in a white wedding gown with a veil— Monkman's time-traveling and gender-fluid alter ego Miss Chief Eagle Testickle— also appears in this work. This is not readily apparent unless the viewer knows about Monkman's dual identity, but "her" muscular forearm is the most obvious clue that this is a man dressed as a woman. Like Marcel Duchamp, who assumed the female persona Rrose Sélavy as his alter ego (see chapter 9), Monkman depicts himself in drag. In this case, however, the act of cross-dressing is political in light of the violent history of the policing of dress of First Nations people. Scott L. Morgensen has traced the impact of the Spanish, Portuguese, French, British, and Dutch colonists on the indigenous peoples of the Americas, and observes that their hegemonic understanding of gender binaries was an attempt to erase those with a Two-Spirit or non-binary persona.[25] Monkman has described his alter ego as a supernatural being "to help Indigenous people negotiate this relationship with the bearded faces—the white people who came."[26] Jonathan Katz interprets Miss Chief as "part modern commodity fetishist, part drag queen, part Aboriginal two-spirit or berdache, at one a dominatrix and a victim, male and female, past and present," such that Monkman complicates the binaries that are traditionally associated with the hegemonic discourses of identity.[27]

Miss Chief adopts the appearance of Harriet Dixon Boulton, an important figure in the history of the Art Gallery of Ontario.[28] She is dressed in a traditional ivory white wedding gown with floral rosette applique and a fingertip veil based on the 1847 wedding portrait of Harriet by George Théodore Berthon (Figure 10.7). Harriet was born in Boston and this style of wedding dress is similar to one in the collection of the Boston Museum of Fine Arts,[29] as well as a dress seen in an 1845 fashion plate (Figure 10.8). Monkman renders Harriet's fashionable dress and veil carefully but takes some liberties in the draping of the bottom third of the skirt, which is not visible in her portrait. The artist also adds modern accessories: white high heels and a handbag with zippered closure that has been set on the ground nearby. These accessories signal to the viewer that this is a contemporary work in which time and tradition have been conflated and reinterpreted to recast the paradigms of art history.

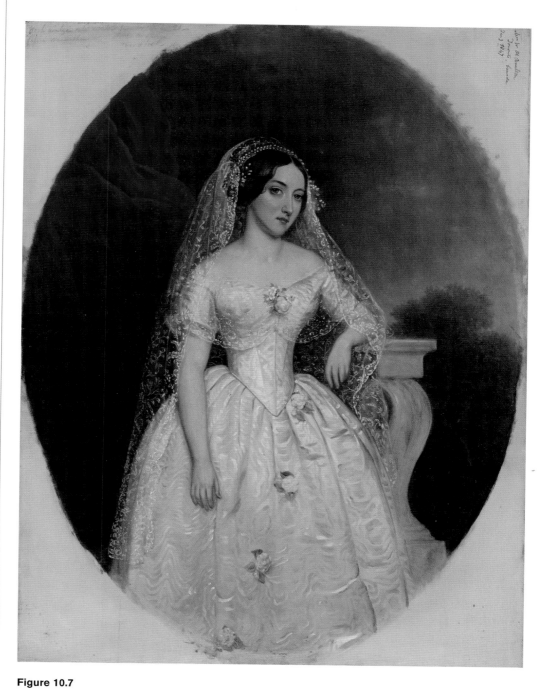

Figure 10.7

George Théodore Berthon, *Portrait of
Mrs. William Henry Boulton (Harriet)*,
1846. Oil on canvas (59.1 × 44.5 cm).

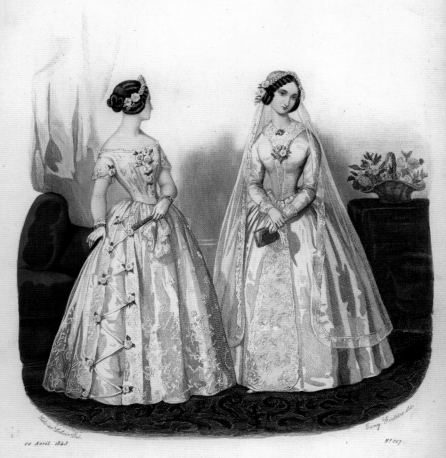

Figure 10.8

Héloïse Leloir, "*Le Caprice*"
(The Whim), *Journal des Dames
et des Mode*, April 20, 1845.

Miss Chief holds in her hand an eagle feather, a symbol of honesty, integrity, and respect that contrasts with the actions of the man who is lifting her skirt hem with his foot. This act might be read as playful if the man believes the woman dressed as a bride is his wife, or as an act with lecherous intent if he believes her to be a First Nations woman.[30] According to Monkman, this figure is William Henry Boulton, Harriet's husband and a former mayor of Toronto, and thus an important figure in the city's history. In his portrait in the collection of Art Gallery of Ontario, William Boulton wears formal evening dress: a dark wool jacket with velvet collar and breeches, a crisp white shirt with a lavish ruffled bib front, an embroidered silk waistcoat, and silk evening slippers.[31] Boulton's dress suggests he is a man of power and importance, but in this case he is relegated to the sidelines as a passive spectator. Close to Boulton, another white man is corralling several horses, and one of the horses rears up in fear, perhaps sensing his menace; this man is also dressed in formal attire accessorized with a top hat and a cloak. These two "gentlemen" could be interpreted as emblematic of the type of men that tried to eradicate the First Nations peoples of Canada through acts of "reeducation" and forced assimilation.

The Academy by Kent Monkman is a complex work that reveals a number of stories that center around issues of gendered and hierarchical power structures as well as the brutal effects of colonization on Canada's indigenous peoples. In this work, Monkman reminds us that the First Nations people were displaced from their lands when the British settled in Toronto, ignoring the oral contracts that were negotiated in good faith. In this multifarious scene, Monkman uses parody to invert the hegemonic norms of art history and stitches together a narrative in which the stereotypes are subverted. The hierarchical and gendered power structures of the artist atelier have been recast and reclaimed to tell a different story from a First Nations perspective in which knowledge is freely shared and the gender binaries of western ideology have been ignored. Monkman inverts the gaze—casting the models as white European males and the artists as First Nations peoples—to disrupt the stereotypical depictions of First Nations peoples and reclaim their place within the art historical canon. In this painting, the role of each figure is articulated through a careful rendering of their dress in a manner that communicates their identity as well as their relationship to each other. In The Academy by Kent Monkman, dress and fashion have been harnessed as an artistic tool to convey the individuals' identities, their relationship to each other, and wider complex issues of gender, race, and colonization.

ENDNOTES

1. Listen to the podcast "Kent Monkman's Mission to Decenter the Colonial Museum," *Hyperallergic*, July 9, 2019. Season 2, Episode 34. Accessed July 19, 2019 at www.hyperallergic.simplecast.com

2. Ibid.

3. Kent Monkman, "The Academy: A New Painting for the Art Gallery of Ontario." Unpublished artist statement, November 2008, 1.

4. Jason Rosenfeld, "The Salon and the Royal Academy in the Nineteenth Century," in Heilbrunn Timeline of Art History. (New York: The Metropolitan Museum of Art, October 2004). Accessed November 26, 2018 at https://www.metmuseum.org/toah /hd/sara/hd_sara.htm

5. Rosenfeld, "The Salon and the Royal Academy in the Nineteenth Century," n.p.

6. Definition of "roundhouse" from "Akinomaagaye Gaamik: Lodge of Learning." Accessed November 24, 2018 at https://akinomaagaye .weebly.com/

7. This statue was excavated in Rome in 1506 and is on display in the Vatican. The sculpture depicts a scene from Virgil's *Aeneid* in which the Trojan priest Laocoön and his two sons writhe in agony as they are being suffocated by two gigantic sea snakes.

8. *Un atelier d'artiste, présumé être celui de David*, Jean-Henri Cless, ca. 1804. Engraving (46.5 × 58.3 cm), Musée Carnavalet, Paris. Accessed November 24, 2018 at http://paris museescollections.paris.fr/fr/musee -carnavalet/oeuvres/un-atelier-d -artiste-presume-etre-celui-de-david #infos-principales

9. James Alexander Dunphy, "Kent Monkman: Challenging History with Heels and Headdresses," Sid Lee Collective, August 9, 2016. Accessed November 6, 2018 at http:// sidleecollective.com/en/Articles /2016/0810_Kent-Monkman/ This interview is no longer accessible online.

10. In Canada, efforts to deal with what was known as the "Indian problem" included denying peoples' full rights as citizens, restrictions on movements and housing on reservations lands, prohibiting traditional ceremonial rituals, and forced attendance at residential schools. This legacy has had tragic consequences on several generations of First Nations peoples in Canada. Morgensen also notes that these types of policies served as a form of population control in Canada, the United States, and Australia. See Scott L. Morgensen, "Cutting the Roots of Colonial Masculinity," in *Indigenous Men and Masculinities: Legacies, Identities, Regneration*, ed. Robert Alexander Innes and Kim Anderson (Winnipeg: University of Manitoba Press, 2015), 48.

11. Monkman, "The Academy," 2.

12. Jonathan D. Katz, "Miss Chief Is Always Interested in the Latest European Fashions," in *Interpellations: Three Essays on Kent Monkman/ Trois essais sur Kent Monkman*, ed. Michèle Thériault (Montréal: Édipress, 2012), 18.

13. Bailey traces the origins of the fur trade in Canada to the latter part of the fifteenth century. He writes: "Although the manufacture of felt hats was under way in continental Europe as early as 1456 it was not until the end of the sixteenth century that hats of this variety became highly fashionable. . . . But during the last quarter of the century [1500s], the fur-trade became of prime concern to many European merchants. The fashion of wearing beaver hats spread rapidly because only the most expensive hats were of beaver." Alfred Goldsmith Bailey, *The Conflict of European and Eastern Algonkian Cultures, 1504–1700: A Study in Canadian Civilization* (Toronto: University of Toronto Press, 1969), 8.

14. See Joyce M. Szabo, "Shared and Unique Traditions and Practices," *Berg Encyclopedia of Dress and Fashion, The United States and Canada*, ed. Phyllis G. Tortora, 360–365.

15. I examined and made drawings of this coat on March 25–26, 2019 at the Canadian Museum of History. The intricate quillwork, fringe ornamentation, and exquisite workmanship are not visible in the photos provided by the museum.

16. Dorothy K. Burnham traces the cross-cultural influence of the French and British on indigenous peoples' dress in her book *To Please the Caribou: Painted Caribou-Skin Coats Worn by the Naskapi, Montagnais, and Cree Hunters of the Quebec-Labrador Peninsula* (Toronto: Royal Ontario Museum, 1992). See also Ruth Phillips, *Trading Identities* (Montreal: McGill-Queen's University Press, 1998).

17. John Flügel first used this phrase in 1930 to describe the shift in attitude at the end of the eighteenth century, when men cast off the wearing of highly ornamented and colorful garments, makeup, and high heels, and instead adopted a sober look characterized by the tailored two-piece or three-piece suit rendered in dark-colored wool. See John Flügel, *The Psychology of Clothes* (New York: International Universities Press, 1969).

18. Monkman comments on the homoerotic subtext to the male scenes of interaction in nineteenth century artists' ateliers. See Monkman, "The Academy," 1.

19. Carmen Robertson notes that the publicity materials for Morrisseau's first international exhibition in 1969 used this phrase to describe the artist. See Carmen Robertson, *Norval Morrisseau: Life & Work* (Toronto: Art Canada Institute, 2016), 11.

20. Monkman, "The Academy," 3.

21. See the description of the Chief's coat, issued by the British Army in 1812 to Oshawana (John Naudee), Anishinaabeg (Ojibwa) on the Royal Ontario Museum online catalogue (Accession #911.3.119). Accessed November 24, 2018 at https:// collections.rom.on.ca/objects /233772

22. Monkman, "The Academy," 3.

23. For more about this sculpture by Rodin, see the Musée Rodin's website, accessed December 3, 2018, at http://www.musee-rodin.fr/en /collections/sculptures/thinker.

24. Monkman, "The Academy," 3. The phrase "noble savage" was often used in early accounts of encounters between Europeans and indigenous populations of North America, especially in the sixteenth and seventeenth centuries; many examples of quotations using that phrase can be found in Alfred Goldsmith Bailey's 1937 book *The Conflict of European and Eastern Algonkian Cultures* (Toronto: University of Toronto Press, 1969).

25. Morgensen, "Cutting the Roots of Colonial Masculinity," 38–41.

26. Mollie Cronin, "Miss Chief and the Resilience," *The Coast*, November 22, 2018. Accessed November 24, 2018 at https://www.thecoast.ca/halifax /miss-chief-and-the-resilience /Content?oid=19376352

27. Katz, "Miss Chief Is Always Interested in the Latest European Fashions," 19.

28. The Art Gallery of Ontario is located at 317 Dundas Street West in Toronto, Canada. This land was first occupied by the indigenous peoples known as the Mississaugas of the New Credit First Nation but was surrendered to the British crown in 1787. That treaty was renegotiated on August 1, 1805 in what was called the Toronto Purchase Treaty No. 13. Thereafter the land was occupied by the Boulton family. In 1846, when Boston-born Harriet Dixon married Toronto mayor William Henry Boulton, she received title to the Georgian manor house on the property as her marriage settlement. Following William's death, Harriet remarried and with her second husband became instrumental in the founding of the Art Gallery of Toronto. See "History of the Grange" for more information about the family and the site of the Art Gallery of Ontario. Accessed November 22, 2018 at http://www .ago.net/history-of-the-grange. In his artist statement, Monkman positions Harriet, in coming from Boston to Toronto, as both an "outsider and principal witness to much of The Grange's history." Monkman, "The Academy," 3.

29. See wedding dress, ca. 1840 in the Boston Museum of Fine Arts (Accession #50.2364ab). Gift of Mrs. Samuel J. Mixter and Mrs. Henry A. Morss, Jr. Accessed November 24, 2018 at https://www.mfa.org /collections/object/wedding -dress-578684

30. There is a long history of sexual violence against indigenous women, including abuse, rape, and forced sterilization. See Andrea Smith *Conquest: Sexual Violence and American Indian Genocide* (Durham: Duke University Press, 2015).

31. This 1846 painting, *Portrait of William Henry Boulton*, by George Théodore Berthon (Accession #GS111) can be seen on the Art Gallery of Ontario collection portal. Accessed November 22, 2018 at https://ago.ca/collection /object/gs111

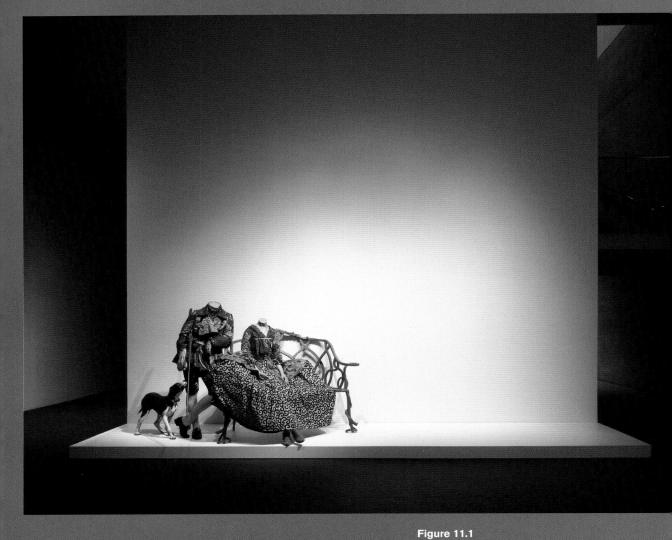

Figure 11.1

Yinka Shonibare, *Mr. and Mrs. Andrews Without Their Heads*, 1998.

Coda

There may be something familiar about the image of the installation *Mr. and Mrs. Andrews Without Their Heads* (1998) from the collection of the National Gallery of Canada (Figure 11.1). Indeed this work references the well-known eighteenth-century portrait of a young aristocratic couple on their expansive estate in the English countryside by Thomas Gainsborough from 1750 that was discussed in chapter 6 (see Figure 6.1). British-born Nigerian artist Yinka Shonibare alters the format by translating Gainsborough's painting into a three-dimensional *tableau vivant* format. He removes the heads of the husband and wife to erase the racial aspects of the original painting and playfully links the work to the beheading of the aristocracy during the French Revolution. The artist also refashions the clothing worn by Robert Andrews and Frances Mary Carter, using colorful African textiles to recast these figures within a broader vision for art history that embraces a culturally diverse populace.

In his art practice, Shonibare often references well-known works from the past (by Gainsborough, Fragonard, Hogarth, and others) to raise questions about power, race, and representation. The artist does this by redressing historical figures in colorful wax-printed cottons that have come to represent African identity in spite of their complex history in relation to globalization.[1] These textiles have come to be the artist's signature and he has also acknowledged his deep interest in fashion, noting "the deeply symbolic meanings of clothing and its transformative powers" as well as recognizing the influence of Vivienne Westwood on his work with regard to "her acute eye for 'Britishness' and its deconstruction through style, wit, and unrepentant sexuality."[2]

Shonibare's works are seductive. Iconic works from art history are brought to life in tableaux vivant formats that harness the beauty and luminous colors of the Dutch wax textiles to draw in the viewer, while offering a deeply thoughtful critique of politics and power structures that govern society. In the portrait of Mr. and Mrs. Andrews by Gainsborough, the idea that Mrs. Andrews is an aristocratic lady of leisure is conveyed through her dress: her immaculate and impractical attire implies the invisible cadre of farmhands doing the work on the vast Andrews estate in Suffolk; she will not be toiling on the land wearing her blue silk dress with hoops and her dainty cream brocade slippers (Figure 6.1). In recasting Robert Andrews and Frances Mary Carter in the textiles that have come to symbolize African identity, Shonibare harnesses fashion to challenge what is otherwise rendered invisible in the portrait. For Shonibare, the idea of leisure is wrapped up with privilege and he observes, "my depiction of it [leisure] is a way of engaging with

that power. It is actually an expression of something much more profoundly serious insofar as the accumulation of wealth and power that is personified in leisure was no doubt a product of exploiting other people."[3] As well as working in sculpture and installation, the artist has also explored other mediums like photography and film to illustrate and challenge the grand narratives of history. In using Dutch wax prints in his work and making it his artistic signature, Shonibare exploits the semiotic qualities of dress and textiles and in so doing, challenges the viewer to consider whose history is being portrayed in western art and fashion. In this way, fashion becomes a medium to discuss the politics of representation.

Shonibare is only one of many artists who harness fashion and textiles in their contemporary art practice, and I chose to close the book with this work because it was my first awakening to the politics of representation. This important topic could be the subject of a book unto itself, and so I invite readers to continue this discussion, using the methodology highlighted here, to unravel and interpret the messages embedded in the works of all artists who embrace fashion, dress, and textiles in their practice.

ENDNOTES

1. These wax-printed cottons illustrate the effects of globalization in that they were inspired by Indonesian batiks, manufactured in the Netherlands and Manchester, and marketed to West African buyers in the nineteenth century. Rachel Kent, "Time and Transformation in the Art of Yinka Shonibare MBE," in *Yinka Shonibare MBE*, edited by Rachel Kent (London: Prestel, 2014), 7.

2. Kent, "Time and Transformation," 16.

3. Yinka Shonibare quoted in Kent, "Time and Transformation," 11.

Appendix I: Observation Checklist (40 Questions)

A. PRELIMINARY BACKGROUND

1.	What is the title of the artwork? Does the title directly reference a work of another artist?
2.	What type of artwork is it (painting, sculpture, photograph, installation, digital, mixed media)?
3.	Who is the artist/creator?
4.	What year was the work created?

5. Is it part of a series (a multiple, a reproduction)?

6. Who owns it now (museum, private collector, institution, gallery)?

7. What are the dimensions of the work (framed and/or unframed)? Is the work large-scale or small-scale relative to the human body?

8. Is the work horizontal or vertical in orientation? Consider how this orientation impacts the work.

9. Has this work been altered in some way from its original state?

B. COMPOSITION

Focal Point

10. Where is the emphasis in the image?

11. What captures your attention first?

People

12. How many persons are included in the artwork?

13. Are the figures in the artwork known persons? Is the work intended as a portrait? Can they be identified by name? If so, can this knowledge of their identity inform your analysis?

14. If there is more than one person, what is their physical position relative to each other? Does their position, posture, or body language echo their relationship?

15. Where is their gaze directed?

Setting

16. Is the setting indoors or outdoors?

17. Does the artwork depict a specific place or setting?

18. What elements of the setting or background are notable?

19. Does the setting convey status, privilege or other meaning?

C. THE FASHIONED BODY

Body

20. Are the people in the artwork clothed? If not, are the naked bodies ornamented or fashioned in some way?

21. How are the people oriented (front facing, three-quarter view, profile, or back facing)? Consider what this orientation signifies.

22. What is the gender of each person in the image? Has the artist emphasized gender or obscured it?

23. Consider the posture of the sitter(s). Are they seated, standing, or reclining? Are parts of the body not visible in the image? Is their posture rigid or relaxed? Is posture indicative of a state of mind and/or training of the body?

24. Are other objects or animals included in the image to depict activities, interests, or status, such as globes, books, horses, or pets? How does the sitter engage with these objects? What is the scale of these objects relative to the sitter's body?

Dress

25. Describe the main elements of clothing for each person in the image in detail, noting the garment category (such as day or evening dress), and how it is worn. Also note whether any outdoor clothing such as capes, wraps, or coats are evident.

26. Can the type of textile(s) be determined? Does the artist attempt to convey the nature of that textile, such as the luster of silk or satin, the coarseness of linen, or the sumptuous pile of velvet? Note the colors and dominant patterns in the textiles used for the clothing.

27. Is the clothing embellished in any way with fur, lace, jewels, embroidery, braid, or beading?

28. Is any element of dress exaggerated? Consider the cut of sleeves, size of collar or ruff, length of train, the wearing of hoops, or other forms of altering the silhouette of the body.

29. Describe the accessories of each person such as hats, gloves, fans, parasols, muffs, purses, bags, belts, shoes, or shawls. Note how they are worn, carried, or placed in the image.

30. Are there visible signifiers of rank or status such as jewelry, medals, swords, or armor?

31. Does the clothing serve as an occupational uniform (military, medical, clerical, labor, or other profession) or marker of identity (royalty)?

32. Describe the hairstyle and makeup of each person.

D. FORMAL QUALITIES

Stylistic Qualities

33. Is this a realistic or abstracted image?

34. Are any parts of the image unfinished or indistinguishable?

35. Does the artwork fit within a certain stylistic period in art history? If so, is it consistent with the dominant characteristics of that style?

Space

36. What is the sense of space in the work? Is there a foreground/middle ground/background? How are they linked? Is the sense of space literal or indeterminate?

37. Has perspective been distorted or altered for specific effect?

38. What is the scale of the artwork relative to the human body and does this create the illusion of space or evoke a feeling or affect?

39. How is space used to contain the representation of the body? Think of the lines within the artwork and how they echo or contain space around the bodies.

Color

40. Does the use of color bring attention to certain forms, create movement or a mood?

Appendix II: Reflection (25 Questions)

A. FORMAL QUALITIES OF THE ARTWORK

1.	What does the artist emphasize visually? What does this signify?
2.	How does the artist emphasize this feature? Through scale, line, color, etc.?
3.	Is there an underlying rhythm, pattern, or geometric structure to the composition?
4.	Is there a sense of balance or has the artist deliberately chosen to destabilize the composition?

5. Does the composition seem unified? Do the elements appear integrated or separate from each other?

6. What do you think the artist is trying to express in this artwork? How is this achieved visually?

7. Does the choice of medium impact the work in a material way?

B. ELEMENTS OF DRESS

8. How has the artist used dress to define the profession, class, status, racial, or gender identity of the sitter?

9. Is the dress of each sitter consistent with his or her gender, age, class, and occupation?

10. Are the garments stylistically consistent with the period in which the artwork was created?

11. Does the garment have stylistic, religious, artistic, or iconic references?

12. How does the clothing shape or fashion the body? Does it disguise, conceal, or reveal the body?

13. Has the artist taken liberties with the visual representation of the sitter(s)? Is the body elongated or distorted in any way? If so, consider whether this distortion reflects norms of beauty for the period.

C. PERSONAL REACTIONS

14. What was the impetus to examine this artwork? Were you interested in the artist, elements of the dress, or the person(s) in the image?

15. Do you have an emotive reaction to the image? Does it appeal to you or repulse you? Does it remind you of something else?

16. Do your personal reactions indicate that cultural beliefs have shifted?

17. Can you identify a personal connection to the work or a bias that should be acknowledged in your research?

D. ARTIST

18. Is this a single work or part of a series? If it is a series, how many are in the series?

19. Has the artist created other works that are not part of a series but otherwise similar to this work? If so, list them here and consider what might be learned from this comparison.

20. Are there any exhibition catalogues or biographies of the artist? Using these sources, as well as artist statements, diaries, or published reviews from the time period (if available), consider whether or not this work is consistent with the artist's oeuvre. Is there something notable or exceptional about this work?

21. Is it known whether or not the artist worked with artist's mannequins, live models, and/or owned or hired costumes?

E. CONTEXTUAL INFORMATION

22. Identify possible search terms for the dress in the artwork. Are there any unique terms related to the dress that may help refine the search parameters? Consider using a dictionary of dress or costume history texts to help identify precise search terms.

23. Can you locate images depicting the same person or similar garments in other visual media such as fashion plates, newspapers, film, or television? If so, list them here and consider the similarities and differences and what this might mean.

24. Identify any related or similar garments from costume history texts or Janet Arnold's pattern books as well as other online dress collections with significant holdings such as The Met, the V&A Museum, the Los Angeles County Museum of Art, the Rijksmuseum, or a university study collection. Consider how you might use such material to enrich your understanding or analysis, especially of any parts of the dress that are distinctive or unusual in some way that may indicate whether or not the garment was fashionable at the time the image was created.

25. Does this work reflect a specific event from history or mark a notable shift in attitudes about gender, beauty, or identity?

Appendix III: Interpretation (5 Questions)

1. Review the material that you have recorded in your observation and reflection on the artwork. What stands out for you?

2. Does this work provoke an emotive reaction, connect to your background or interests, or otherwise inspire a research question or questions?

3. What does the work have to say about the artist and the visual traditions of the period in which it was made?

4. What does the depiction of fashion in the artwork say about the culture of the period?

5. Consider the artwork and the fashions depicted therein in relation to a conceptual framework or lens of interpretation that is linked to your research focus. Identify that framework here and briefly consider one or more key texts related to that theory. The suggested frames of reference include, but are not limited to:

Status

Modernity

Ideals of beauty

Identity, including gender, sexuality, or ethnicity

Politics of representation

Globalization

Other

Bibliography

Allan, Scott, Emily A. Beeny, and Gloria Groom (eds.). *Manet and Modern Beauty: The Artist's Last Years*. Los Angeles: Getty Publications, 2019.

Alsteens, Stijn and Adam Eaker. *Van Dyck: The Anatomy of Portraiture*. New Haven: Yale University Press, 2016.

Andersson, Andrea and Julie Crooks (eds.). *Mickalene Thomas: Femmes Noires*. Fredericton: Goose Lane Editions, 2018.

Arnold, Janet. *Patterns of Fashion 1, Englishwomen's dresses and their construction c. 1660–1860*. London: MacMillan, 1972.

—-. *Patterns of Fashion 2, Englishwomen's dresses and their construction c. 1860–1940*. London: MacMillan, 1977.

Ashelford, Jane. *The Art of Dress: Clothes Through History 1500–1914*. London: National Trust, 1996.

Auricchio, Laura. *Adélaïde Labille-Guiard: Artist in the Age of Revolution*. Los Angeles: The J. Paul Getty Museum, 2009.

Baetjer, Katharine. "The Women of the French Royal Academy." In *Vigée Le Brun*, edited by Joseph Baillio, Katharine Baetjer, and Paul Lang. New Haven: Yale University Press, 2016.

Bailey, Alfred Goldsmith. *The Conflict of European and Eastern Algonkian Cultures, 1504–1700: A Study in Canadian Civilization*. Toronto: University of Toronto Press, 1969 [1937].

Baillio, Joseph, Katherine Baetjer, and Paul Lang (eds.). *Vigée Le Brun*. New Haven: Yale University Press, 2016.

Barnard, Malcolm. *Fashion as Communication*. London: Routledge, 2002 [1996].

Barthes, Roland. *Camera Lucida: Reflections on Photography*. Translated by Richard Howard. New York: Hill and Wang, 2010 [1981].

Baudelaire, Charles. "The Modern Public and Photography." In *Classic Essays on Photography*. Edited by Alan Trachtenberg, 83–89. Sedgwick: Leete's Island Books, 1980.

—-. "The Painter of Modern Life." In *The Painter of Modern Life and Other Essays*. Translated and edited by Jonathan Mayne, 1–41. New York: Phaidon Press Inc., 2010.

Baur, Eva-Gesine. "Rococo and Neoclassicism: The Painting in the 18th Century." In *Masterpieces of Western Art*. Edited by Ingo F. Walther, 335–400. London: Taschen, 2002.

Belsey, Hugh. *Thomas Gainsborough: A Country Life*. Munich: Prestel, 2002.

Berger, John. "Drawing Is Discovery." *Statesman and Nation 46* (August 29, 1953): 232.

—-. *Ways of Seeing*. London: Penguin Books, 1972.

—-. *Understanding a Photograph*. Edited and introduced by Geoff Dyer. London: Penguin Books, 2013 [1967].

Bilyeu, Elizabeth Anne (ed.). *Witness: Themes of Social Justice in Contemporary Printmaking and Photography*. Salem: The Jordan D. Schnitzer Family Foundation in association with the Hallie Ford Museum of Art, 2018.

Burnham, Dorothy K. *To Please the Caribou: Painted Caribou-Skin Coats Worn by the Naskapi, Montagnais, and Cree Hunters of the Quebec-Labrador Peninsula*. Foreword by Adrian Tanner. Toronto: Royal Ontario Museum, 1992.

Butler, Judith. *Gender Trouble: Feminism and the Subversion of Identity*. New York: Routledge, 2007.

Cahen, Gustave B. *Eugene Boudin, sa vie et son oeuvre*. H. Floury: Paris, 1900.

Casey, Sarah. "A Delicate Presence: The Queer Intimacy of Drawing." *Tracey | Journal Drawing In-Situ* (July 2016): 1–8.

Causey, Andrew. *Drawn to See: Drawing as an Ethnographic Method*. Toronto: University of Toronto Press, 2017.

Chrisman-Campbell, Kimberly. "Bertin, Rose." In *The Berg Companion to Fashion*. Edited by Valerie Steele. Oxford: Bloomsbury Academic, 2010.

—-. *Fashion Victims: Dress at the Court of Louis XVI and Marie Antoinette*. New Haven: Yale University Press, 2015.

Craik, Jennifer. "The Cultural Politics of the Uniform," *Fashion Theory* 7, no. 2 (2003): 130.

Crooks, Julie. "Mickalene Thomas: Femmes Noires." In *Mickalene Thomas: Femmes Noires*. Edited by Andrea Andersson and Julie Crooks, 12–25. Fredericton: Goose Lane Editions, 2018.

Davis, Lucy. "Interacting with the Masters: Reynolds at the Wallace Collection." In *Joshua Reynolds: Experiments in Paint*. Edited by Lucy Davis and Mark Hallett, 28–42. London: Paul Holberton, 2015.

Davis, Lucy and Mark Hallett. "Introduction: The Experimentalist." In *Joshua Reynolds: Experiments in Paint*. Edited by Lucy Davis and Mark Hallett, 10–17. London: Paul Holberton, 2015.

De Marly, Diana. *The History of Haute Couture 1850–1950*. London: B.T. Batsford Ltd., 1980.

De Young, Justine. "Women in Black: Fashion, Modernity and Modernism in Paris." PhD dissertation, Northwestern University, 2009.

Dickerson, Vanessa D. *Dark Victorians*. Chicago: University of Chicago Press, 2008.

Dimond, Frances and Roger Taylor. *Crown & Camera: The Royal Family and Photography 1842–1920*. Harmondswoth: Penguin Books, 1987.

Edwards, Betty. *Drawing on the Right Side of the Brain: A Course in Enhancing Creativity and Artistic Confidence*. Los Angeles: Tarcher, 1986 [1979].

Edwards, Lydia. *How to Read a Dress: A Guide to Changing Fashion from the 16th to the 20th Century*. London: Bloomsbury Academic, 2017.

Entwistle, Joanne. *The Fashioned Body: Fashion, Dress and Modern Social Theory*. Cambridge: Polity Press, 2000.

Fernandes, Myra A., Jeffrey D. Wammes, and Melissa E. Meade. "The Surprisingly Powerful Influence of Drawing on Memory." In *Current Directions in Psychological Science* 27 no.5 (2018): 302–308.

Flügel, John. *The Psychology of Clothes*. New York: International Universities Press, 1969 [1930].

Forbes, Frederick E. *Dahomey and The Dahomans: Being the Journals of Two Missions to the King of Dahomey, and Residence at His Capital, in the Years 1849 and 1850*. Vol. II. London: Longman, Brown, Green and Longmans, 1851.

Garb, Tamar. "Painting the Parisienne: James Tissot and the Making of the Modern Woman." In *Bodies of Modernity, Figure and Flesh in Fin-de-Siècle France*, 81–113. London: Thames and Hudson, 1998.

Garber, Marjorie. *Vested Interests, Cross-Dressing and Cultural Anxiety*. New York: Routledge, 2011.

Gibbs-Smith, Charles H. *The Fashionable Lady in the 19th Century*. London: Victoria & Albert Museum, 1960.

Goodson, Michael. "Introduction: Pleasure and Reckoning." In *Mickalene Thomas: I Can't See You Without Me*, 8-11. Columbus: Wexler Centre for the Arts with Artbooks, 2018.

Gower, Ronald Sutherland. *Thomas Gainsborough*. London: George Bell & Sons, 1903.

Guy-Sheftall, Beverly. "Rebel Woman." In *Mickalene Thomas: I Can't See You Without Me*, 81–92. Columbus: Wexler Centre for the Arts with Artbooks, 2018.

Hall, James. *The Self-Portrait: A Cultural History*. London: Thames & Hudson, 2014.

Hall, Stuart, Jessica Evans, and Sean Nixon (eds.). *Representation* (second edition). London: Sage Publications, 2013.

Hallett, Mark. *Reynolds: Portraiture in Action*. New Haven: Yale University Press, 2014.

Hamilton, James. *Gainsborough: A Portrait*. London: Weidenfeld & Nicholson, 2018.

Hayes, John. *The Drawings of Thomas Gainsborough*. London: A. Zwemmer Ltd., 1960.

—-. *Thomas Gainsborough, Paintings and Drawings*. New York: Phaidon Press Ltd., 1975.

—-. *Thomas Gainsborough*. London: The Tate Gallery, 1980.

Heidegger, Martin. *Martin Heidegger: Basic Writings from Being and Time (1927) and The Task of Thinking (1964)*. Edited by David Farrell Krell. Toronto: Harper Perennial, 2008.

Heinrich, Christoph. "Eugène Boudin, A Vividness of Touch." In *Nature as Muse, Inventing Impressionist Landscape from the Collection of Frederic C. Hamilton and the Denver Art Museum*, 44–52. Norman: University of Oklahoma Press, 2013.

Hollander, Anne. *Seeing Through Clothes*. Berkeley: University of California Press, 1993 [1975].

—-. *Sex and Suits: The Evolution of Modern Dress*. New York: Alfred A. Knopf, 1994.

hooks, bell. *Black Looks: Race and Representation*. New York: South End Press, 1992.

Jean-Aubry, Gérard. *Eugène Boudin*. London: Thames & Hudson, 1969.

Johnson, Deborah. "R(r)ose Selavy as Man Ray: Reconsidering the Alter Ego of Marcel Duchamp." *artjournal* 72 (Spring 2013): 80–94.

Johnston, Lucy. *Nineteenth-Century Fashion in Detail*. London: V&A Publications, 2005.

Jordanova, Ludmilla. *The Look of the Past: Visual and Material Evidence in Historical Practice*. Cambridge: Cambridge University Press, 2016.

Kant, Immanuel. *Critique of Judgement*. Edited by Nicholas Walker, translated by James Creed. Meredith Oxford: Oxford University Press, 2007.

Katz, Jonathan D. "Miss Chief Is Always Interested in the Latest European Fashions." In *Interpellations: Three Essays on Kent Monkman/Trois essais sur Kent Monkman*. Edited by Michèle Thériault, 10–21. Montréal: Édipress, 2012.

Kent, Rachel. "Time and Transformation in the Art of Yinka Shonibare MBE." In *Yinka Shonibare MBE*, edited by Rachel Kent. London: Prestel, 2014.

Koda, Harold. *Extreme Beauty: The Body Transformed*. New York: Metropolitan Museum of Art, 2001.

Laver, James. *Vulgar Society: The Romantic Career of James Tissot, 1836–1902*. London: Constable, 1936.

—-. *Costume and Fashion: A Concise History*. New York: Thames & Hudson, 2002.

Lehmann, Ulrich. *Tigersprung: Fashion in Modernity*. Cambridge: MIT Press, 2000.

Lochnan, Katharine. "Introduction." In *Seductive Surfaces: The Art of Tissot*. Edited by Katharine Lochnan, xi–xvi. New Haven: Yale University Press, 1999.

Lynden, Anne M. *A Royal Passion: Queen Victoria and Photography*. Los Angeles: Getty Publications, 2014.

Mackrell, Alice. *Art and Fashion: The Impact of Art on Fashion and Fashion on Art*. London: Batsford, 2005.

Maeder, Edward. "Decent Exposure: Status, Excess, the World of Haute Couture, and Tissot." In *Seductive Surfaces: The Art of Tissot*. Edited by Katharine Lochnan, 77–94. New Haven: Yale University Press, 1999.

Marsh, Jan (ed.). *Black Victorians: Black People in British Art 1800–1900*. Hampshire: Lund Humphries, 2005.

Marshall, Nancy Rose and Malcolm Warner. *James Tissot: Victorian Life/Modern Love*. New Haven: Yale University Press, 1999.

Matyjaszkiewicz, Krystyna. "Costume in Tissot's Pictures." In *James Tissot*. Edited by Krystyna Matyjaszkiewicz, 64–77. Oxford: Phaidon Press and Barbicon Art Gallery, 1984.

Mida, Ingrid. "The Curator's Sketchbook: Reflections on Learning to See," *Drawing: Research, Theory, Practice* 2 no.2 (2017): 275–285.

—-. "The Slow Approach to Seeing." In *Teaching Fashion*. Edited by Holly Kent, 95–102. London: Bloomsbury Academic, 2018.

—-. "Refashioning Duchamp: Analysis of the Waistcoat Readymade Series and Other Intersections of Art and Fashion." PhD dissertation, York University, 2019.

Mida, Ingrid and Alexandra Kim. *The Dress Detective: A Practical Guide to Object-based Research in Fashion*. London: Bloomsbury Academic, 2015.

Monkman, Kent. "The Academy: A New Painting for the Art Gallery of Ontario." Unpublished artist statement, 2008.

Morgensen, Scott L. "Cutting the Roots of Colonial Masculinity." In *Indigenous Men and Masculinities: Legacies, Identities, Regneration*. Edited by Robert Alexander Innes and Kim Anderson, 38–61. Winnipeg: University of Manitoba Press, 2015.

Mulvagh, Jane. *Vogue History of 20th Century Fashion*. London: Viking, 1988.

Munich, Adrienne. *Queen Victoria's Secrets*. New York: Columbia University Press, 1996.

Murrell, Denise. *Posing Modernity: The Black Model from Manet and Matisse to Today*. New Haven: Yale University Press, 2018.

Naumann, Francis M. *New York Dada: 1915–1923*. New York: Harry N. Abrams, 1994.

Nochlin, Linda. "Why Have There Been No Great Women Artists?" In *ARTnews* January 1971: 22–39, 67–71.

Palmer, Alexandra. "Looking at Fashion: The Material Object as Subject." In *The Handbook of Fashion Studies*. Edited by Sandy Black, Amy de la Haye, Joanne Entwistle, Agnès Rocamora, Regina A. Root, and Helen Thomas, 44–60. New York: Bloomsbury Academic, 2013.

Phillips, Ruth. *Trading Identities*. Montreal: McGill-Queen's University Press, 1998.

Postle, Martin. *Thomas Gainsborough*. London: Tate Publishing, 2002.

—-. "Joshua Reynolds and His Workshop." In *Joshua Reynolds: Experiments in Paint*. Edited by Lucy Davis and Mark Hallett, 54–69. London: Paul Holberton, 2015.

Rauser, Amelia. "From the Studio to the Street: Modelling Neoclassical Dress in Art and Life." In *Fashion in European Art: Dress and Identity, Politics and the Body, 1775–1925*. Edited by Justine De Young. New York: I.B. Tauris, 2017.

Ribeiro, Aileen. *Clothing Art: The Visual Culture of Fashion, 1600–1914*. New Haven: Yale University Press, 2017.

Ribeiro, Aileen with Cally Blackman. *A Portrait of Fashion: Six Centuries of Dress at the National Portrait Gallery*. London: St. Martin's Press, 2015.

Robertson, Carmen. *Norval Morrisseau: Life & Work*. Toronto: Art Canada Institute, 2016.

Rocamora, Agnès and Anneke Smelik (eds.). *Thinking Through Fashion: A Guide to Key Theorists*, London: I.B. Tauris & Co. Ltd., 2016.

Rothstein, Natalie. *Four Hundred Years of Fashion*. London: V&A Publications, 1984.

Ruskin, John. *The Elements of Drawing with a New Introduction by Lawrence Campbell*. New York: Dover Publications, 1971 [1857].

Sagne, Jean. "All Kinds of Portraits, the Photographer's Studio." In *A New History of Photography*. Edited by Michel Frizot, translated by Colin Harding, 103–129. Milan: Konemann, 1998.

Saint-Laurent, Cecil. *The Great Book of Lingerie*. New York: The Vendome Press, 1986.

Sargent, Antwaun. "Sisterhood Is a Behaviour: Mickalene Thomas's Restaging of Womanhood." In *Mickalene Thomas: Femmes Noires*. Edited by Andrea Andersson and Julie Crooks, 64–72. Fredericton: Goose Lane Editions, 2018.

Sayre, Henry M. *Writing About Art*. New Jersey: Pearson, 2009 [1995].

Schweitzer, Marlis. "Accessible Feelings, Modern Looks: Irene Castle, Ira L. Hill, and Broadway's Affective Economy." In *Feeling Photography*. Edited by Elspeth H. Brown and Thy Phu, 204–238. Durham: Duke University Press, 2014.

Sheriff, Mary D. *The Exceptional Woman: Elisabeth Vigée Le Brun and the Cultural Politics of Art*. Chicago: The University of Chicago Press, 1996.

Simon, Marie. *Fashion in Art, The Second Empire and Impressionism*. London: Philip Wilson Publishers Ltd., 1995.

Smith, Andrea. *Conquest: Sexual Violence and American Indian Genocide*. Durham: Duke University Press, 2015.

Sontag, Susan. *On Photography*. New York: Farrar, Straus and Giroux, 1977.

Steele, Valerie. *Paris Fashion: A Cultural History*. New York: Oxford, 1998 [1988].

—-. "L'aristocrate comme oeuvre d'art." In *La Mode retrouvée: Les robes trésors de la comtesse Greffulhe*. Edited by Olivier Salliard, 60–74. Paris: Palais Galliera, 2015.

Szabo, Joyce M. "Shared and Unique Traditions and Practices." In *Berg Encyclopedia of World Dress and Fashion: The United States and Canada*. Edited by Phyllis G. Tortora, 360–365. Oxford: Bloomsbury Fashion Central, 2010.

Tarrant, Naomi E. "The Portrait, the Artist and the Costume Historian." *Dress* 22 no. 1. (1995): 69–77.

Tétart-Vittu, Françoise. "The Origins of Haute Couture." In *Paris Haute Couture*. Edited by Olivier Saillard and Anne Zazzo, translated by Elizabeth Heard, 18–21. Paris: Flammarion, 2012.

Tomkins, Calvin. *Duchamp: A Biography*. New York: Thames & Hudson, 2014, 148–149.

Triggs, Stanley G. "The Man and the Studio." McCord Museum of Canadian History, 2005.

Troy, Nancy J. *Couture Culture: A Study in Modern Art and Fashion*. Cambridge: MIT Press, 2003.

Tsai, Eugenie (ed.). *Kehinde Wiley: A New Republic*. New York: Brooklyn Museum in association with DelMonico Books, 2015.

Uzanne, Louis Octave. *The Frenchwoman of the Century: Fashions, Manners, Usages.* Edited and translated by D. Sébastian Sanchez Y Gusman. New York: George Routledge and Sons, 1887.

Van Hafften, Julia, *Berenice Abbott: A Life in Photography.* New York: W.W. Norton & Company, 2018.

Veblen, Theodore. *The Theory of the Leisure Class: An Economic Study of the Evolution of Institutions.* London: Macmillan, 1899.

Vigée Le Brun, Elisabeth. *Memoirs of Madame Vigée Le Brun.* Translated by Lionel Strachey. USA: Dodo Press, 1903 [1835].

Vincent, Susan J. *The Anatomy of Fashion: Dressing the Body from the Renaissance to Today.* New York: Berg, 2009.

Waugh, Norah, *The Cut of Women's Clothes 1600–1930.* New York: Theatre Art Books, 1968.

Weber, Caroline. *Queen of Fashion: What Marie Antoinette Wore to the Revolution.* New York: Henry Holt and Company, 2006.

—-. *Proust's Duchess: How Three Celebrated Women Captured the Imagination of Fin-de-Siècle Paris.* New York: Knopf, 2018.

Wentworth, Michael. *James Tissot.* Oxford: Clarendon Press, 1984.

Wick Reeves, Wendy. "Brittle Painted Masks: Portraiture in the Age of Duchamp." In *Inventing Marcel Duchamp: The Dynamics of Portraiture.* Edited by Anne Collins Goodyear and James W. McManus. Cambridge: MIT Press, 2009.

Wilcox, Claire and Circe Henestrosa. *Frida Kahlo: Making Herself Up.* London: V&A Publishing, 2018.

Wilson, Elizabeth. *Adorned in Dreams: Fashion and Modernity.* London: I.B. Tauris, 2011 [1985].

Image Credits

Cover Franz Xaver Winterhalter, *The Empress Eugénie Surrounded by her Ladies in-Waiting*, 1855. Oil on canvas (300 × 420 cm). Musées Nationaux du Palais de Compiègne, France (MMPO 941). Bridgeman Images.

Figure 0.1 Elisabeth Vigée Le Brun (unsigned copy), *Marie Antoinette in a Chemise Dress (La Reine en Gaulle)*, after 1783. Oil on canvas (92.7 × 73.1 cm). National Gallery of Art, Washington, D.C., Timken Collection (1960.6.41). Image in public domain.

Figure 0.2 Elisabeth Vigée Le Brun, *Marie Antoinette in Court Dress*, 1778. Oil on canvas (273 × 193.5 cm). Vienna Kunsthistorisches Museum, Austria (GG 2772). Leemage/Corbis via Getty Images.

Figure 0.3 Elisabeth Vigée Le Brun, *The Duchesse de Polignac (Yolande Gabrielle Martine de Polastron) in a Straw Hat*, 1783. Oil on canvas (92.2 × 73.6 cm). Musée National des Châteaux de Versailles et de Trianon, France (MV 8971). Leemage/Corbis via Getty Images.

Figure 0.4 Elisabeth Vigée Le Brun, *Marie Antoinette with a Rose*, 1783. Oil on Canvas (116.8 × 88.9 cm). Musée National des Châteaux de Versailles et de Trianon, France (MV 3893). Leemage/Corbis via Getty Images.

Figure 1.1 Bertram Park, *A Dress of Charming Proportion in Beautiful French Brocade, Period 1775–85*, 1913. Hand-colored photograph, Plate 18 in *Old English Costumes: A Sequence of Fashions through the Eighteenth and Nineteenth Centuries, Presented to the Victoria & Albert Museum, South Kensington by Harrods Ltd.* (London: W. H. Smith & Son, 1913). Author's collection.

Figure 1.2 Adélaïde Labille-Guiard, *Self-Portrait with Two Pupils, Marie Gabrielle Capet and Marie Marguerite Carreaux de Rosemond*, 1785. Oil on canvas (210.8 × 151.1 cm). Image © The Metropolitan Museum of Art (53.225.5) via Art Resource, New York.

Figure 1.3 Elisabeth Vigée Le Brun, *Self-Portrait with Cerise Ribbons*, 1782. Oil on canvas (64.8 × 54 cm). Kimbell Art Museum, Texas (ACK 1949.02). Fine Art Images/Heritage Images/Getty Images.

Figure 1.4 Elisabeth Vigée Le Brun, *Self-Portrait with Daughter Julie (à l'Antique)*, 1789. Oil on wood (130 × 94 cm). Musée du Louvre, France (3068). Leemage/Corbis via Getty Images.

Figure 1.5 Valentine Green, *Mary Isabella, Duchess of Rutland (after Joshua Reynolds)*, 1780. Mezzotint on cream, laid paper (60 × 38.7 cm). Yale Center for British Art, New Haven, Paul Mellon Collection (B1977.14.10211). Image in public domain.

Figure 1.6 Sir Joshua Reynolds, *Portrait of Lady Worsley*, 1776. Oil on canvas (236 × 144 cm). Harewood House, Yorkshire, England. Christophel Fine Art/Universal Images Group via Getty Images.

Figure 1.7 Southworth & Hawes, *Portrait of three unidentified young women*, ca. 1856. George Eastman Museum, New York (1974.0193.0502). Getty Images.

Figure 1.8 Fratelli Alinari, *Portrait of three young Japanese women in kimono*, ca. 1865. Getty Images.

Figure 1.9 James Jacques Tissot, *Spring*, ca. 1878. Oil on canvas (141.6 × 53.3 cm). Universal Images Group via Getty Images.

Figure 1.10 James Jacques Tissot, *July*, ca. 1878. Oil on canvas (87.6 × 59.0 cm). Universal Images Group via Getty Images.

Figure 1.11 Ingrid Mida, *All Is Vanity*, 2010. Digital image (printed 61 × 91.4 cm). Private collection.

Figure 2.1 James Jacques Tissot, *October*, 1877. Oil on canvas (216 × 108.7 cm). Montreal Museum of Fine Arts, Quebec (1927.410). Universal Images Group via Getty Images.

Figure 2.2 James Jacques Tissot, *October*, 1878. Etching and drypoint on paper (55 × 28 cm). Art Gallery of Ontario, Toronto (94/223).

Figure 2.3 Ingrid Mida, Study drawing of *October* by Tissot, 2017. Pen and ink (36 × 46 cm).

Figure 2.4 Artist unknown, *Illustrirte Frauen-Zeitung*, May 17, 1875. The Metropolitan Museum of Art, New York. Image in public domain.

Figure 2.5 Gustave Janet, *La Mode Artisique*, 1878. The Metropolitan Museum of Art, New York. Image in public domain.

Figure 2.6 Unknown maker, dolman coat, ca. 1880s. Costume Institute at The Metropolitan Museum of Art, New York (Accession #C.I.39.29). Image in public domain.

Figure 3.1 Camille Silvy, *Portrait of Sarah Forbes Bonetta with her husband James Davies*, September 15, 1862. Hulton Archive/Getty Images.

Figure 3.2 Camille Silvy, *Portrait of Prince Albert*, January 1, 1861. Albumen print (11.4 × 6.4 cm). The J. Paul Getty Museum, Los Angeles (Object #99.XD.16.6). Image in public domain.

Figure 3.3 Camille Silvy, *Portrait of Sarah Forbes Bonetta*, 15 September 1862. Albumen print (8.3 × 5.6 cm) Image © National Portrait Gallery, London (NPG Ax61380).

Figure 3.4 Camille Silvy, *Portrait of James Davies*, 1862. Hulton Archive/Getty Images.

Figure 4.1 Mickalene Thomas, *Le déjeuner sur l'herbe: Les trois femmes noir*, 2010. Rhinestones, acrylic, and enamel on wood panel (304.8 × 731.5 cm). Image © Mickalene Thomas/SOCAN.

Figure 4.2 Édouard Manet. *Le déjeuner sur l'herbe*, 1863. Oil on canvas (208 × 264.5 cm). Musée d'Orsay, Paris (RF1668). Getty Images.

Figure 4.3 Unknown maker, summer dress in graphic black and white print, 1970s. Ryerson Fashion Research Collection, Toronto (Accession #1987.02.008). Photo by Victoria Hopgood, 2019.

Figure 4.4 Donald Brooks, dress with sequins, 1970s. Ryerson Fashion Research Collection, Toronto (Accession #2014.07.058). Photo by Victoria Hopgood, 2019.

Figure 5.1 Pierre-Louis Pierson and Virginia Oldoini, *Scherzo di Follia*, ca. 1861–1867, printed ca. 1930. Gelatin silver print from glass negative (39.8 × 29.8 cm). The Metropolitan Museum of Art, New York, Gilman Collection (2005.100.198). Image in public domain.

Figure 5.2 Pierre-Louis Pierson and Virginia Oldoini, *One Sunday*, ca. 1861–1867. Corbis via Getty Images.

Figure 5.3 Sarah Casey, *Absent Presence (Wedding Dress front)*, 2018–2019. Drawing, wax on paper (100 × 140 cm). Photo by Mark Bentele (with a black felt backing underneath). Image courtesy of the artist.

Figure 6.1 Thomas Gainsborough, *Mr. and Mrs. Andrews*, 1750. Oil on canvas (69.8 × 119.4 cm). National Gallery, London (NG6547). Getty Images.

Figure 6.2 Thomas Gainsborough, cropped image of Robert Andrews and Frances Mary Carter, 1750. Oil on canvas. National Gallery, London (NG6547). Getty Images.

Figure 6.3 Unknown maker, wedding dress worn by Helen Slicher, ca. 1750–1760. Rijksmuseum, Amsterdam (Accession#BK-1978-247). Image in public domain.

Figure 6.4 Unknown maker, court dress, British, ca. 1750. The Metropolitan Museum of Art, New York (Accession #C.I.6513.1a-c). Image in public domain.

Figure 6.5 Unknown maker, casaquin and petticoat front, ca. 1725–1740. The Metropolitan Museum of Art, New York (Accession #1993.17ab). Image in public domain.

Figure 6.6 Unknown maker, casaquin and petticoat back, ca. 1725–1740. The Metropolitan Museum of Art, New York (Accession #1993.17ab). Image in public domain.

Figure 6.7 Thomas Gainsborough, *Conversation in a Park: Thomas Gainsborough and His bride, Margaret*, ca. 1746. Oil on canvas (73 × 63 cm). Hulton Fine Art Collection/Getty Images.

Figure 8.5 Charles Frederick Worth, evening gown, 1882. Brooklyn Museum Costume Collection at the Metropolitan Museum of Art (Accession #2009.300.635ab). Image © The Metropolitan Museum of Art via Art Resource, New York.

Figure 8.6 Artist unknown, *Revue de la Mode*, *Gazette de la Famille*, January 14, 1883. Rijksmuseum, Amsterdam (Accession #RP-P-OB-103.094). Image in public domain.

Figure 8.7 A. Chaillot, *Revue de la Mode*, *Gazette de la Famille*, December 13, 1885. Rijksmuseum, Amsterdam (Accession #RP-P-OB-103.154). Image in public domain.

Figure 8.8 Artist unknown, evening coat in satin and brocaded velvet, *La Mode Illustrée*, *Journal de la Famill*e, November 12, 1883. Author's collection.

Figure 8.9 House of Worth (1858–1956), evening mantle, ca. 1887. Front view. Length at center back: 48 in. (121.9 cm). Brooklyn Museum Costume Collection at the Metropolitan Museum of Art (Accession #2009.300.127). Image © The Metropolitan Museum of Art via Art Resource, New York.

Figure 8.10 Paul Nadar, *Portrait of Élisabeth, Countess Greffulhe (1860–1952), née de Riquet de Caraman-Chimay, 1896*. Palais Galliera, Musée de la Mode de la Ville de Paris, France. Fine Art Images/Heritage Images/Getty Images.

Figure 9.1 Marcel Duchamp and Man Ray, *Portrait of Marcel Duchamp as Rrose Sélavy*, 1921. Bettman/Getty Images.

Figure 9.2 Photographer unknown, *Denise Poiret*, 1919. Keystone-France/Gamma-Keystone via Getty Images.

Figure 9.3 Caroline Reboux, silk velvet hat with ostrich feathers, ca. 1920s. Los Angeles County Museum of Art, California (48.30.5) Image in public domain.

Figure 9.4 Artist unknown, *Walking the Dog*, ca., 1920–1921. Pochoir print. *Art Gout Beauté*, 1921. Historica Graphica Collection/Heritage Images/Getty Images.

Figure 9.5 Photographer unknown, *Berenice Abbott*, ca. 1920s. Gamma-Keystone via Getty Images.

Figure 10.1 Kent Monkman, *The Academy*, 2008. Acrylic on canvas (205.7 × 297.2 cm). Art Gallery of Ontario, Toronto (2008/114). Included with permission of the artist.

Figure 10.2 Photographer unknown, *Life Drawing Class*, 1896. Museum of the City of New York, Byron Collection. Getty Images.

Figure 10.3 Paul Kane, *Falls of Colville on the Columbia River*, ca. 1846–1948. Oil on canvas (48.3 × 72.4 cm). Corbis Historical via Getty Images.

Index

Acknowledgments

I have been inspired by fans of *The Dress Detective* as well as the intellectual curiosity of my former students, including Teresa Amado, Elizabeth Barrette, Jennifer Braun, Anouk Brouwer, Eva Chen, Chris Der, Olivia Da Cruz, Hannah Dobbie, Victoria Hopgood, Xiao-Xiao Li, Alys Mak-Pilsworth, Riley Kucheran, Anna Martini, Jessica Oakes, Gabrielle Trach, Victoria Verge, Jazmin Welch, and Millie Yates.

I would like to acknowledge the kind assistance of staff at various museums that I visited during the course of this project, including: The Metropolitan Museum of Art in New York; The National Gallery of Canada in Ottawa; The Canadian Museum of History in Hull; The Art Gallery of Ontario in Toronto; The Art Institute of Chicago; The J. Paul Getty Museum and the Los Angeles County Museum of Art in Los Angeles; The Victoria & Albert Museum, The National Gallery, and The National Portrait Gallery in London; and so many others. I would especially like to thank curator Dr. Alexa Griest at the Art Gallery of Ontario for her patience in allowing me to study and draw Tissot's etchings and other works. I am also grateful to artists Sarah Casey, Kent Monkman, Yinka Shonibare and Mickalene Thomas for granting permission to include their artworks in my book.

This book would not have been written without the enthusiastic support of my editor and publisher Frances Arnold. I am deeply grateful for her encouragement and belief in my writing abilities. I am also sincerely thankful for the help of Yvonne Thouroude, who sourced the images from Getty Images on my behalf. And I am grateful for the assistance of Victoria Hopgood, who photographed garments from the Ryerson Fashion Research Collection for this book. I am also appreciative of the efforts of Arielle Mida and Riley Kucheran in giving me feedback on early drafts of selected chapters.

I also wish to express my deep gratitude for the love and support of my family, including my sons Michael and Jonathan, who were subjected to many art gallery and museum visits during their childhood. My devoted and loving husband has also been tireless in his support of my work, and has also patiently waited for me many times as I practiced the *slow approach to seeing* by drawing in galleries and museums around the world.